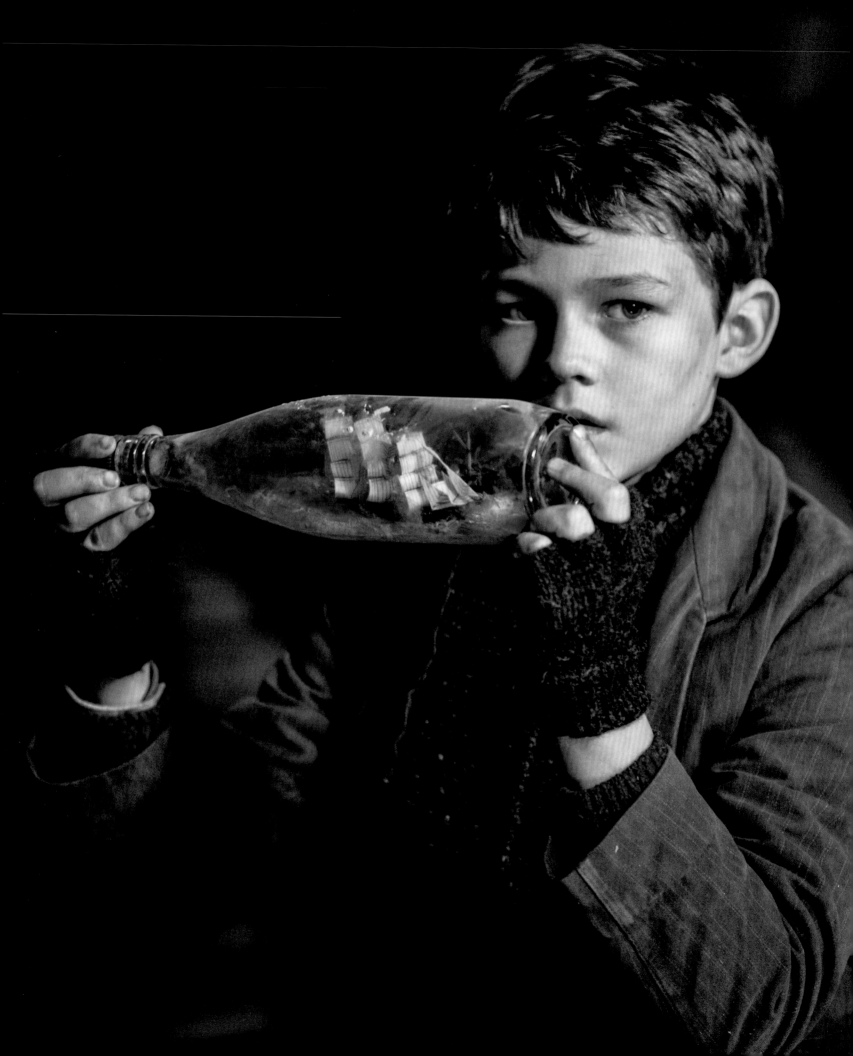

THE ART OF

PAN

WRITTEN BY

Christopher Grove

FOREWORD BY **Joe Wright**

INTRODUCTION BY **Garrett Hedlund**

INSIGHT EDITIONS

San Rafael, California

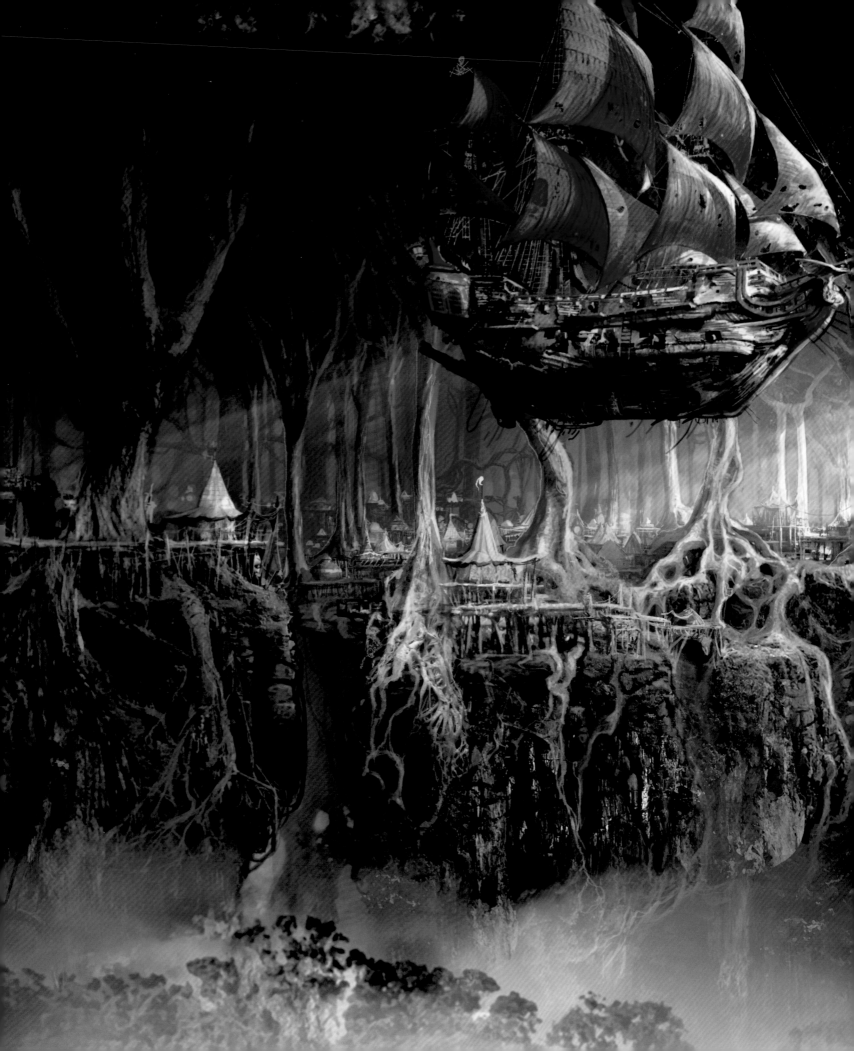

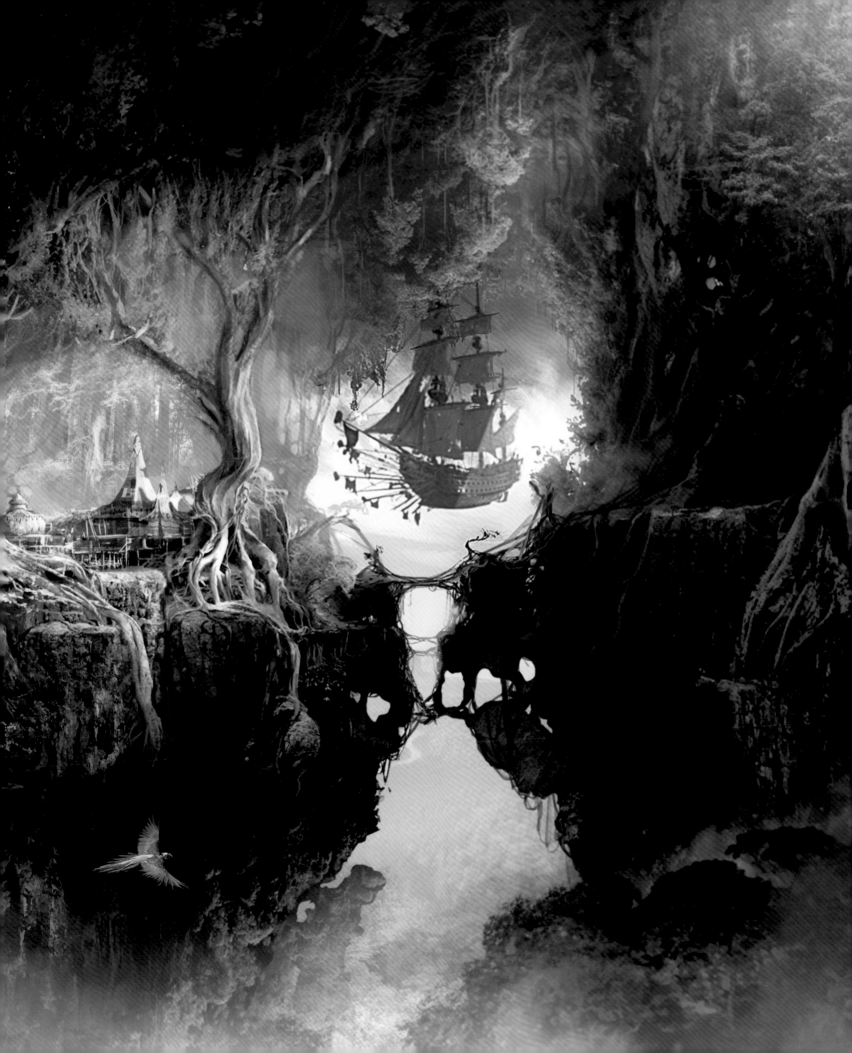

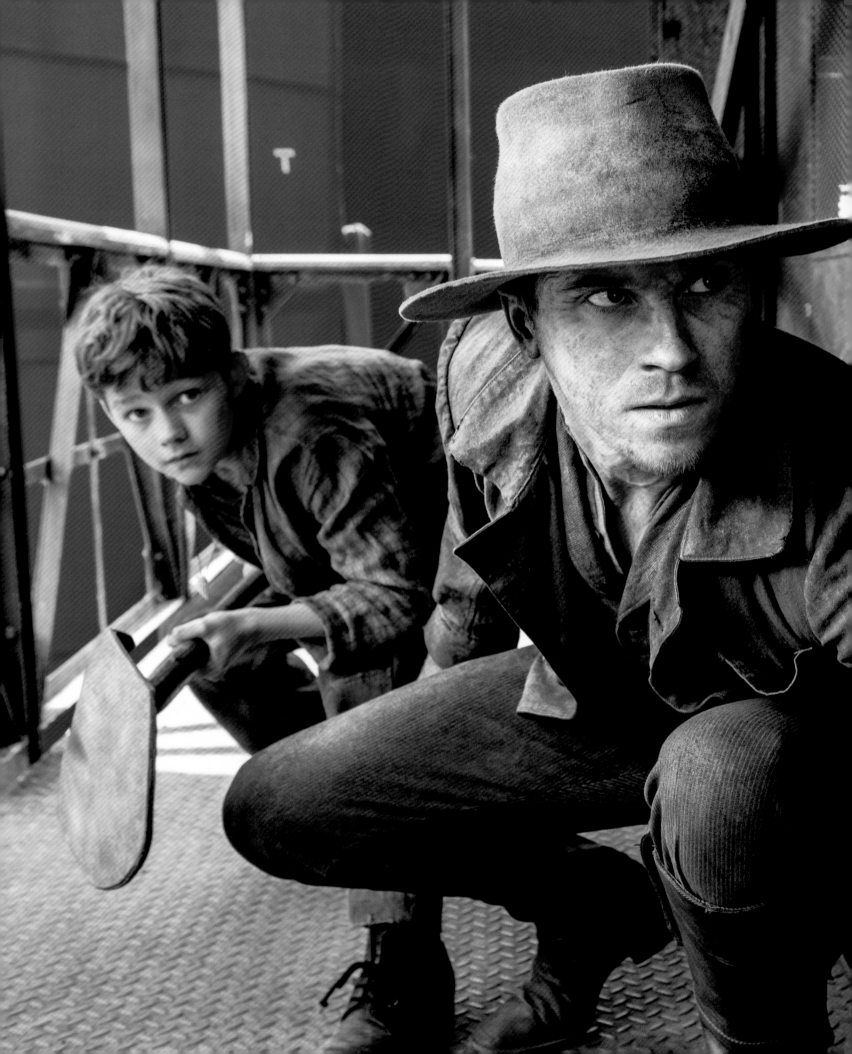

Contents

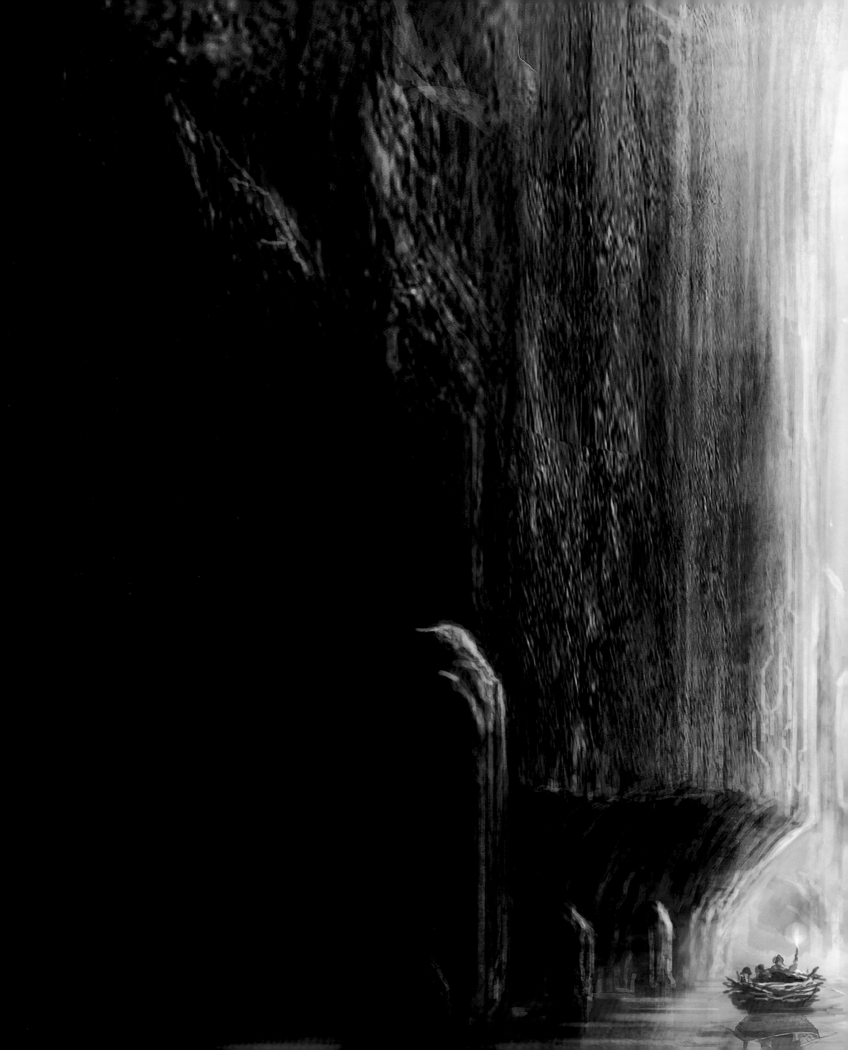

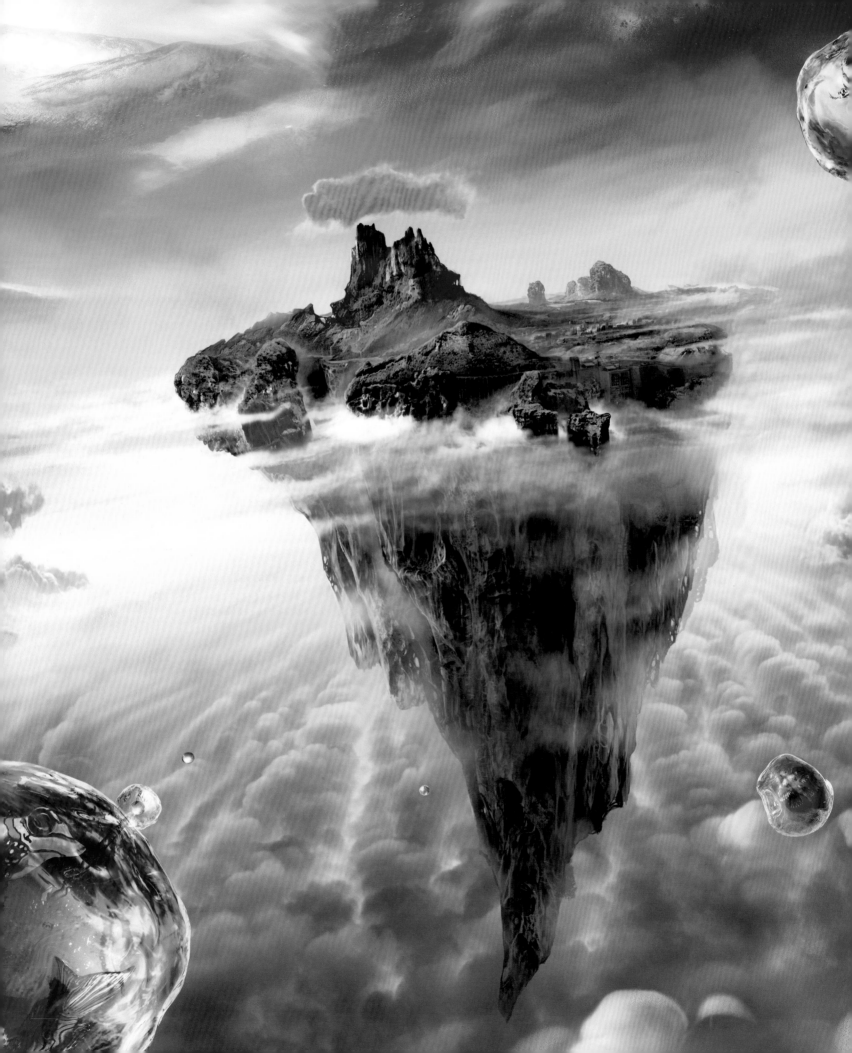

Foreword

BY JOE WRIGHT

From the moment the screenplay for *Pan* came to my attention, I knew that this movie could be something really special. I'd never read a script like it before. Throughout my career, I have read many more adult-skewing movie scripts, and this one had a kind of heart to it that I hadn't found in other stories of this scale.

The Neverland of Jason Fuchs' script is a world of imagination. It's a place where things that Peter might have seen in his life are reappropriated and turned into the extraordinary, the surreal, and the fantastical. And, above all else, it's the place where we witness how Peter becomes the Peter Pan of J. M. Barrie's classic 1911 novel.

I reread the book to figure out the true character of Barrie's Peter Pan. He's both good and bad. He has wonderful qualities—he has a vivid imagination and an extraordinary will, and he's a leader. But he's also given to lying, he can't read and write, and he's very forgetful. As Wendy says at one point (and I'm paraphrasing here), "If he forgets things so quickly, how can we expect he will go on remembering us?"

So *Pan* tries to answer the questions: How did Peter get to Neverland? And will he be able to defeat Blackbeard? By the end of the film we're left with a series of questions not yet answered: Why does Hook become such a bad guy? (In this telling he's definitely a good guy. *And* with both hands.) What comes next in Peter's relationship with the Darling children? And when does Tinkerbell show up?

It's such a great treat to direct a film for kids because you can free yourself of any seriousness and just have some fun.

My son was three when we started this, and I was looking for a film that I could make for him.

While Jason's script was a fantastic starting point for making *Pan,* I wouldn't have gotten anywhere without our amazing team of producers, creative department heads, behind-the-scenes crew (costumes, production design, set decorating, stunts, visual effects, hair and makeup, and more), and, of course, our cast. I've worked with some amazing ensembles, and the cast of *Pan*—Hugh Jackman (Blackbeard), Rooney Mara (Tiger Lily), Amanda Seyfried (Mary), Garrett Hedlund (Hook), this wonderful newcomer Levi Miller (Peter)—and more has been a dream to work with.

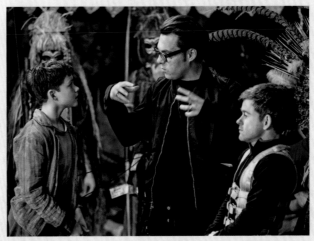

OPPOSITE Pan *offers an exquisite reimagining of Neverland and its colorful inhabitants.* **ABOVE** *Director Joe Wright brings his keen eye for design and dramatic flair to the project.*

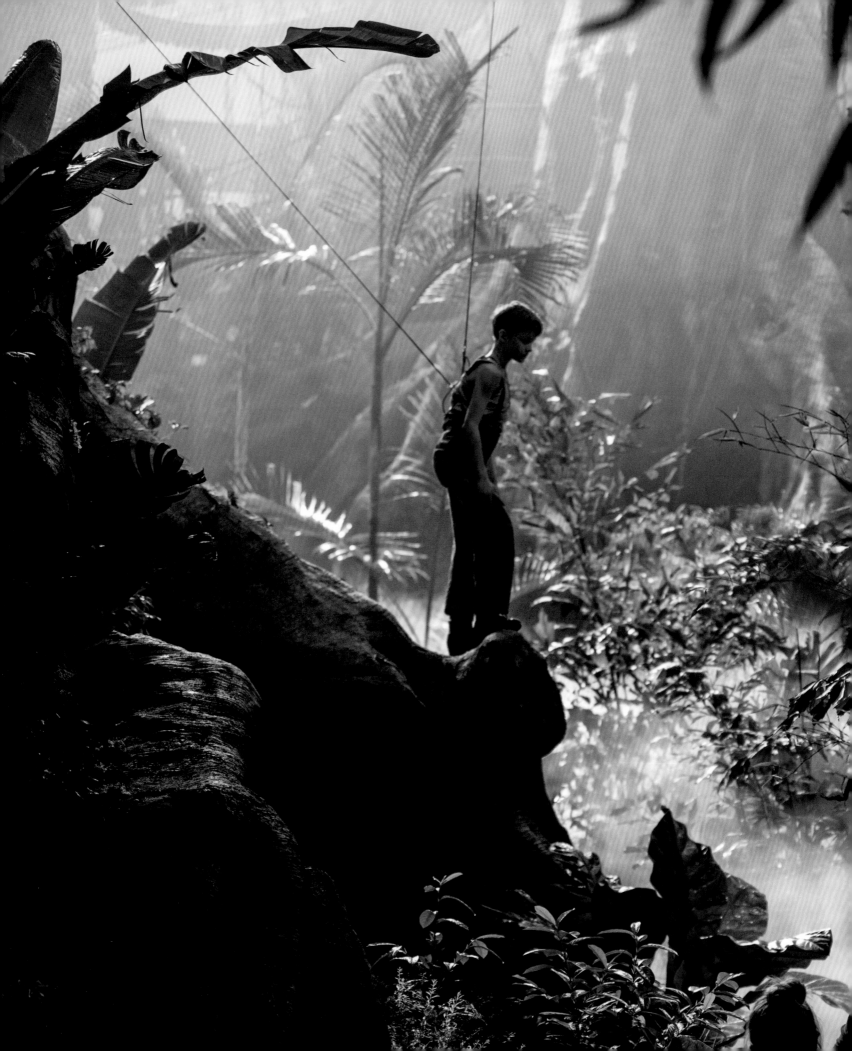

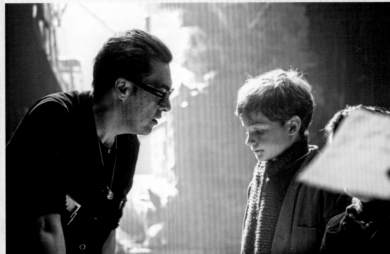

LEFT *Young actor Levi Miller learns how to fly as Peter Pan.*
ABOVE *After seeing many young actors for the part, director Joe Wright knew that newcomer Miller would be the perfect actor to play Pan.*

Finding Levi was almost as big a quest as making the movie. It was a global casting, and we saw thousands of kids. But then in walked Levi, and we all knew right away that this was our Peter. He has a lightness and kind of wonder that were just the right qualities for the character. It was much the same way when Garrett and Rooney read for us—they made the decision a no-brainer. They made it easy. And then there's Hugh Jackman. Blackbeard is dark and evil, and Hugh is none of those things, which is why it was so much fun to work with him. He was also a great company leader. On a film like this, that is a very important thing to have.

I'm never sure how to talk about my approach to filmmaking when I'm asked. It's difficult for me to look at my approach objectively because it's just what I do, and I've never seen anyone else do it. I think it's critical that everyone feels involved. I want everyone from the cameraman, the extras, and the riggers to the cast and all of the creative team to have a sense of ownership of the project. I love people's imaginations, and I want everyone to give of their imagination.

I hope the movie will be a very exciting, enjoyable ride. There's lots of humor, and there's a tender soul to the story as well. I think that's unusual for a film like this. Ultimately, that's my job—to protect the tender soul of it.

Introduction

BY GARRETT HEDLUND

When I first learned about director Joe Wright's imaginative take on the origins of Peter Pan and Captain Hook, I had a feeling it was going to be quite a fantastic ride. It turns out that my hunch was correct. This movie invites audiences to meet most of the characters that everybody knows and loves as they are before they appear in J. M. Barrie's classic work. I was quite honored to be chosen to play Hook, a complicated character who has yet to become the villain of various animated and live-action productions and portrayed by the likes of Cyril Ritchard, Hans Conried, Dustin Hoffman, Jason Isaacs, and Christopher Walken.

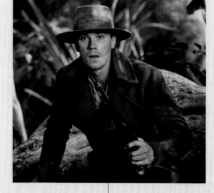

The James Hook of our movie is actually Peter's ally, but he has his own agenda. His goal is to return to his home—a place that he can't quite remember because he's lived in Neverland for so long. If you pay attention, you may even notice clues about whom he might become in the future. Peter, Tiger Lily, and Hook are all searching for things: Peter is yearning for his mother, Tiger Lily is looking for a savior, and Hook is trying to find a way to return home. Slowly, they realize that the only family they may ever need has been standing right by their side all along.

I recall that on one of the first days of rehearsal, Joe had all the pirates gathered in one place to exercise together. It was an approach that we often see in theatrical productions. In a way, it was the perfect introduction, because most people have seen a stage production of this work, and we had the freedom to be just as big and over-the-top in order to prepare for the role.

Pan allowed me to have lots of fun playing a multilayered character who forms an interesting bond with the young Peter and develops romantic feelings for Tiger Lily. I even got to be part of a fantastically choreographed trampoline fight. It was all part of the colorful, immersive Neverland experience—one that I hope will be shared by audiences all over the world.

I believe that Peter Pan has always been a sought-after fantasy because it touches on some of our deepest fears. It deals with the fear we all have of getting older, the fear of dying and of our own mortality. It also presents us with a version of life that many of us would love to see and takes us to a place where children can play, fly, and be children forever.

Through it all, *Pan* also offers this great message of hope and perseverance. It reminds us that it's possible to overcome the dark experiences and nightmares of our lives. Everyone has a little bit of Peter Pan in them—the heroic, helpful side that never gives up. We hope the movie will enforce this optimistic message—that one day, we can turn our back to the nightmares of life and fly with Peter to a magical world where everyone lives together peacefully and joyously.

ABOVE AND OPPOSITE *Garrett Hedlund offers a fresh new take on the familiar character of James Hook, who helps Peter understand his true calling in the movie.*

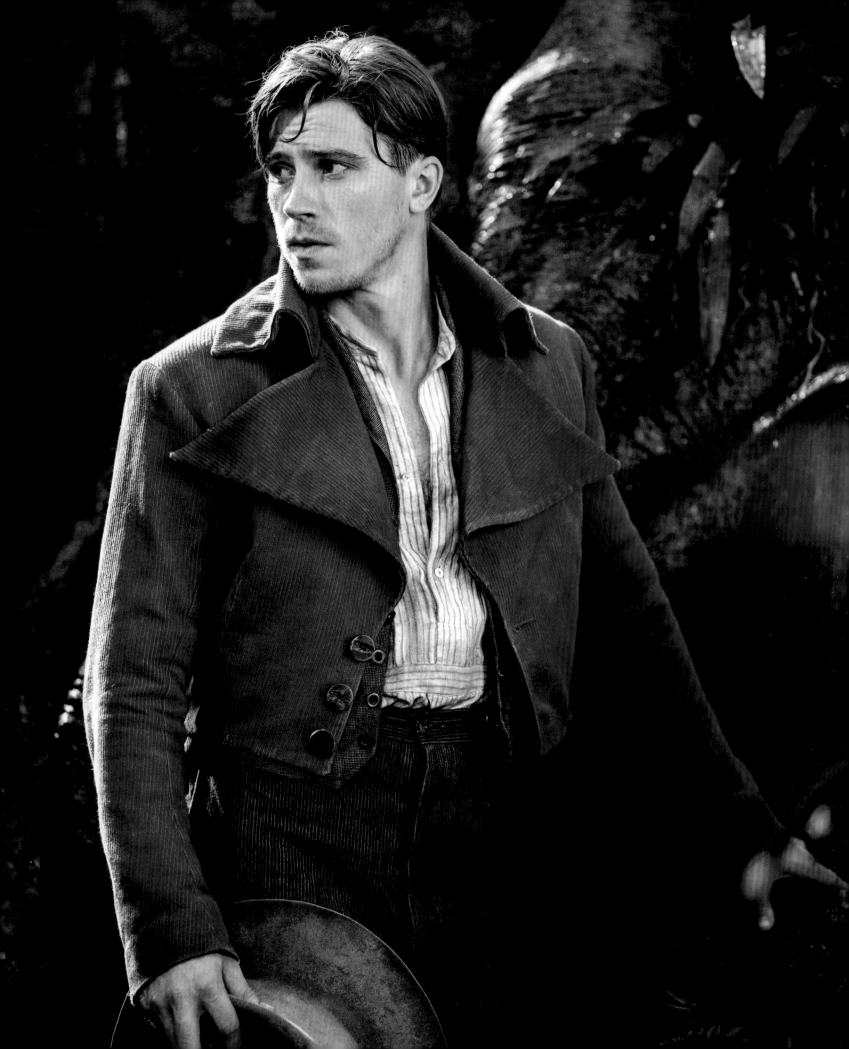

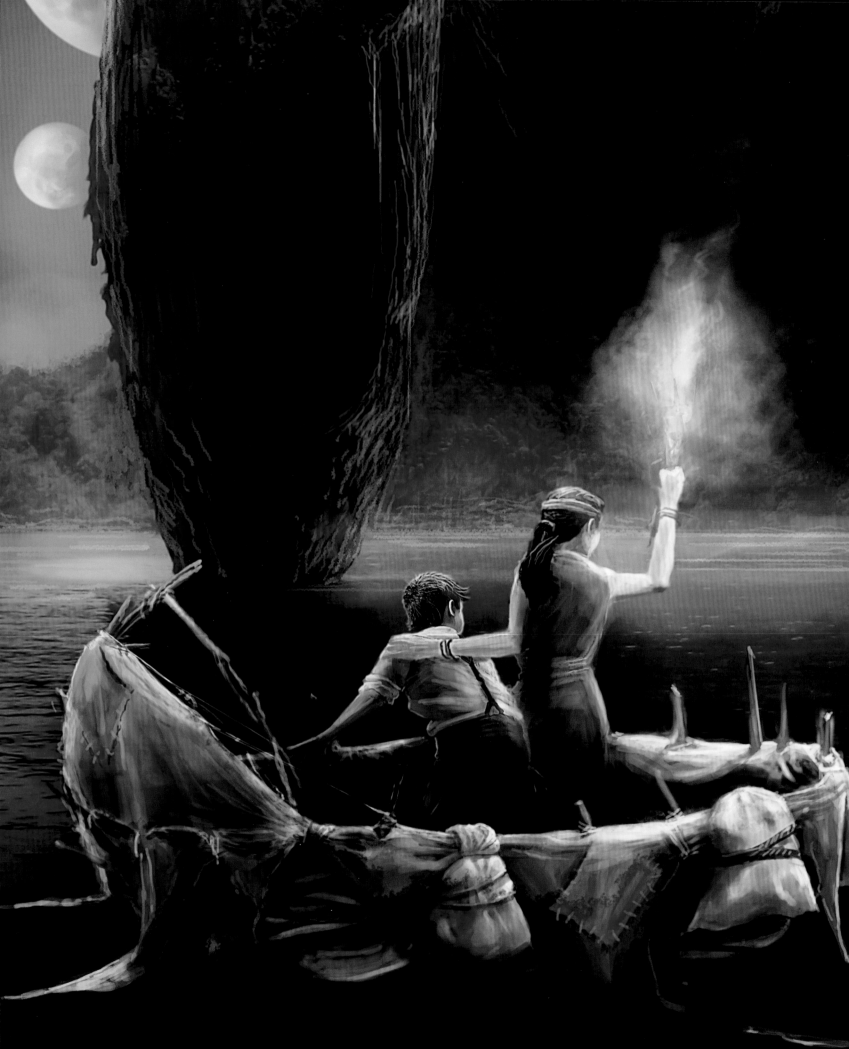

The Origin Story of an Ageless Hero

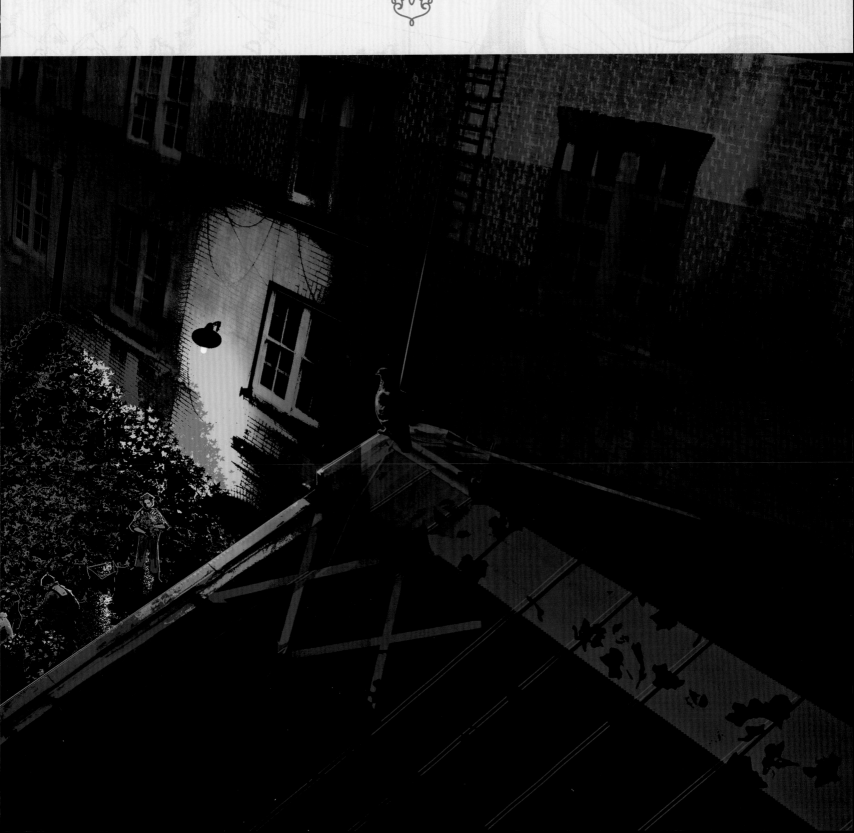

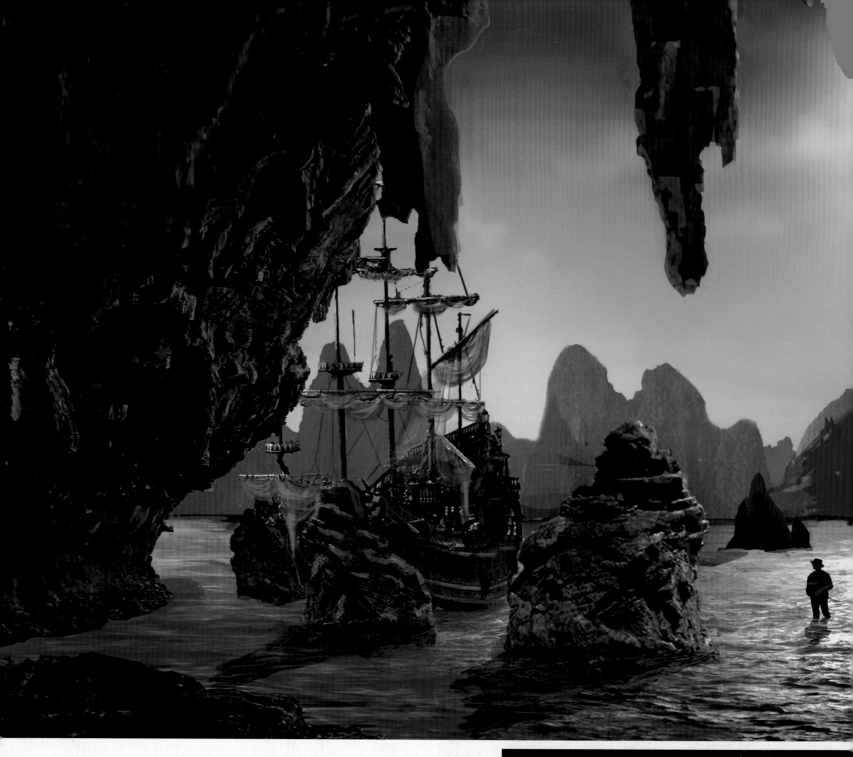

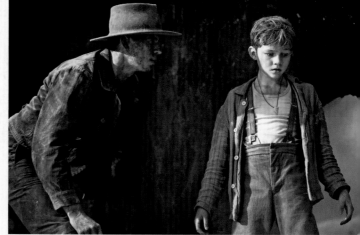

When the idea for *Pan* first began to bubble around in the brain of screen-writer Jason Fuchs, he was stuck on a malfunctioning Peter Pan theme park ride. Oh, and he was nine years old.

"My father and I were in a flying pirate ship over a miniature London. It was, to this day, the best twenty-five minutes of my life," recalls Fuchs, now twenty-eight.

Up in the ride vehicle, with LED stars twinkling all around and Peter and Wendy flying five feet from his face, Fuchs started to wonder: How did Peter *get* to Neverland? Why can he fly? How did he and Hook meet for the first time, and why do they hate each other so much?

"From that moment on, I desperately wanted to see a film that told the full story," Fuchs says.

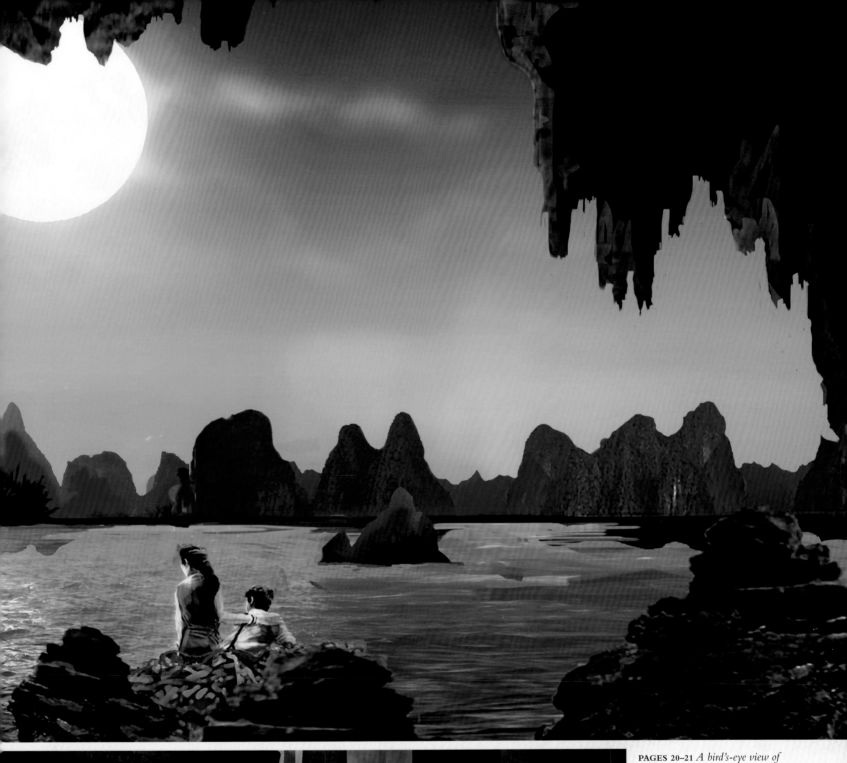

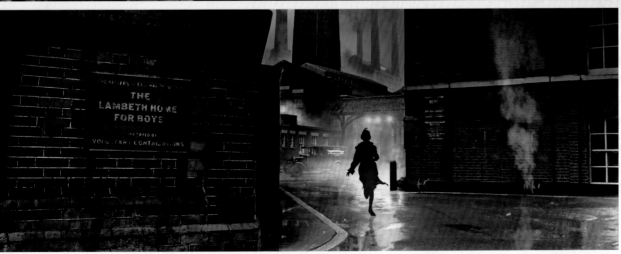

PAGES 20–21 *A bird's-eye view of Peter and Nibs, who are forced to rake the leaves outside the orphanage after disobeying Mother Barnabas.* **ABOVE** *Peter and Tiger Lily join forces to free the boys and save them from the dark schemes of Blackbeard.* **OPPOSITE BOTTOM** *Peter faces many obstacles before discovering his true origins.* **LEFT** *Peter's mother (Amanda Seyfried) makes a crucial decision in the opening sequence of the movie.*

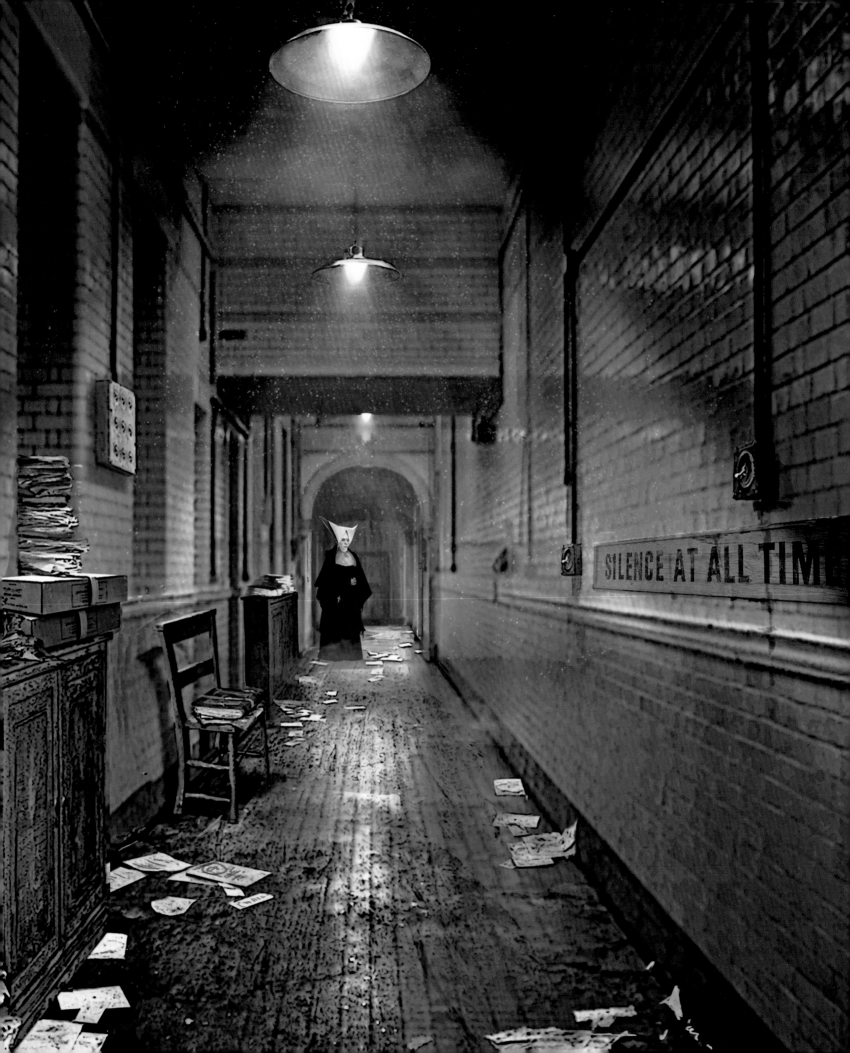

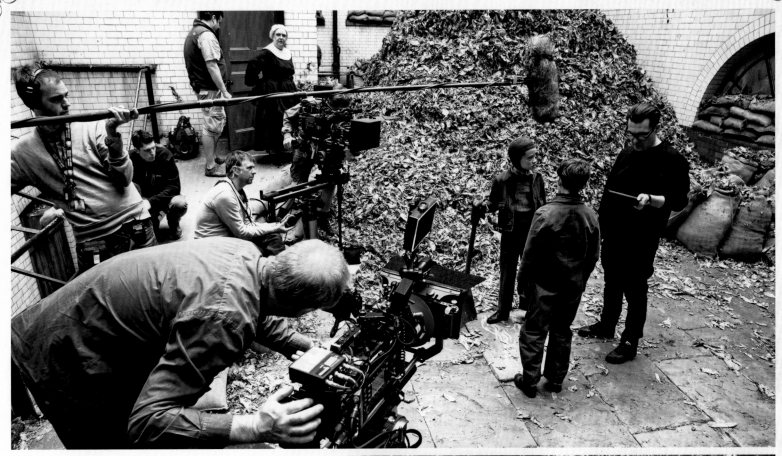

Fortunately for him no one ever made that movie. Two years ago, after over a decade as a successful actor and with just one other script under his belt, Fuchs finally wrote it. A century after the publication of J. M. Barrie's novel *Peter and Wendy*, a prequel to Peter Pan's story was born.

"One of the many reasons readers and audiences keep coming back to Barrie's work and its adaptations is the enduring power of that fantastical work," says Fuchs.

When the script found its way to producer Paul Webster at director Joe Wright's Shoebox Films in London, the reaction was immediate. "It was exceptionally good," says Webster. "It was very funny and very moving. We learn how Peter becomes Peter Pan." He sent the script to Wright that evening.

"Joe was in Los Angeles and scheduled to fly back to London that night. But after he read the script he got on the phone with Warner Bros. and set up a meeting with studio executives for the next day," Webster continues.

"I'd never read anything like it," recalls Wright. "The script had a heart to it that I hadn't found in other films of this scale."

Oftentimes, big-budget family fantasies like *Pan* take many years to get off the ground. Yet, in this case, the transition from concept to development and production was remarkably smooth. After the director's first pitch meeting with studio executives,

the pace picked up. "Both Greg [Berlanti, producer] and I were blown away by everything Joe had to say," recalls producer Sarah Schechter. "He shared his vision with us. We did another draft of the script with Joe's input, and he started doing some artwork to present it to the Warner Bros. team." Shortly after that meeting, *Pan* got the green light and went into production.

After a decade of making a series of highly successful dramas aimed firmly at an adult audience (*Pride & Prejudice, Atonement, Anna Karenina*), Wright welcomed the daunting challenge of directing his first all-family big-budget film, laden as it was with fantastical landscapes and characters, and, as with any tentpole movie, loads of computer-generated imagery.

OPPOSITE *Mother Barnabas is the cruel authority figure in the orphanage.* **TOP** *London's Kensington Gardens has been closely associated with the Peter Pan story.* **ABOVE** *Director Joe Wright works closely with young actors Levi Miller and Lewis MacDougall.* **FOLLOWING PAGES** *A map of Neverland.*

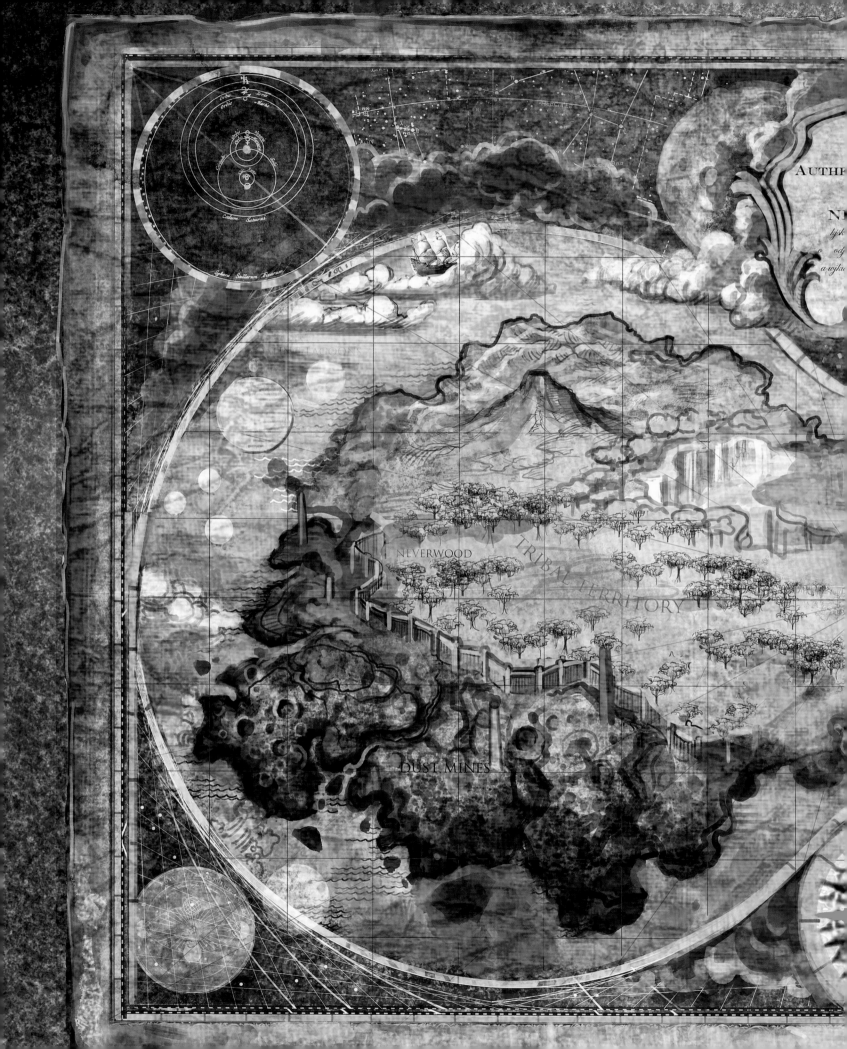

AUTH

N

kjsk

odj

a wjku

NEVERWOOD

TRIBAL TERRITORY

DUST MINES

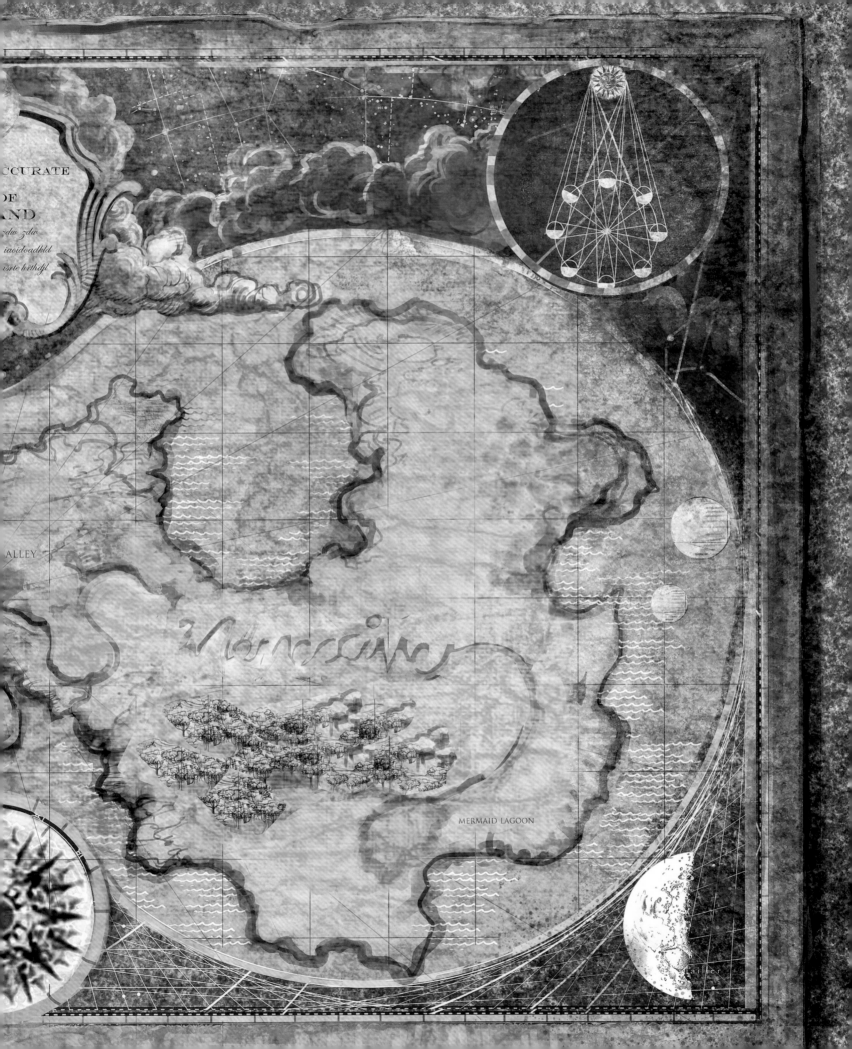

CCURATE

OF

AND

ALLEY

MERMAID LAGOON

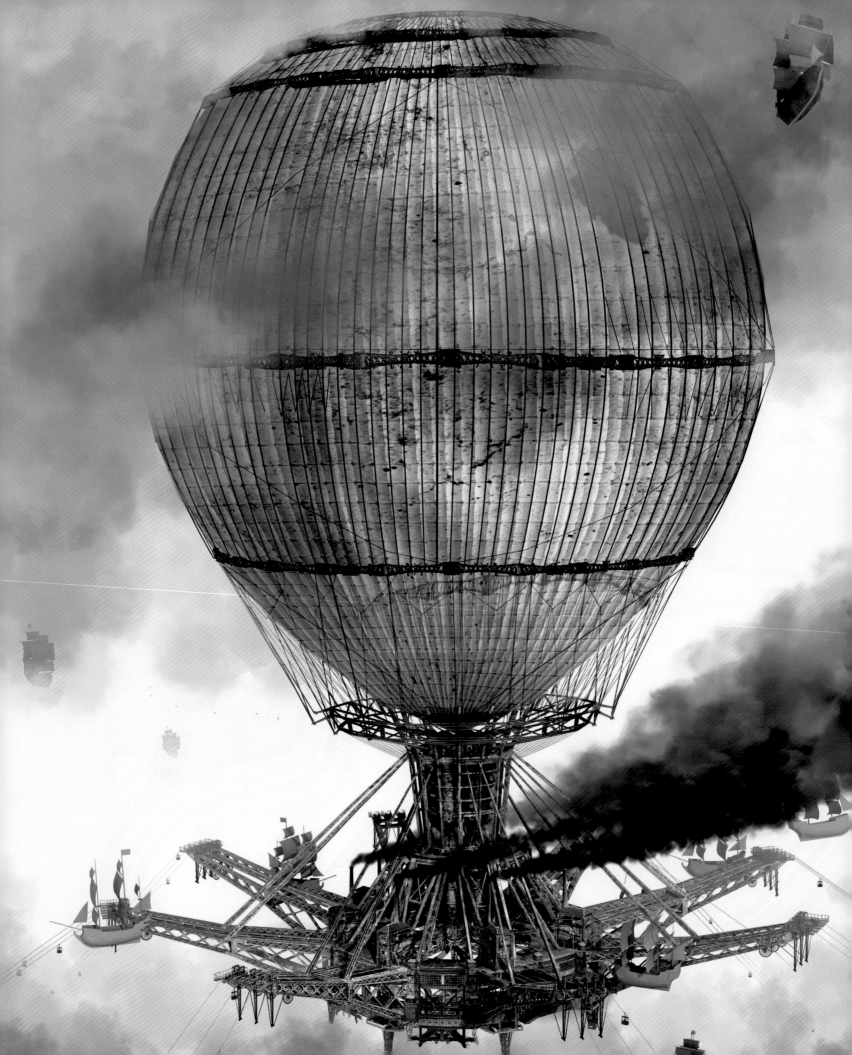

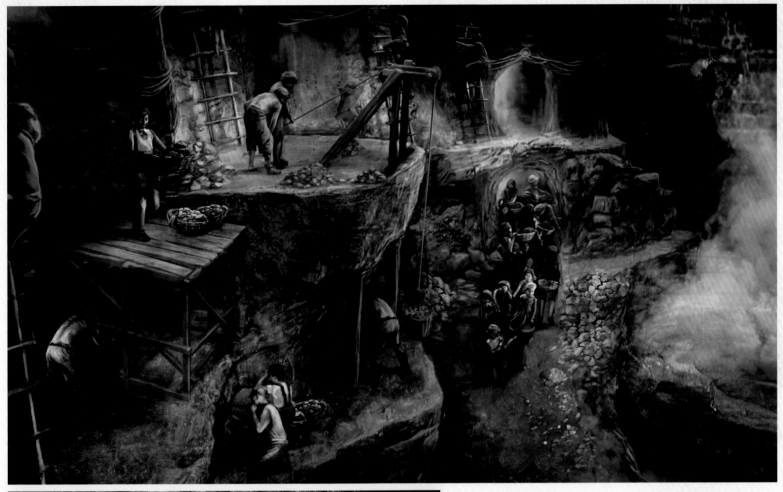

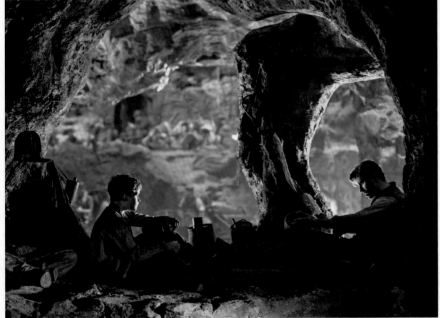

OPPOSITE *Giant pirate galleons and an enormous balloon were conceived as a way to spirit Peter and the other orphans away to Blackbeard's mines.* **TOP AND FOLLOWING PAGES** *Blackbeard forces his slaves to mine for youth-restoring fairy bones known as* pixum. **ABOVE** *Peter and Hook come up with a plan to escape from Blackbeard's mines.*

FLIGHTS OF FANCY

"Here was an opportunity to free our imaginations and to be as silly as we liked," says Wright. "When you are filming *Anna Karenina* [as he did in 2012] and think of a joke, you can't put it in the film. It wouldn't work." But on the set of *Pan* with actors such as Hugh Jackman (Blackbeard), Rooney Mara (Tiger Lily), Amanda Seyfried (Mary), and Garrett Hedlund (Hook) on board and a running battle between pirates, villagers, and, of course, Peter (newcomer Levi Miller), nothing was off limits.

Often when Wright and producers were pitching ideas to each other about how to shoot a scene it was the so-called "ridiculous idea" that ended up being shot. For example, during an early sequence centered on the escape from Blackbeard's mines, two galleons floating in midair were scripted to be on a collision course. "Instead of a straightforward avoidance maneuver, someone suggested we turn one of them upside down," Wright says. And just like that, with Mr. Smee (Adeel Akhtar) hanging from the feet of Hook, the ships and the story moved forward. "There's a wonderful democracy of ideas when you're working with Joe," says the film's cinematographer, Seamus McGarvey. "It's a round table of ideas, and he's at the center of the wheel."

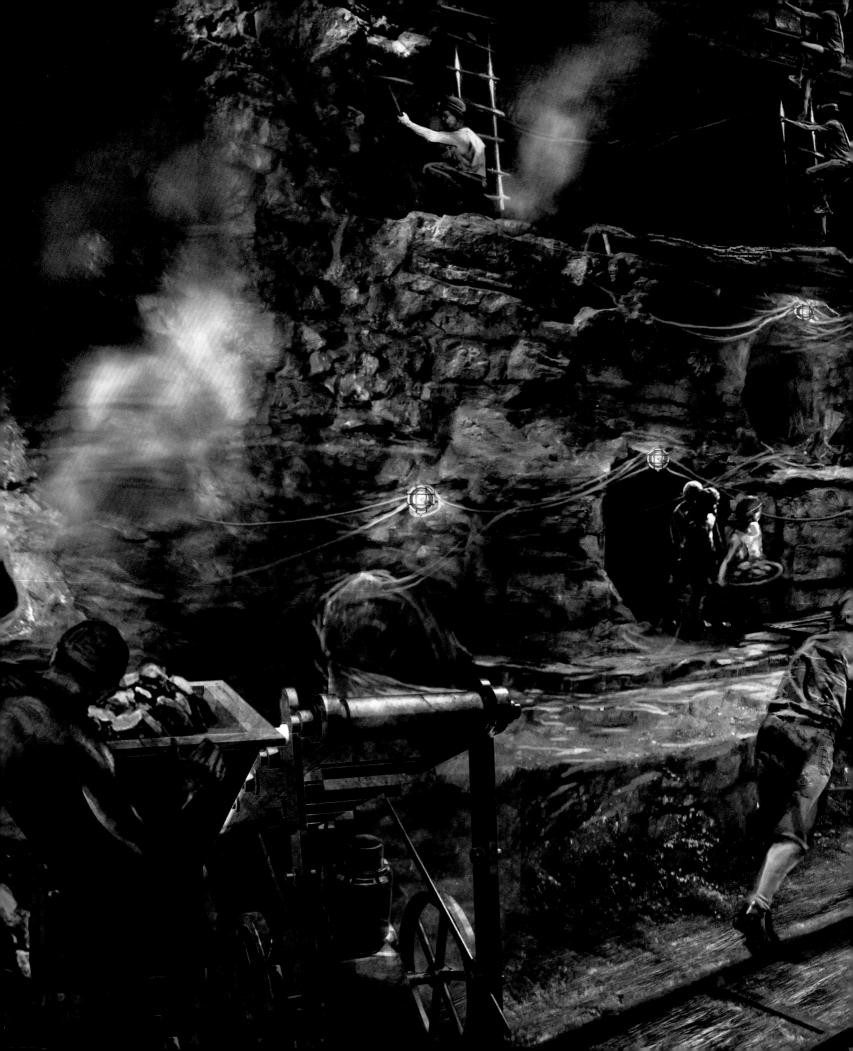

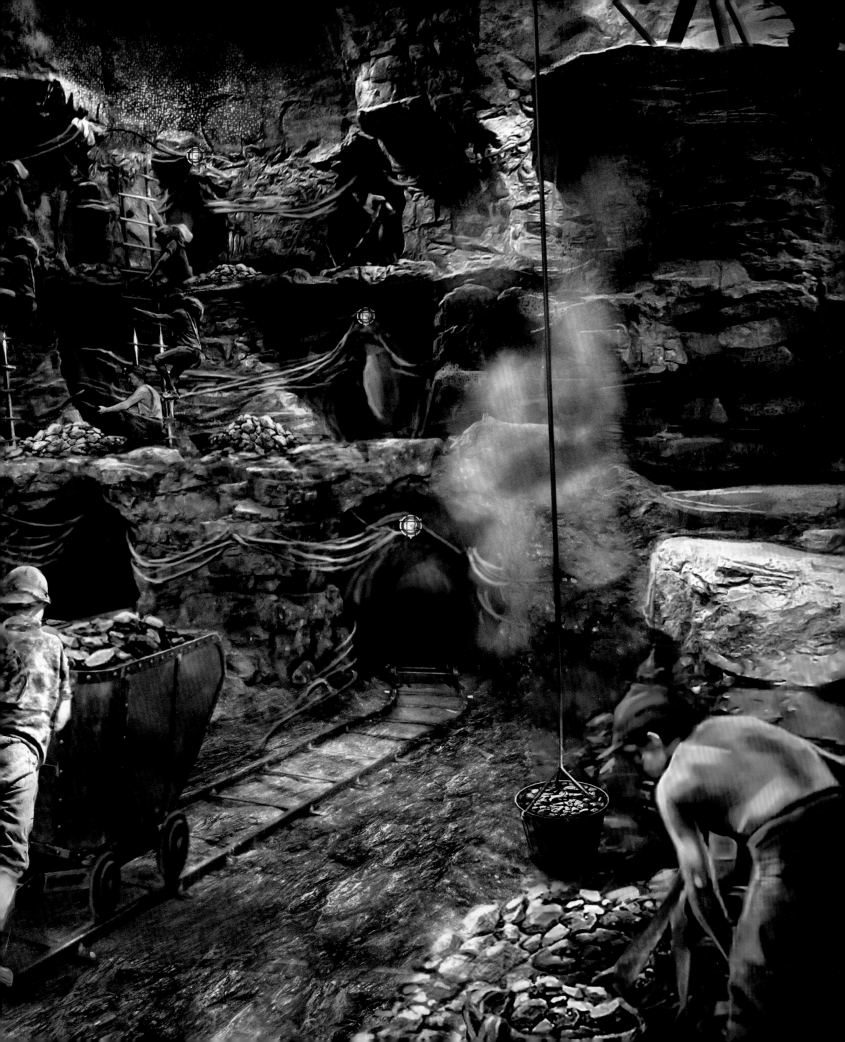

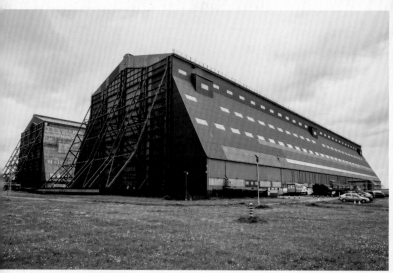

ASSEMBLING A MAGICAL TEAM

Wright began to put together a peerless team of cast and crew that wouldn't crumble under pressure. "We're the Joe Wright filmmaking family," says Webster. First on board were Shoebox Films veterans McGarvey (whose professional association with Wright dates back to 1998 when he was director of photography on Wright's short film *The End*), Oscar®-winning costume designer Jacqueline Durran (who has worked on all of Wright's films), makeup and hair designer Ivana Primorac, storyboard artist David Allcock, and casting directors Dixie Chassay and Jina Jay. And there were first timers who had admired Wright's work from afar and jumped at the opportunity to collaborate with him, including BAFTA Award–winning production designer Aline Bonetto, stunt coordinator Eunice Huthart, set designer Dominic Capon, and visual effects supervisor Chas Jarrett.

No matter what film he happens to be working on, Wright says he prefers to shoot as much as possible "in-camera." That is, the fewer CG visual effects, the better. As the story of *Pan* takes place in a London that no longer exists, as well as Neverland, a place that has *never* existed, many filmmakers might have opted to shoot as much of the action as they could with actors placed against a green screen, with the backgrounds to be added digitally later.

But that is not Wright's style. "Having the reality and scope of the sets not only helps the actors, it also helps create this potentially limitless world that's magical," says Hugh Jackman.

With the studio's backing, Wright's team built three sets inside two old airship sheds in Cardington, Bedfordshire, 60 miles north of London. The sheds have a five-acre footprint, making them five times larger than the biggest Hollywood soundstage. The largest of the three sets, the Neverland native village and surrounding jungle, filled an area approximately the

ABOVE *A five-acre airship shed in Cardington, Bedfordshire, was home to the massive sets built for the movie.* **OPPOSITE** *An artist's illustration of the tribal village of Neverland, which was originally planned to be located atop the island's giant trees.*

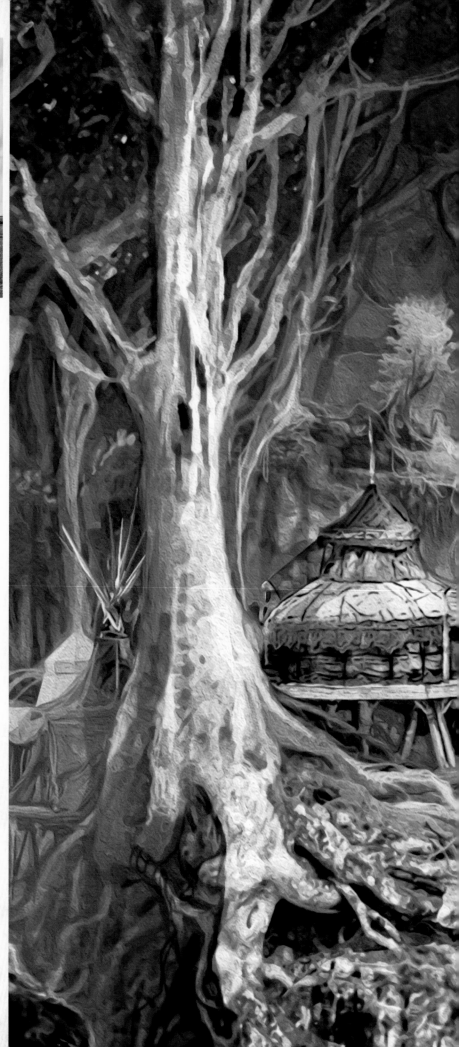

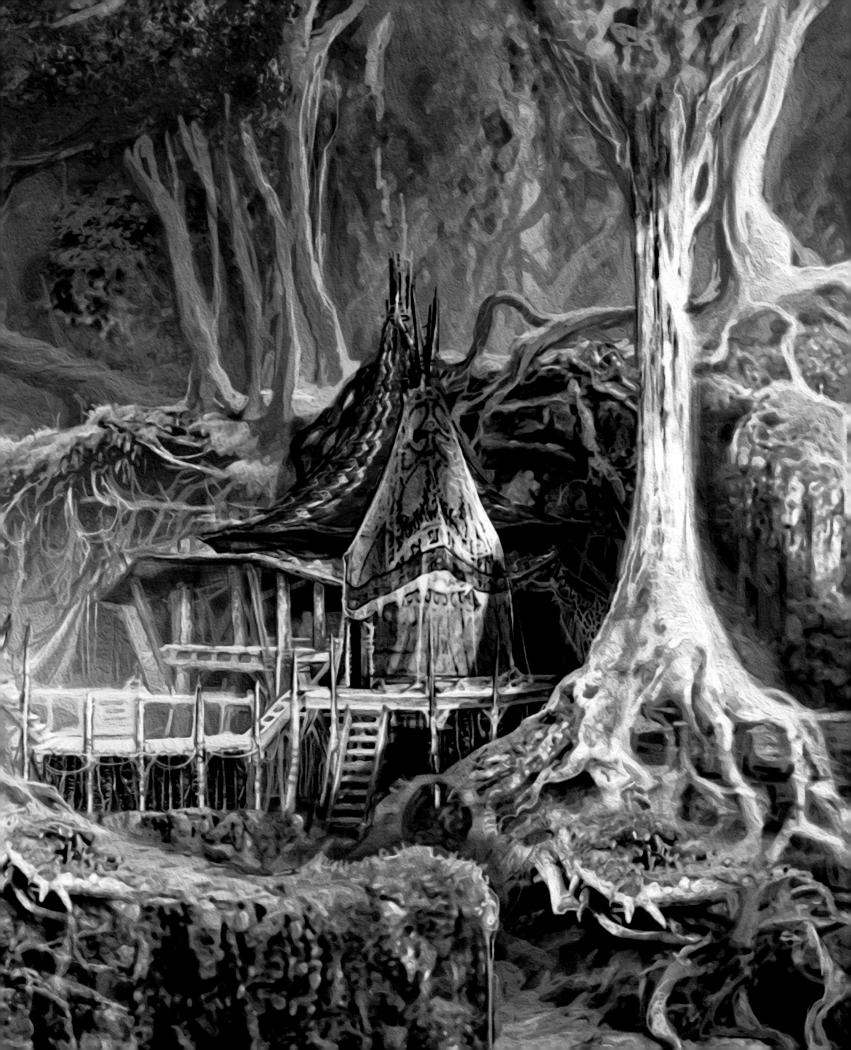

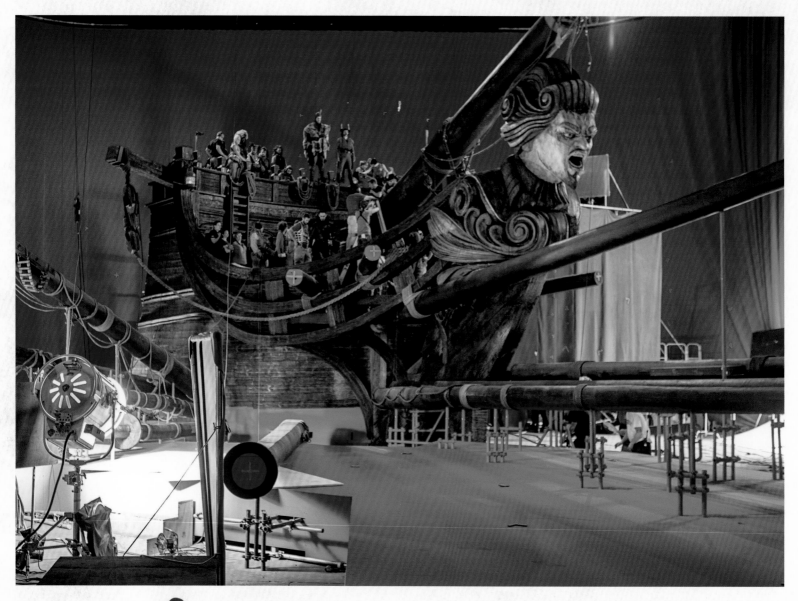

ABOVE *One of the Cardington sets featured the intricately built deck of Blackbeard's ship* Queen Anne's Revenge *positioned in front of a giant green screen.*
OPPOSITE *Designs for Blackbeard's exquisite 18th century–style galleon.*

size of an American football field, with trees rising to 42 feet above the studio floor. It took crewmembers ten minutes to walk from one end of the shed to the other. "Shooting on this set, with this story and with this cast, was like entering a long tunnel," says Bonetto. "We took a deep breath and began."

The other two sets—the deck of Blackbeard's boat *Queen Anne's Revenge* and the set of Blackbeard's hellacious mines—measured 100 feet by 40 feet and 100 feet by 100 feet respectively. Aside from those sets, the mines, dorms, Neverbird nest, and bamboo forest were shot at Warner Bros. Studios Leavesden, home of Harry Potter.

"Inevitably in a film of this scale, you need to have visual effects, because you're creating a world that exists only in our minds," says McGarvey. "But Joe was keen to ground everything in reality and, as much as possible, have the actors have a visceral experience on the physical sets."

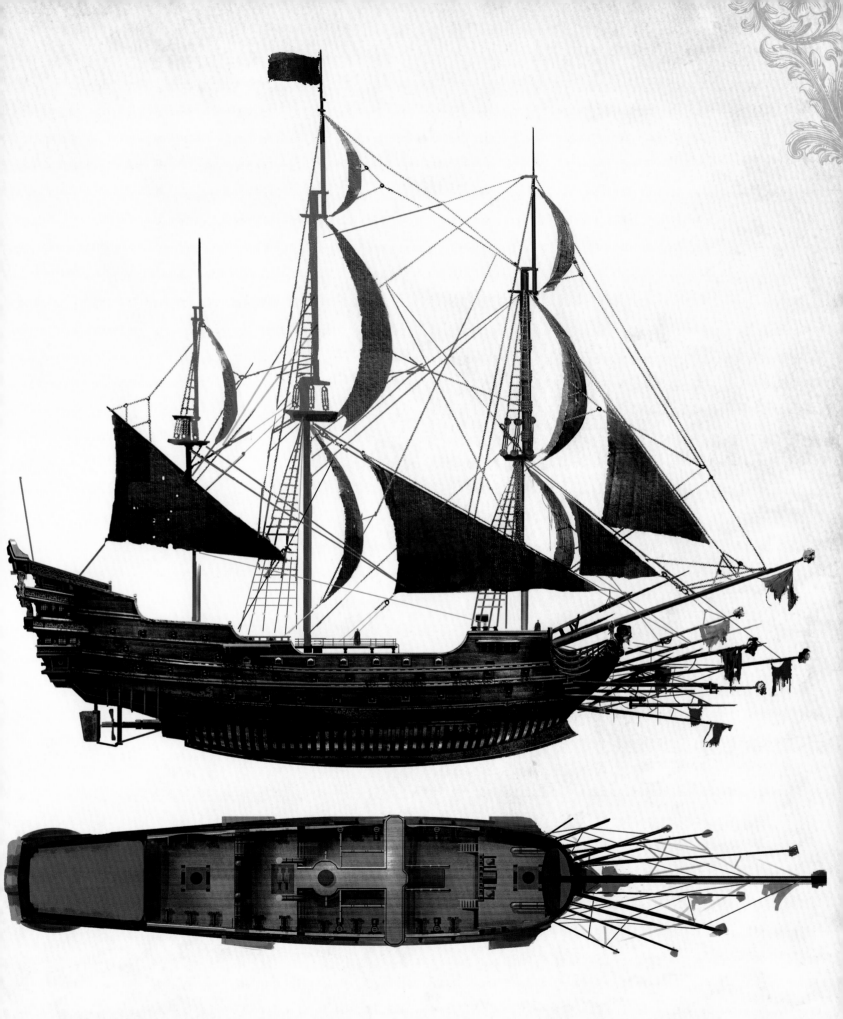

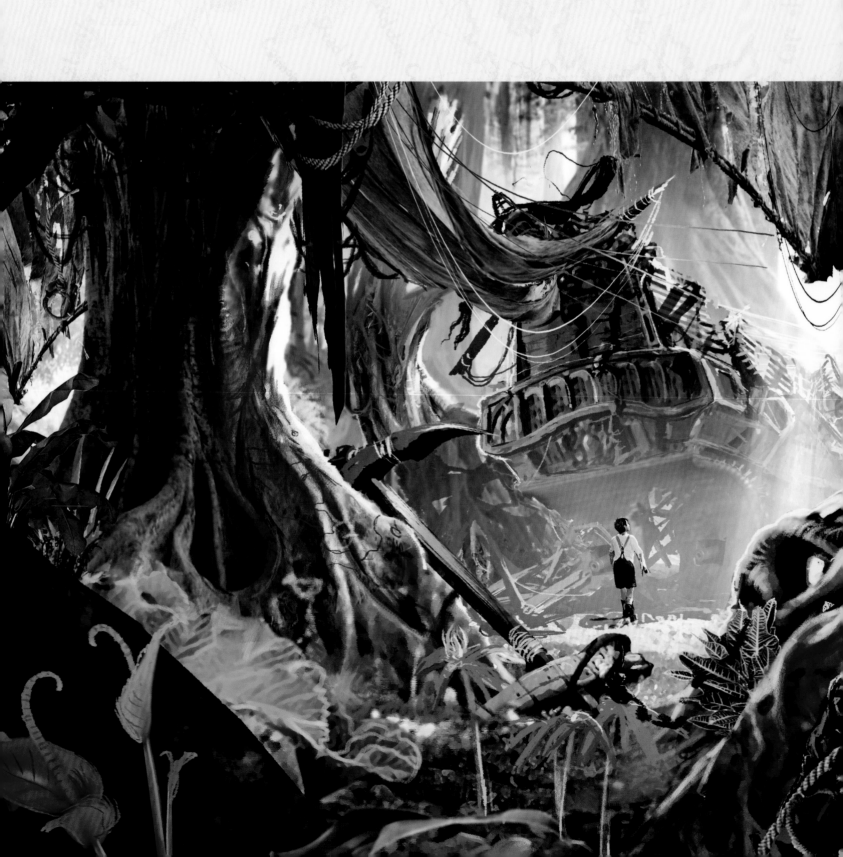

In Search of the Perfect Cast

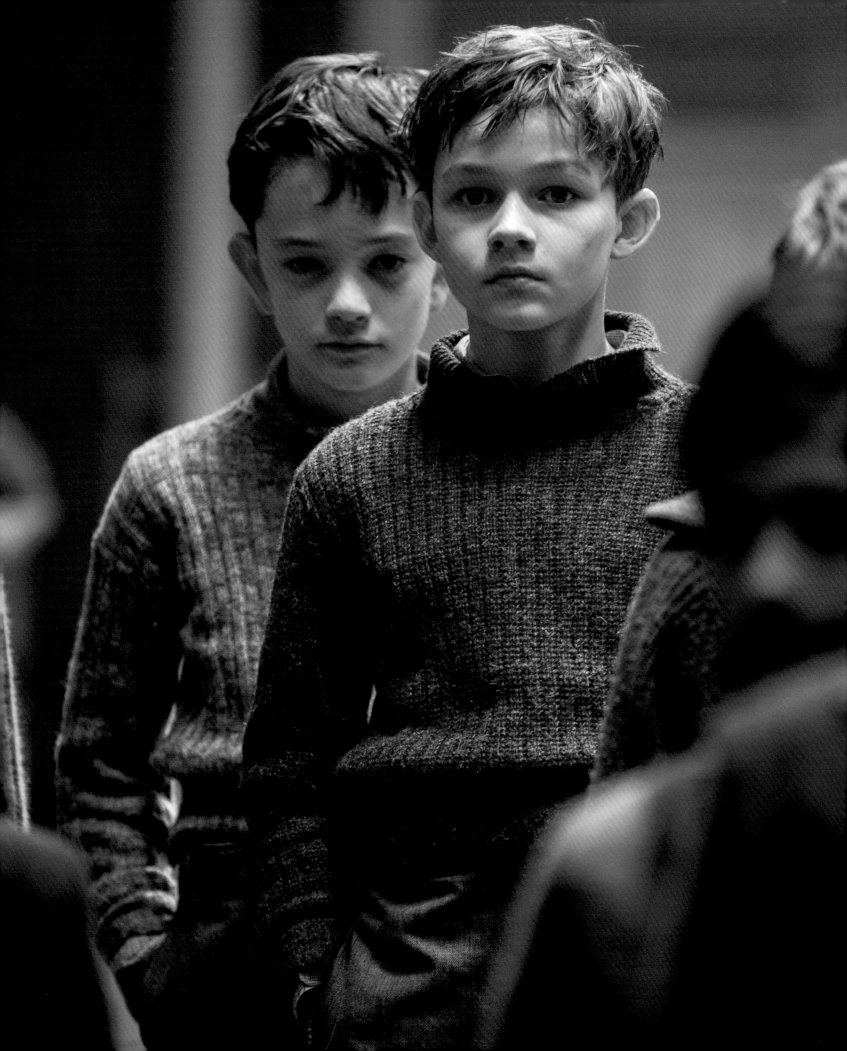

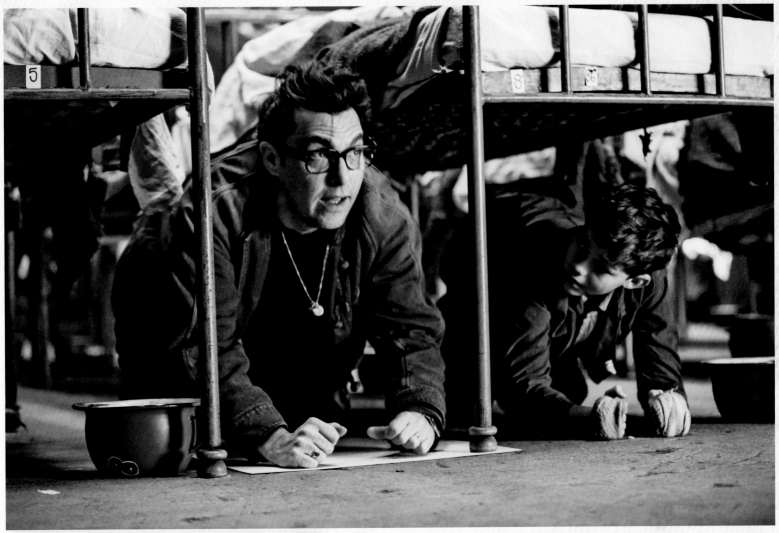

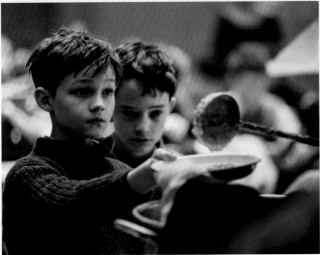

OPPOSITE AND ABOVE *Peter challenges the Dickensian conditions of the orphanage in the first act of the movie.* **TOP** *Director Joe Wright explains the particulars of an early London scene to the young actor.* **PAGES 36–37** *After escaping the mines, Peter explores the lush, tropical forest of Neverwood.*

As for the cast of actors picked to play on the stages they had built, nothing was more important than finding a young actor to play the title role of Peter. "It was a global search," says casting director Dixie Chassay. And it was one that started at home in England with an open call at London's legendary sporting venue, Wembley Stadium.

"We pulled out all the stops," says Webster. "We had casting directors working for us in every English-language territory in the world." The process pretty quickly came down to one—Australian actor Levi Miller—a young boy who, until now, had never acted in a film. "I got a lump in my throat watching his first audition," Webster says. The other producers and Wright felt the same way and scheduled a face-to-face meeting and audition with Miller. "He had a lightness and levity and brightness about him but also a soulfulness that set him apart," adds Wright.

To anchor the film, Wright and his colleagues knew they'd need a top talent to take on the role of the film's antagonist, Blackbeard. His rivalry with Peter is the central conflict of the story. He is the character with whom all the other major figures battle—including Hook, Peter, and Tiger Lily. Blackbeard is described in the script as "the pirate that all the pirates fear," and that was the central reason Jackman was eager to play him. "I like him because he's scary and he'll take your head off at a moment's notice and probably enjoy it," says Jackman. "But he's also sort of fun and likeable."

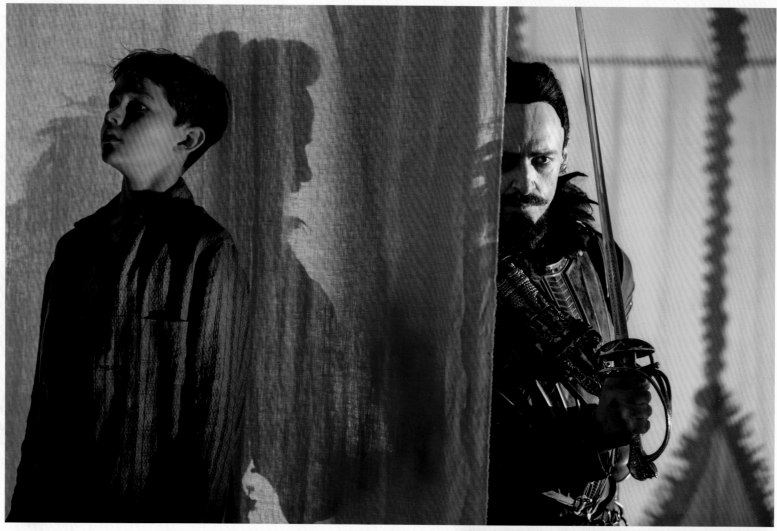

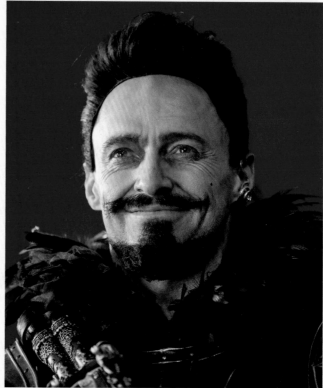

ABOVE *Peter and Blackbeard have a very tense, dramatic dynamic in the movie.*
RIGHT *Jackman portrays the film's villain, Blackbeard.*
OPPOSITE *Blackbeard's character is drawn as an elegantly costumed pirate who has a Svengali-like control over the other pirates and laborers of the pixum mines.*

The Warner Bros.' studio executives were thrilled when they watched early footage of Jackman and Miller on screen together.

"The first private scene between Blackbeard and Peter in Blackbeard's drawing room below decks leaves a very strong impression," says Berlanti. "Their performances, the look of the scene, the feel of the scene—it's a great moment of drama. It's a scene that's going to stick with the audience."

Adds Schechter, "One of the pinnacles of this experience was having Hugh join the cast. He's not just a huge movie star and an amazing actor, but he's also a wonderful person. He made it all a pleasure. He is so phenomenal in the part."

The creative team also knew that the actors cast as Hook and Tiger Lily would be crucial to the success of the film. In *Pan* the character of Hook is a stalwart fellow and a buddy/ older brother of Peter's. But he's also a character with contradictions—good-hearted but also selfish.

When Hook first meets Peter and finds out that Peter can fly, his initial reaction is to see the young boy as his ticket out of Blackbeard's hellish mines.

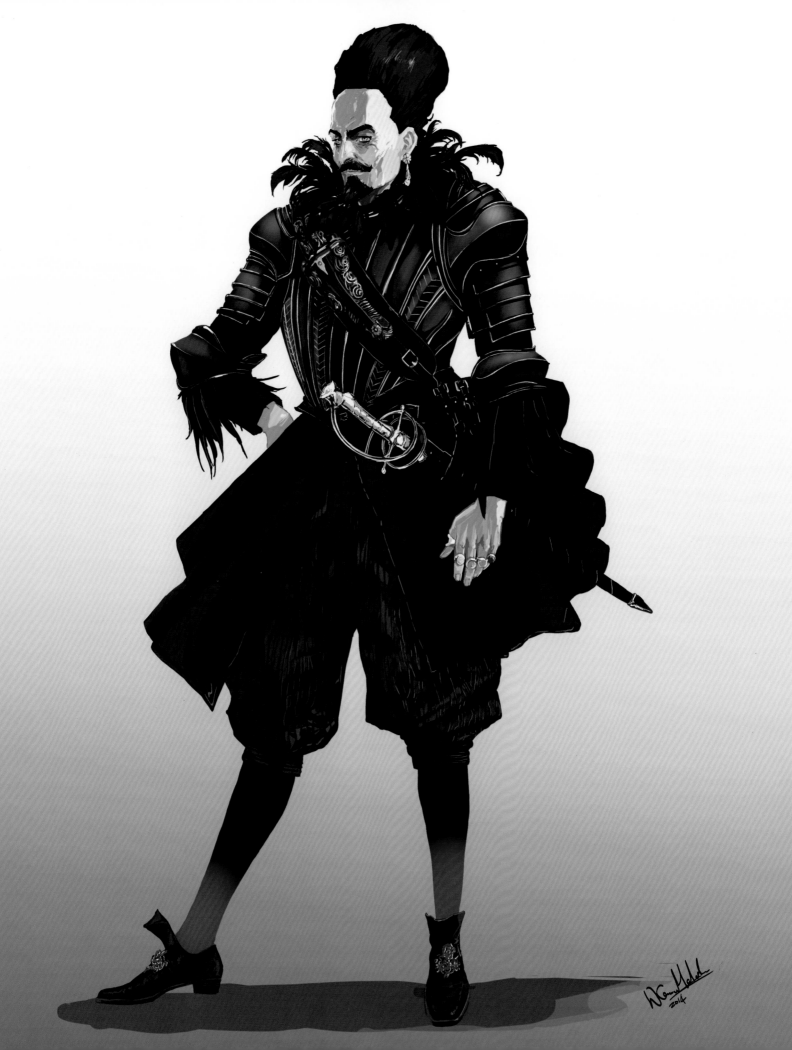

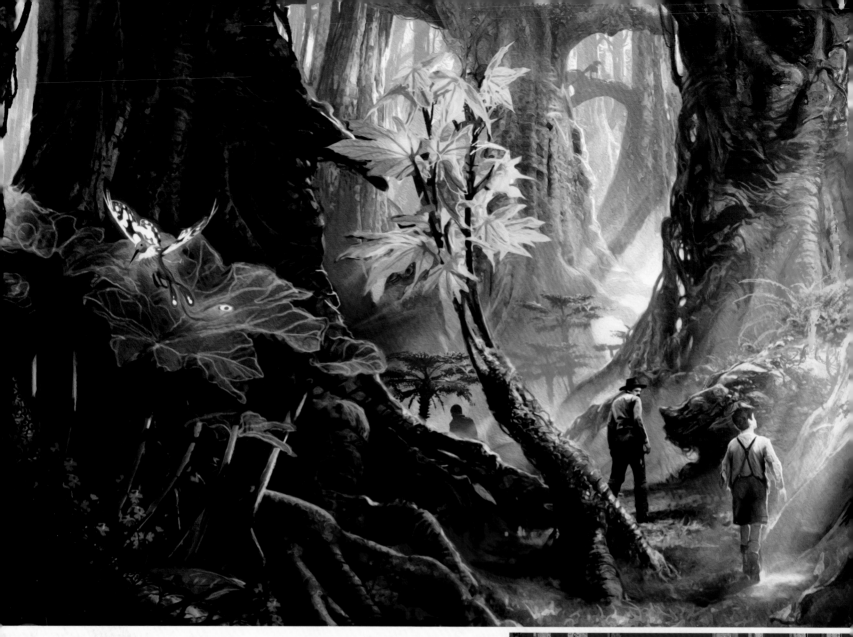

"We needed Hook to be a kind of all-American boy in a 'they-don't-make-'em-like-that-anymore' way. A really masculine, old-fashioned movie star," Webster says. "And when we looked at Garrett's audition tape, it was obvious that Hook was going to be played by him. And that was that."

Finally, there was the role of Tiger Lily to fill. With Peter a prepubescent boy and Wendy Darling yet to appear in the story of Peter's life, the relationship between the dashing James Hook and Tiger Lily is *the* love interest of *Pan*, albeit a Katharine Hepburn/Spencer Tracy-eseque romantic comedy love/hate relationship.

Actress Rooney Mara was the one chosen to play the challenging part. "Rooney truly captures the spirit of Tiger Lily, better than everyone else we saw," says Wright. "She had a really difficult part to play," adds producer Paul Webster. "Tiger Lily is a member of the royal court in this multiethnic tribal village, and she has to bring a kind of 21st-century modern sentiment to what's really an old-fashioned character. The part is also quite physically demanding. On top of all that, she is a noble person and still has to be quite accessible to Peter, because they build a deep relationship through the course of the movie. You need a very accomplished actress to deliver all of that, and Rooney did a terrific job of delivering all of that."

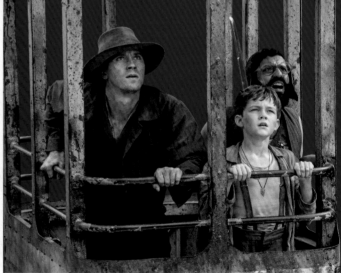

TOP *An illustration of a scene featuring Peter and Hook exploring Neverland.* **ABOVE** *Hook, Peter, and Mr. Smee (Adeel Akhtar) react in a major action sequence, filmed against the blue screen.* **OPPOSITE** *Tiger Lily, Peter, and Hook are aided by the sirens of the Mermaid Lagoon.*

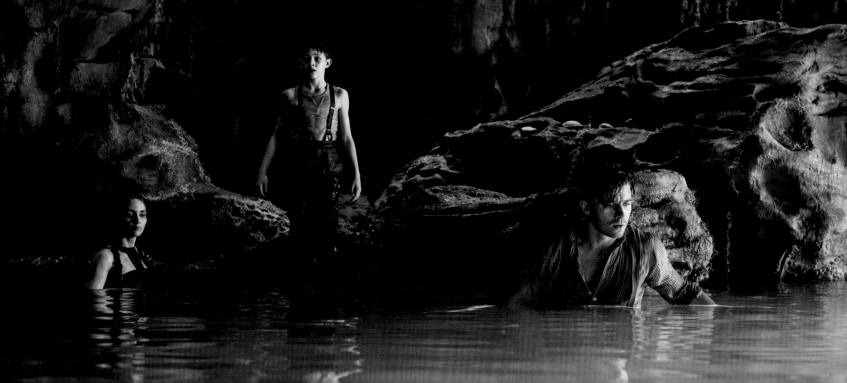

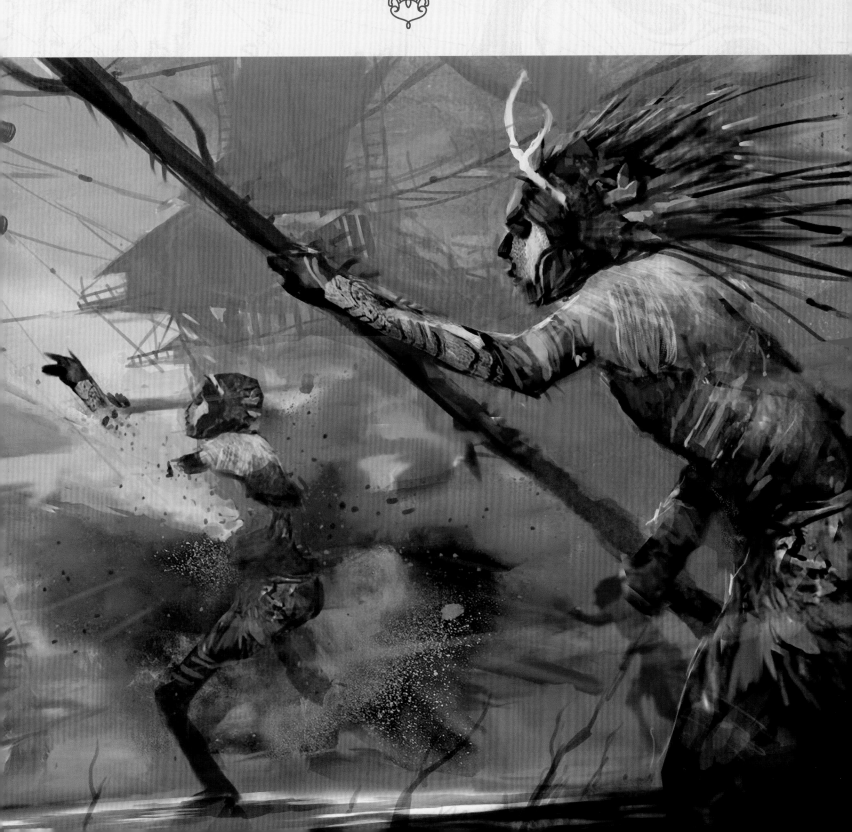

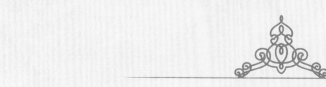

Peter Pan

You can have the best sets, locations, cast and crew, an engaging script, a team of award-winning producers, and a brilliant director, but in order to make a movie about Peter Pan truly soar, you must find the right actor to play Peter.

Normally, when producers are looking for an unknown child actor to take on the role of a lifetime they give themselves at least six months to get the job done. But because Warner Bros. executives were eager to get *Pan* into production, Joe Wright had just three. "We auditioned a lot of kids very quickly," says producer Paul Webster, "and a lot of them were very, very good."

Sometimes it takes a little cultural distance to interpret a character as beloved as the British Peter. "The Australian boys we saw, in particular, were very strong," Webster says. Out of that antipodean pack, young Levi Miller jumped to the fore and dazzled everyone. "He was great. He was fantastic. He was fearless," notes the producer.

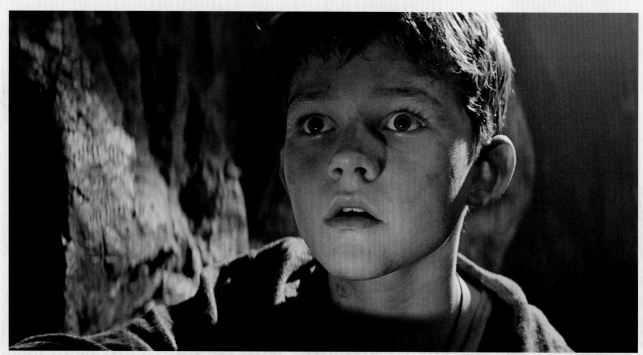

PREVIOUS PAGES *The Neverland villagers forge a brave battle against the forces of Blackbeard and his pirates.* **ABOVE AND OPPOSITE** *Australian newcomer Levi Miller landed the central role of Peter following a lengthy international casting search.*

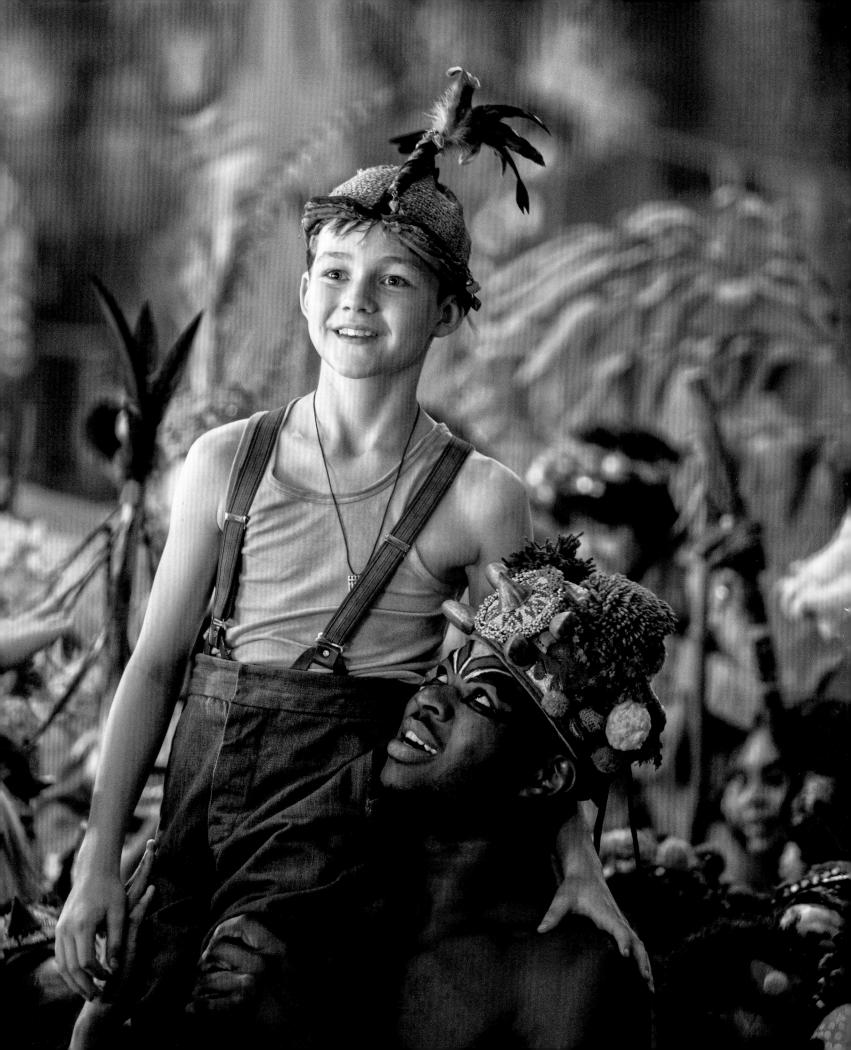

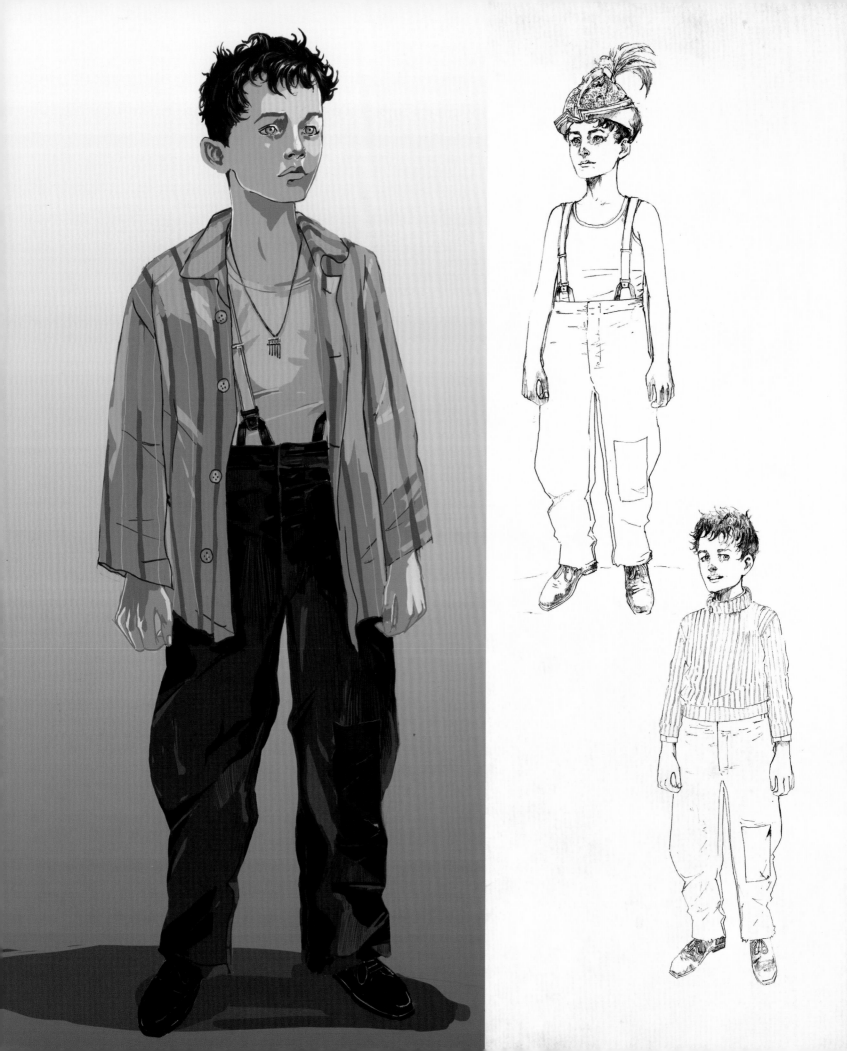

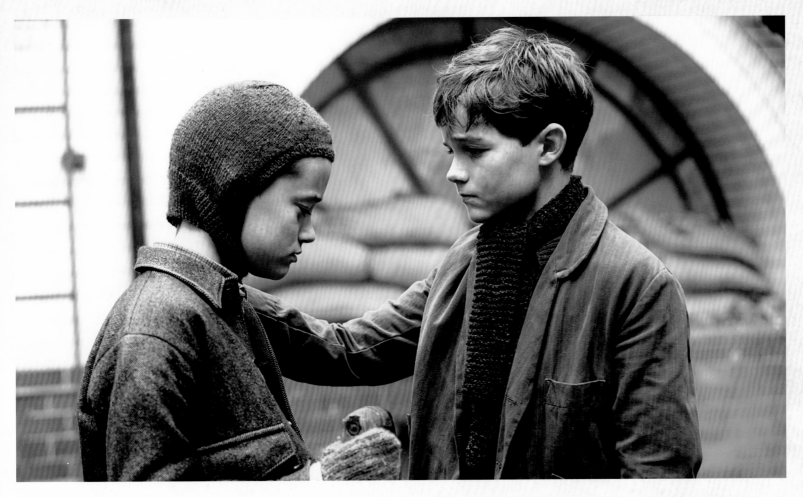

"Peter is a thoughtful character," says Miller, whose poise belies his age. "He likes to live dangerously. He's strong. And," Miller adds with a smile, "he's probably the most mysterious character in the film."

Pan is Miller's first film: His previous experiences were limited to commercials and short films. "Levi's very present," says producer Sarah Schechter. "He has a really good, big heart. And he has tremendous access to his emotions."

Peter's journey in *Pan* comprises the part the character is conscious of—his need to find his mother and to find himself—and the part he's unaware of, at least at first, which is that he's the child of a regular mother and a father from the fairy kingdom. That, and the fact that he can fly. "The action is fighting the pirates, getting through the jungle, getting through the mountain to find his mother," says Miller.

"We asked Levi to do some stunts that a fully fit adult would find hard to do," says stunt coordinator Eunice Huthart. But the dedicated eleven-year-old put in hours of physical training, and it paid off. "He overcame the obstacles. He worked hard. He always did it," she says.

Garrett Hedlund (*TRON: Legacy, Unbroken*), who portrays James Hook in the movie, was equally impressed with his costar's natural talent. "He's such an extraordinary young boy," says Hedlund. "Every day that we worked together, I would find something new about him that completely separates him from any other kids his age. He's so confident, imaginative, and creative. They looked all over the world for someone who is that special, and they found the real thing with Levi."

Miller had a lot to accomplish—fulfill the objectives of complicated action sequences, fulfill the arc of the character from defiant orphan to a self-assured young leader, and, in many ways, carry forward the hopes of a new Warner Bros. franchise.

All of which, says Miller, was made easier working with the great cast and with Wright: "Joe treated me like a best friend, which is what I like. It's not like we're working. It felt like we were on a break from school."

OPPOSITE *Three sketches created for Peter's character in the movie, which inspired Jacqueline Durran's final costume designs.* **ABOVE** *Peter comforts his friend Nibs (Lewis MacDougall) in the London orphanage run by the nuns.* **RIGHT** *An illustration of Peter's iconic pan flute.* **FOLLOWING PAGES** *Peter and Hook set out on a journey through the forest to learn more about Peter's mother and her relationship with Neverland.*

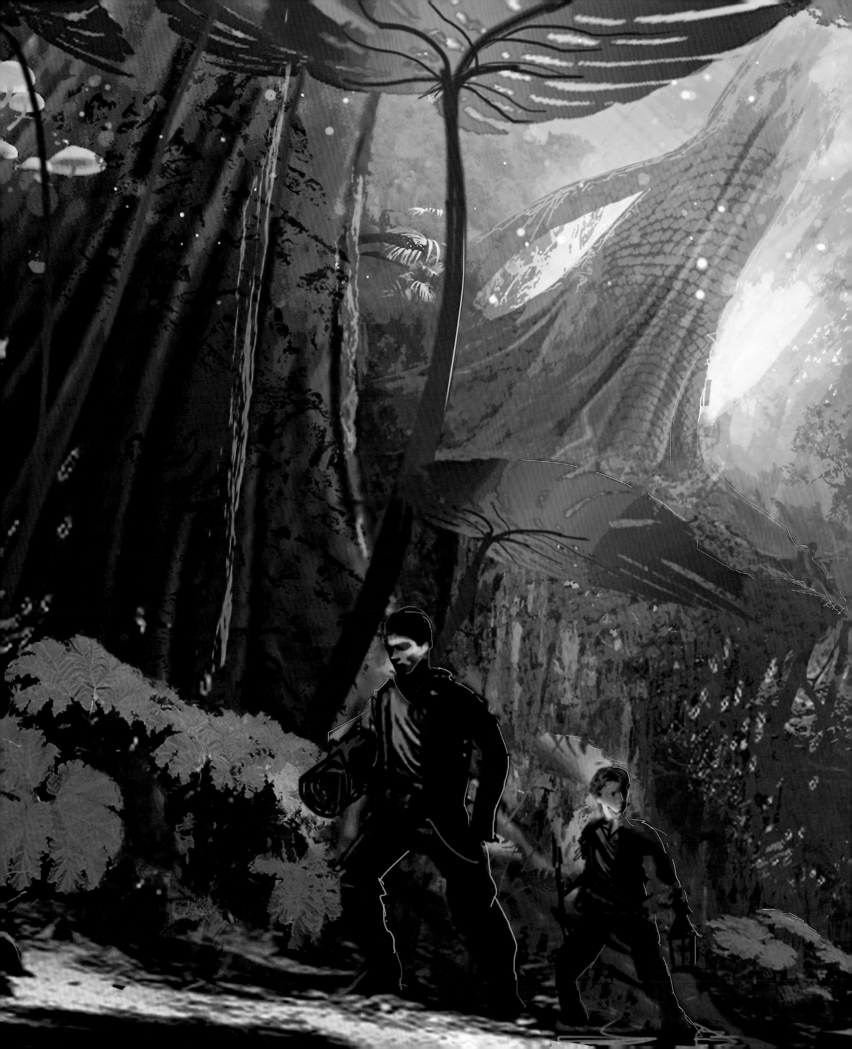

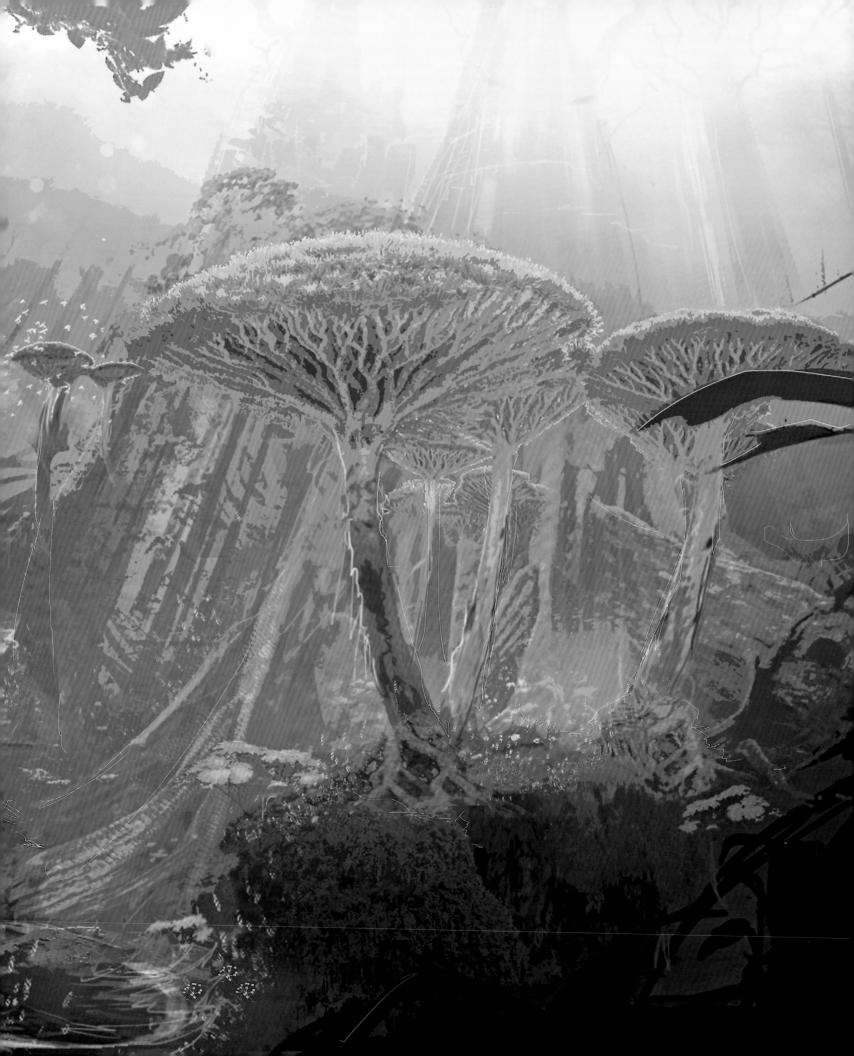

Blackbeard

In J. M. Barrie's 1911 classic *Peter and Wendy* we only hear about Blackbeard. In *Pan*, audiences finally get to meet Neverland's chilling villain and learn about his complicated relationship with the young hero of the story.

Dressed in pantaloons, leather boots, doublet, feather ruff, and armor in menacing tones of black and red, and sporting a wicked, modified Van Dyke beard and moustache and a Samurai-inspired wig—from the first minute we see Hugh Jackman's Blackbeard, it's clear: He's not a man you want to mess with.

"Blackbeard is the pirate that all the pirates fear," says Jackman. "He's the self-appointed dictator of Neverland. He's psychotic. He's a great fighter. He has no friends, even amongst the pirates. And he keeps everybody very much on edge."

Jackman says he jumped at the opportunity to play the film's bad guy because of the script and because he'd get to work with director Joe Wright.

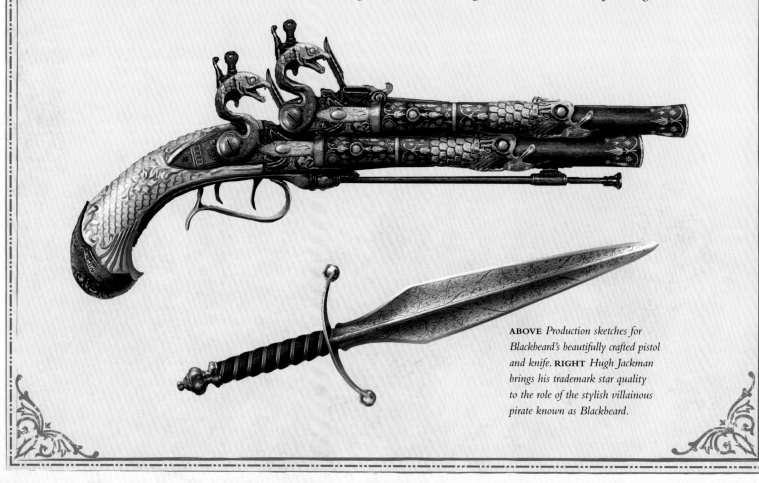

ABOVE *Production sketches for Blackbeard's beautifully crafted pistol and knife.* **RIGHT** *Hugh Jackman brings his trademark star quality to the role of the stylish villainous pirate known as Blackbeard.*

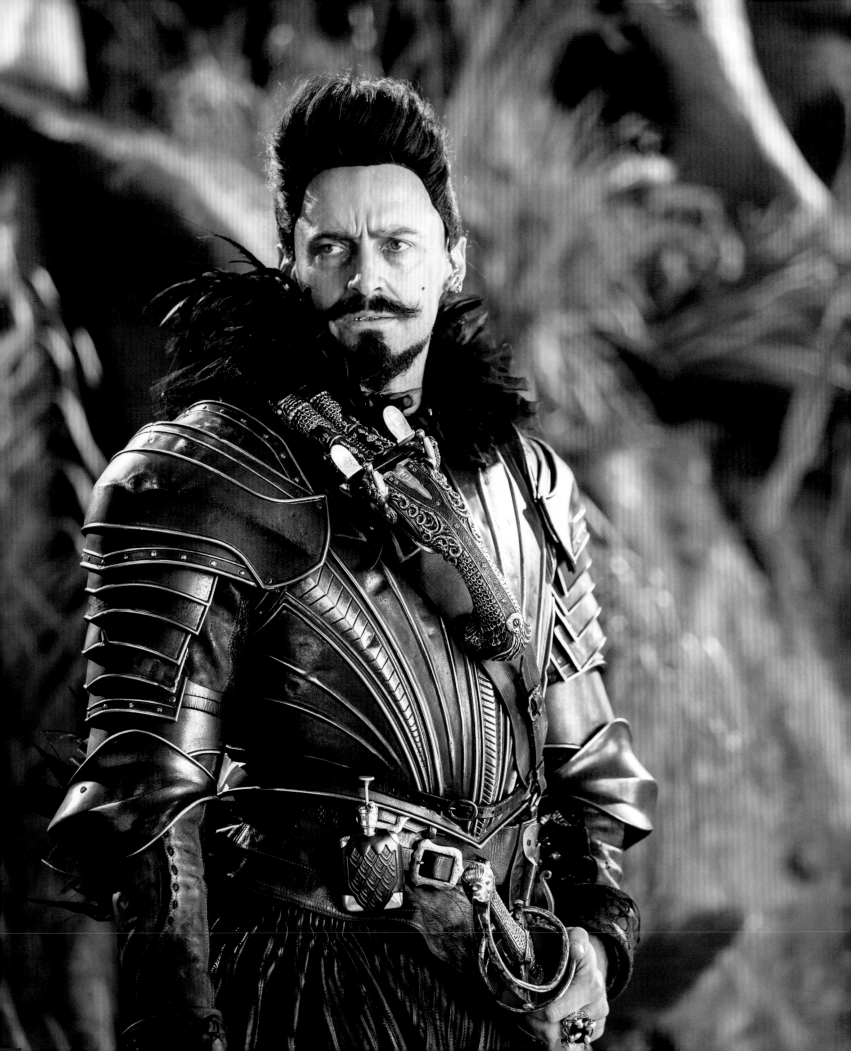

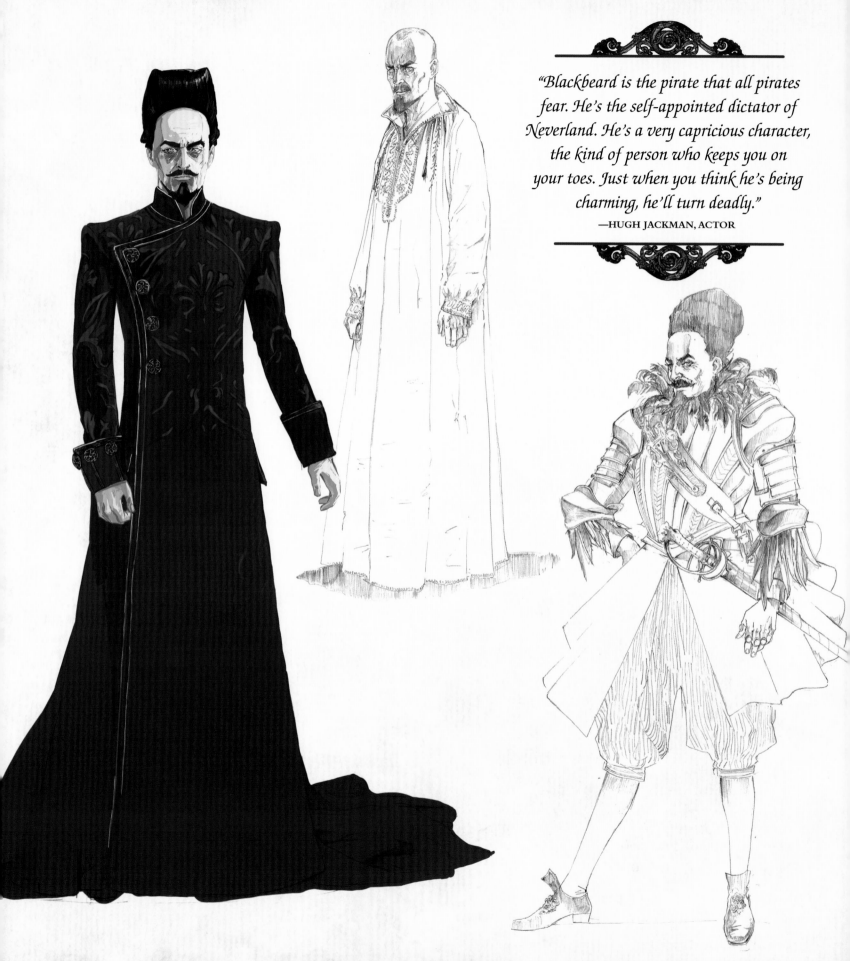

"Blackbeard is the pirate that all pirates fear. He's the self-appointed dictator of Neverland. He's a very capricious character, the kind of person who keeps you on your toes. Just when you think he's being charming, he'll turn deadly."
—HUGH JACKMAN, ACTOR

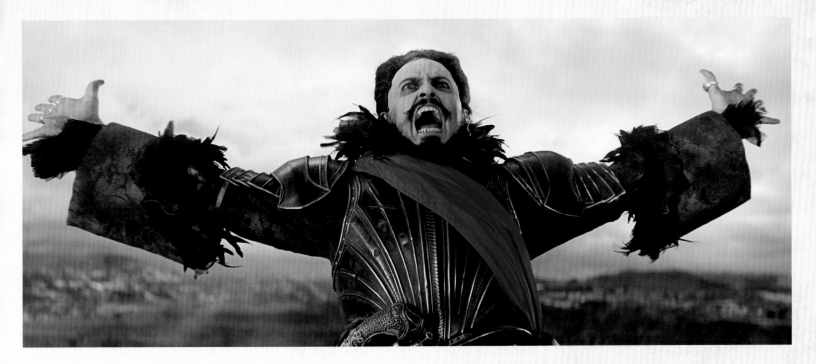

"Joe does the unexpected, both in the choice of films he does and within each film," Jackman says. "Visually he's a genius."

But while Blackbeard may be dangerous, Jackman and Wright also wanted to establish that he is a great entertainer. When audiences see Blackbeard's first entrance in the film, they'll immediately see what this means. "He loves the sound of his own voice," says Jackman. "He loves to make speeches. They're drops of gold that he's bestowing on the people. And damn, he's having a good time!"

Behind the showman, though, is a man armed to the teeth with ornate weapons and deadly intentions.

"Blackbeard is the character you love to hate," says producer Paul Webster. "He's got elements of pantomime about him, but he's sinister and deadly. Just when you think he's being kind and nice with you, he'll sucker you up with a deadly punch."

Prior to shooting, Jackman and Wright had a conversation about previous screen incarnations of Blackbeard. "We pretty much deliberately distanced ourselves from them," Jackman says.

Which, incidentally, is how Jackman's Blackbeard ended up bald. Edward Teach, the historical figure on which Blackbeard is modeled, would tie his hair and beard into a type of dreadlocks and light them on fire prior to battle. There was a haze

of smoke about him as he boarded the ship that would add to his terrifying aura. As the actor recalls, "When Joe told me this I said 'Cool!' And we decided to make Blackbeard a bald man with an ornate wig for vanity's sake."

Jackman has never played a bad guy quite like Blackbeard, and he's had the time of his life doing it. "Yeah, he's scary," says Jackman. "But he's sort of fun. He loves his life, he loves being a pirate, and he's terrified of losing it. I like him."

OPPOSITE *Costume sketches for Blackbeard's character.* **ABOVE** *Blackbeard makes a threatening speech after having his authority challenged.* **BELOW** *Director Joe Wright and Jackman agreed to make Blackbeard entirely bald and sport an elaborate wig for vanity's sake.*

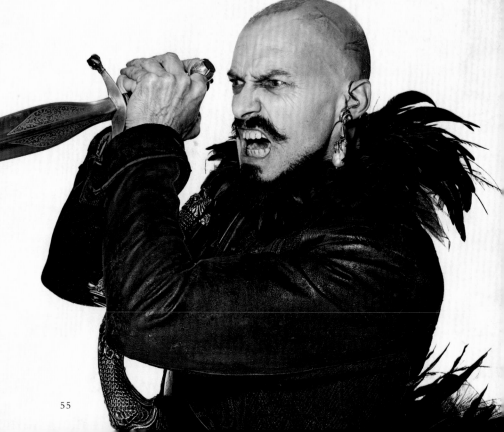

Hook

Being a prequel to the original Peter Pan story, *Pan* reveals some interesting things about characters the audience thought it knew. Case in point: James Hook before he becomes the evil Captain Hook we've read about throughout the years, missing hand and all.

In this telling, Hook is a good guy—an affable, handsome, charming, if slightly narcissistic, young man from the Midwest. Think Gary Cooper crossed with Harrison Ford or the heroes from John Ford's *Rio Grande* and *She Wore a Yellow Ribbon*. That's exactly why costume designer Jacqueline Durran dressed him in khaki and desaturated green and an adventurer's crushable fedora.

When the audience first encounters Hook, he's a prisoner in Blackbeard's mines. And he's a world away from J. M. Barrie's Hook and from all the animated and live-action versions the book has inspired. "He's a mysterious man in the mines who seems quite lost," says Garrett Hedlund, who plays Hook. He's also a deflated man with no idea of what he might become.

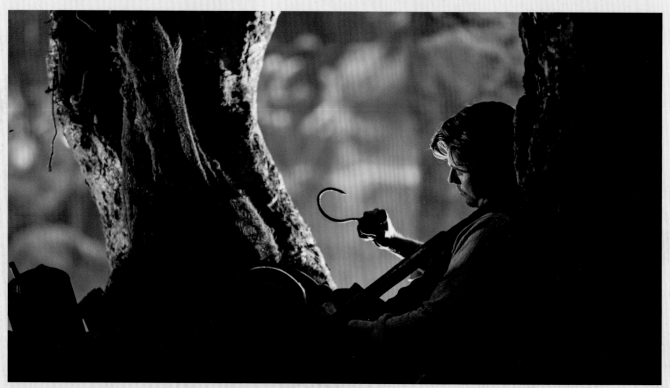

ABOVE *James Hook is pictured with the famous hook that will define his character in the classic Peter Pan story.* **OPPOSITE** *The filmmakers reimagined Hook as a swashbuckling Indiana Jones–type figure.*

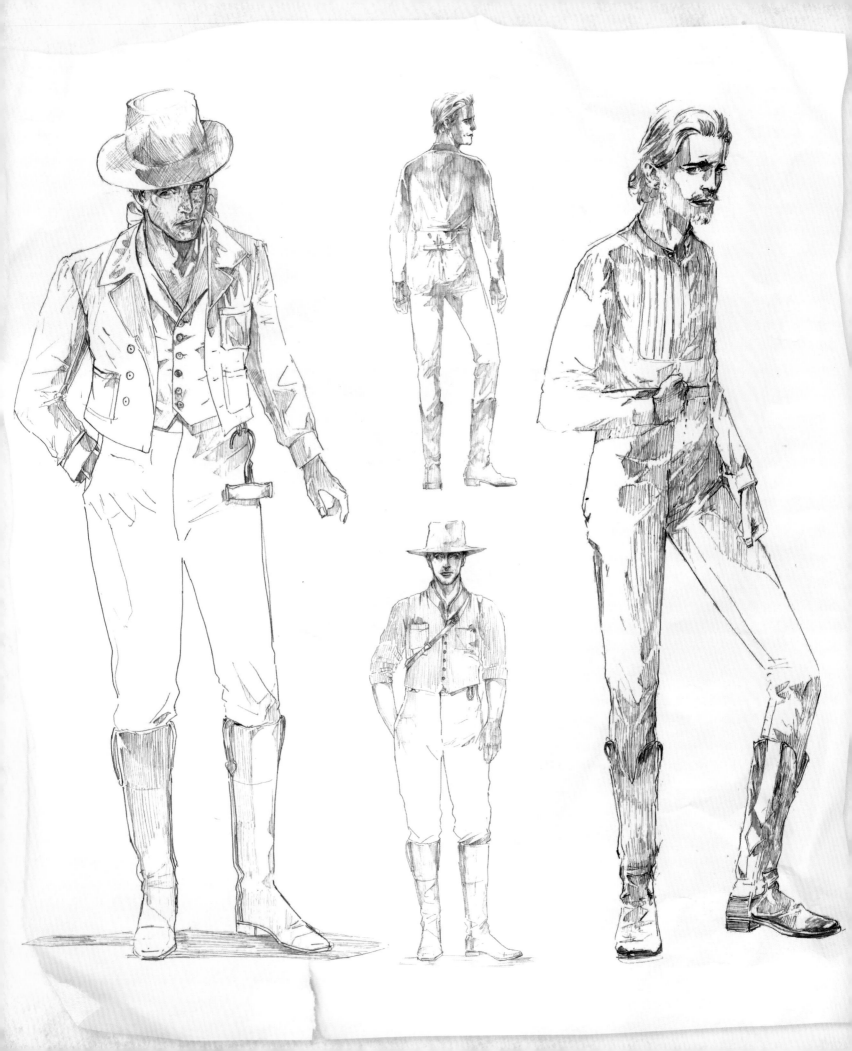

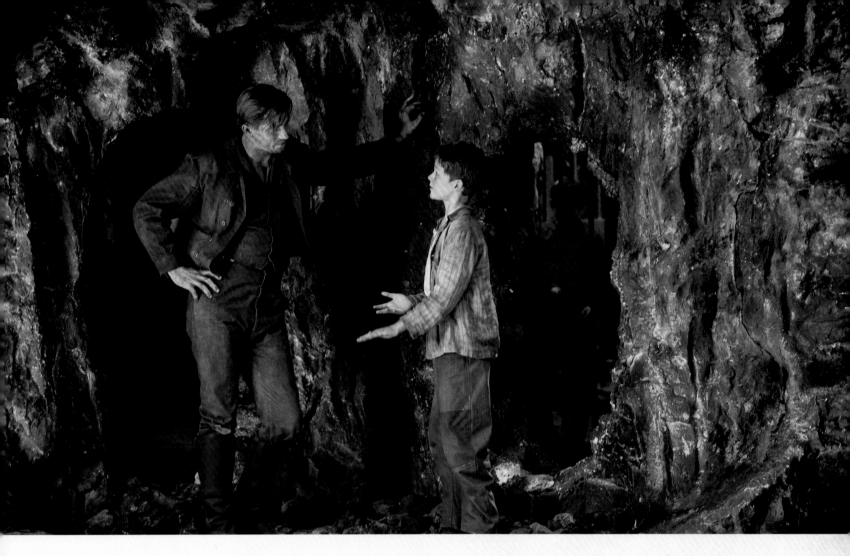

But when Hook witnesses Peter being pushed from a plank to his apparent death—the moment at which Peter realizes he can fly and saves himself—Hook brightens, realizing Peter is his ticket out.

"Hook is charming and loyal, but he's also capable of being selfish," Hedlund says. "He figures that if he can literally and figuratively rest on Peter's shoulders, he'll be able to get back home. Even though he really doesn't remember what his home is like."

Initially, Hook is Peter's ally by convenience—a starting point for a relationship that will deepen as the story moves forward. "It's a special relationship between them," Hedlund continues. "It's a brotherly relationship where they need each other. Peter needs Hook for protection. Hook needs Peter to help him gain his freedom."

Off the set, Hedlund quickly formed a bond with the young actor who plays Peter, Levi Miller, which added to their chemistry on screen. "I see a lot of myself at that age in Levi, although he's way smarter than I was. I forget that Levi's just eleven years old. When I talk to him I feel like I'm talking to a buddy, and that's definitely a benefit to the journey our characters take on screen."

Before shooting began, Hedlund and Wright worked on the character in some unusual ways. "When I met with Joe for the first time, he wanted to explore a version of the later Hook—not just the one we've seen but the one that *could* be," Hedlund recalls. "We went into everything—the peaks and the valleys of darkness and the self-loathing, the crybaby, the hysterical, the extreme everything. So we worked on monologues from some other material to explore these things. It was really helpful in adding all these wonderful colors to my character's life."

"You'll see some inklings of the classic, well-known character he's going to become later in his life," says producer Greg Berlanti. "I wouldn't use the word 'evil.' But there are some hints in the movie."

ABOVE *Hook and Peter discover that they have many things in common as they plan their escape from Blackbeard's mines.* **OPPOSITE** *Costume sketches for Hook reflect the overall heroic and rough-and-rugged qualities of the character.* **BELOW** *Concept art for the character's iconic tool.*

Tiger Lily

The feisty, colorful, and athletic princess of the *Pan* movie is quite different from the previous incarnations of Tiger Lily. A dynamic part of Neverland's native village, she has a take-no-prisoners approach to life and can keep up with any evil villain or pirate.

To fill this challenging role, Wright tapped versatile actress Rooney Mara, who made a huge impression with the producers with her portrayal of the lead character in *The Girl with the Dragon Tattoo* (2011).

"In other versions of Peter Pan, Tiger Lily didn't speak or have much of a personality," says Mara. "I play a completely new Tiger Lily. Joe [Wright] wanted her to feel like she was from another world, an outsider even in her own village. She's a strong female, but she also has a soft, nurturing side to her."

Tiger Lily has heard about Peter Pan all her life, and in fact it's Peter's mother, Mary, who has trained her to become such an able warrior. She has also been brought up to hate the pirates because of how they've exploited her village.

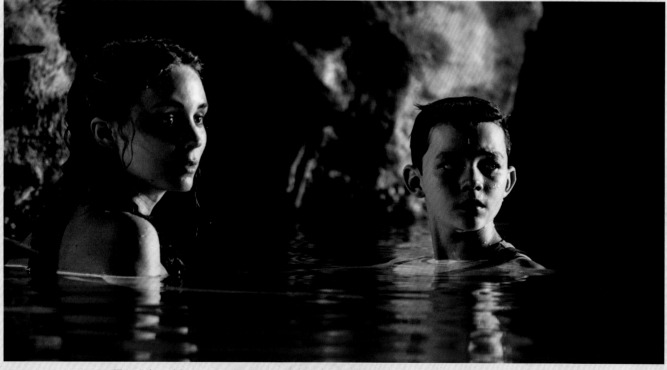

ABOVE *Tiger Lily and Peter experience the magic of Mermaid Lagoon.* **OPPOSITE** *As designed by Jacqueline Durran, Tiger Lily's colorful costumes and headdress were inspired by a multitude of cultures from around the world.*

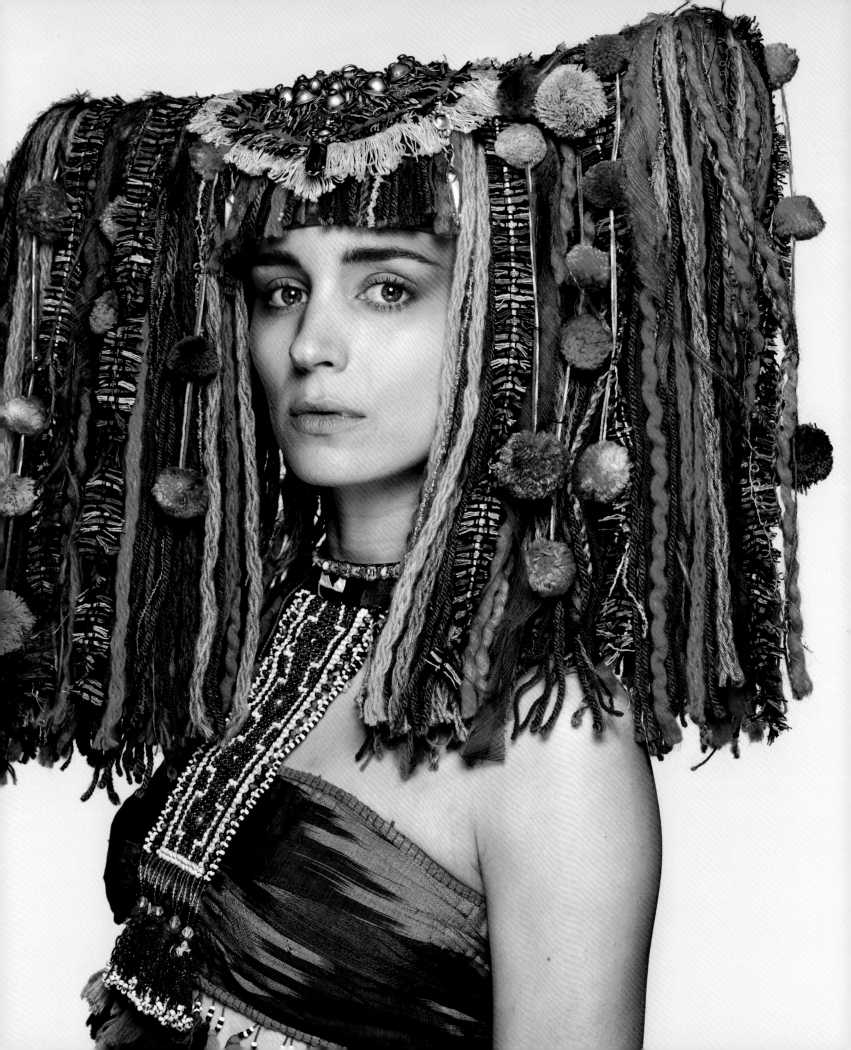

When she meets Hook for the first time, she feels an instant attraction, even while she mistakes him for a pirate. "She's very curious about him," says Mara. "She finds him a bit odd, funny, and exciting, and throughout the film their relationship turns into something else."

Costume designer Jacqueline Durran and hair and makeup designer Ivana Primorac designed Tiger Lily's unique look by culling cultural cues from around the world. "I had some pictures that I showed to Ivana of what I thought my hair would look like, and it was almost exactly what she had envisioned," says Mara. "When I showed up for my first hair and makeup fitting, they put the wig on me and added the makeup the way they'd imagined it, and that was that. It's never happened before. Usually, there's a lot of back and forth and finessing involved. But my first fitting with them is what you see in the movie."

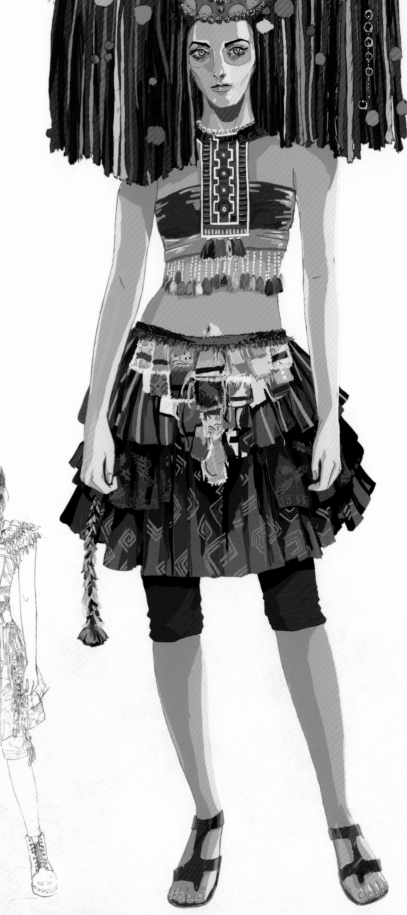

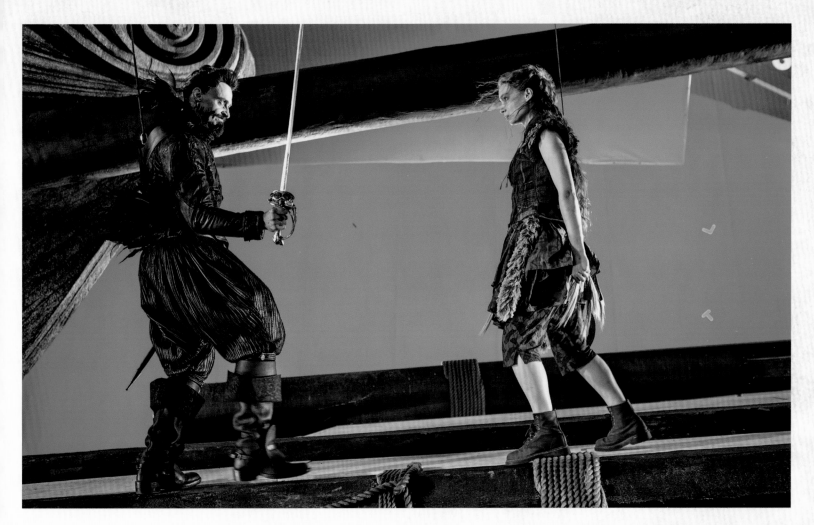

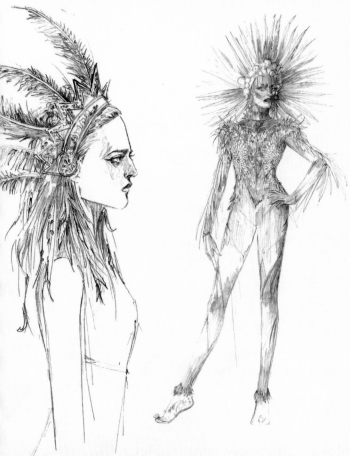

Mara's Tiger Lily is a tough princess who is not afraid to challenge the fearsome Blackbeard. And boy can she fight. With the guidance of stunt coordinator Eunice Huthart, Mara was able to master *Pan's* complex, acrobatic fight sequences. Among the challenges: "My costume was quite unforgiving, and every move had to look perfect," Mara says. "There is a crucial scene in which I have to fight balanced on spikes. It was one thing to learn a fight like that on the ground—but to learn it on what was basically a balance beam was very difficult. By the time we finished the spike sequence and moved on to fighting on actual solid ground, it was all easy after that."

Through all the fights Mara focused on keeping Tiger Lily's fighting style specific to her character. "There's a heavy martial arts influence in the village. But I wanted Tiger Lily to feel slightly animalistic. Though she's technically a great warrior, I wanted her to feel more organic and in tune with the natural world around her."

ABOVE *Pan's Tiger Lily is envisioned as a strong and regal character who is not afraid to battle Blackbeard in order to protect her village.* **OPPOSITE AND LEFT** *Some of the initial sketches for Tiger Lily depict feathered costumes and exotic headdresses.*

The Mermaids

hat would Neverland be without its mysterious, otherworldly sirens of the deep? As imagined by screenwriter Jason Fuchs and director Joe Wright, *Pan*'s trio of mermaids are helpful creatures who rescue Peter, Hook, and Tiger Lily from the jaws of a ferocious crocodile in a river.

Utilizing the technical wizardry of motion capture and digital computer animation, all three mermaids are portrayed by one actress, Cara Delevingne (*Anna Karenina, Tulip Fever*). The model-turned-actress, who also starred in Wright's *Anna Karenina*, says it was exciting to play the characters because of their mysterious powers. "They're quite unusual, because they read minds. They're really cool. They swim around and save people."

To prepare for her roles, the director showed Delevingne footage of other CGI-assisted characters. Then she worked closely with the film's visual effects supervisor, Chas Jarrett, to understand how to work with a robotic crane to create the illusion of being a mermaid swimming underwater. "I practiced a lot," says Delevingne. "I don't move very slowly, ever, so it was quite challenging for me. I had to work on my core a lot because the machine kind of holds you around your waist, so you really get to slow everything down."

To create and fully understand the mermaids' history and personalities, the actress had many conversations with Wright. "I wanted them to make these noises, a mix of singing, beatboxing, and whale and dolphin vocalizations. Which, it turns out, they have done for the final version of the film," she says.

Playing the fantastic creatures has whetted Delevingne's appetite for more *Pan* movies. "I'm hoping that in the next movie they get to fly, speak all the languages in the world, and play musical instruments," she says.

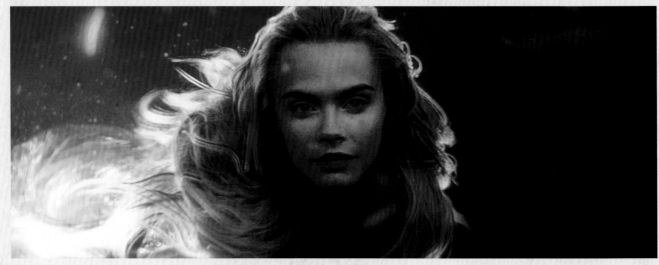

ABOVE *Thanks to green screen technology and CGI, actress Cara Delevingne portrays three different mermaids in the movie.*
OPPOSITE *Early development art depicts of one of the movie's benevolent mermaid characters.*

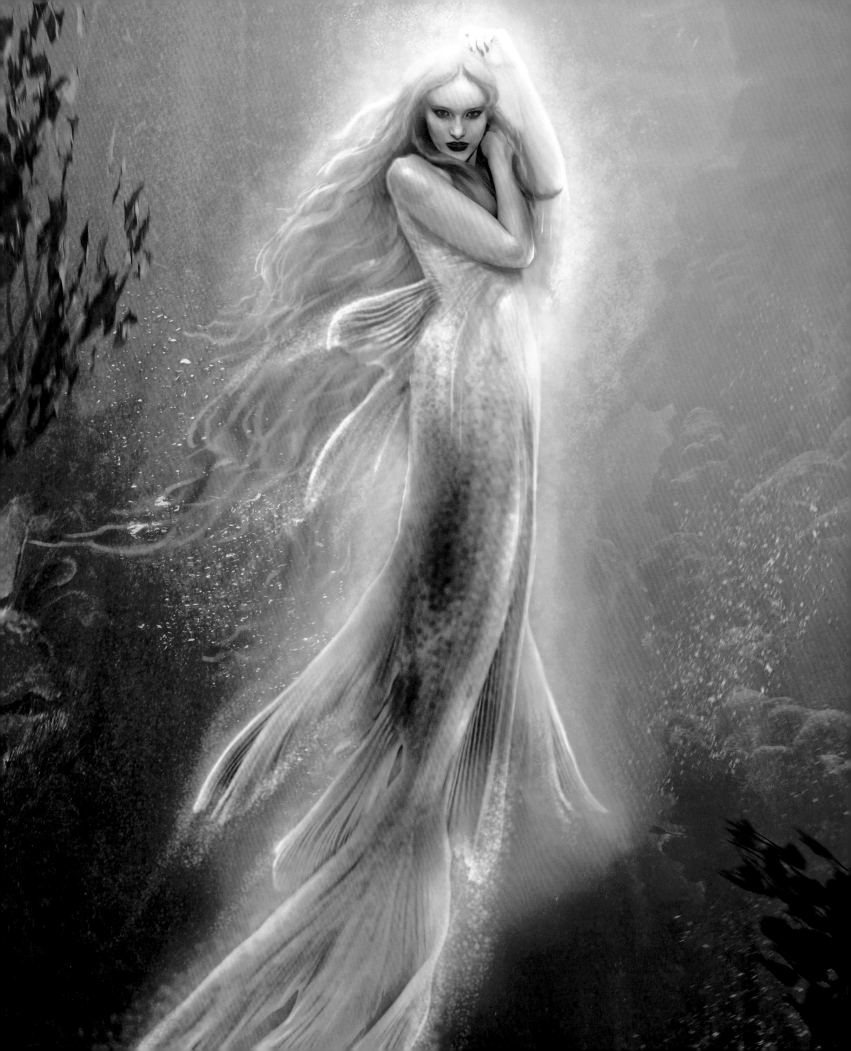

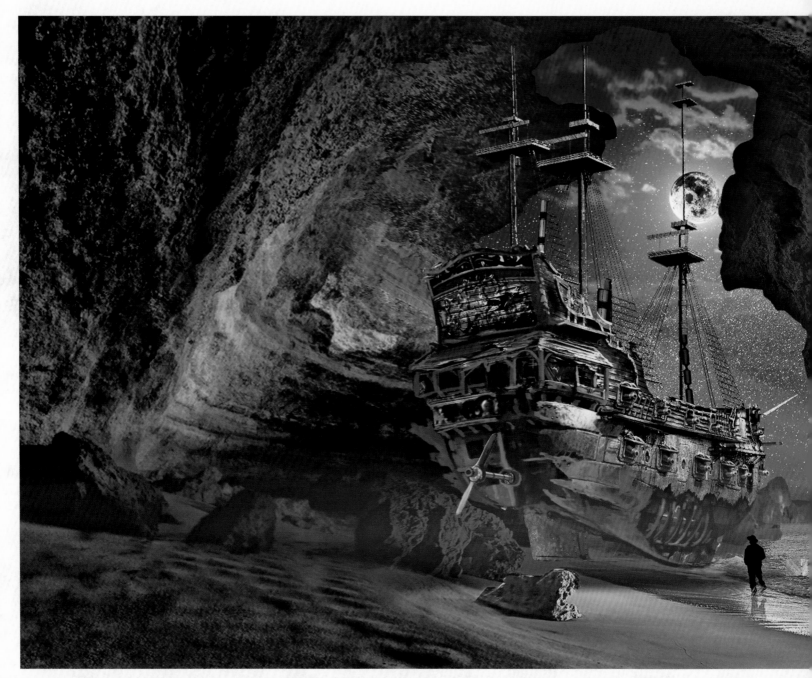

An artist's depiction of Neverland's mysterious Mermaid Lagoon and its luminous waters.

Mary

While Mary, Peter's mother, may not have as much screen time as some of the other major characters in *Pan*, she plays a pivotal and emotional role in the story.

Portrayed by radiant actress Amanda Seyfried (*Les Misérables, Mamma Mia!*), Mary sets the film's action in motion after she's confronted with various obstacles when she tries to drop her son off at an orphanage.

"It's the late 1920s, and we see Mary jumping over a fence with her baby. It's a very clever scene because you see that she's this kind of young, mysterious, brave, and strong woman," says Seyfried. "The audience is not quite sure about the identity or the motives of this enigmatic woman, but it's pretty much understood that she's a dynamic figure—someone who has the answer to some of the mysteries of this tale."

Mary also returns in a poignant scene toward the end of the film when she floats through Neverland and sees Peter for the first time since she left him as a little boy. "It's kind of Peter's vision. We have this reunion between Peter and Mary," Seyfried says. "It's a pivotal moment where you really see what he's been fighting for and what his journey has been about. The audience finally gets to understand the heart of the story."

The scene proved to be a challenging one in terms of its physical demands. "I was on a rig, a robot arm, and I had these motion capture dots on my face," she says. "It's a beautifully written scene, and they designed the way they shot it so that I wouldn't have to worry about the technical aspects of the take. Joe [Wright] played music for us and helped us get in the zone."

Seyfried, who accepted the ethereal role before even seeing the script, says Steven Spielberg's *Hook* was one of her favorite childhood movies. "My sister used to tell me that she went to magic school every night while I was sleeping," Seyfried recalls. "She promised one night she would take me with her because it was like Neverland. Even though she couldn't take me there, with this film, I finally got to visit that world!"

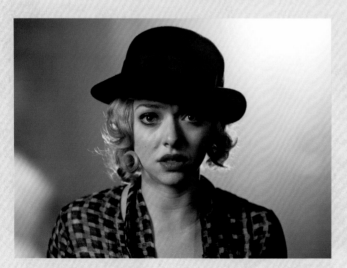

ABOVE AND OPPOSITE *Actress Amanda Seyfried portrays Peter's mother, who is forced to leave her baby at an orphanage at the beginning of the tale.*

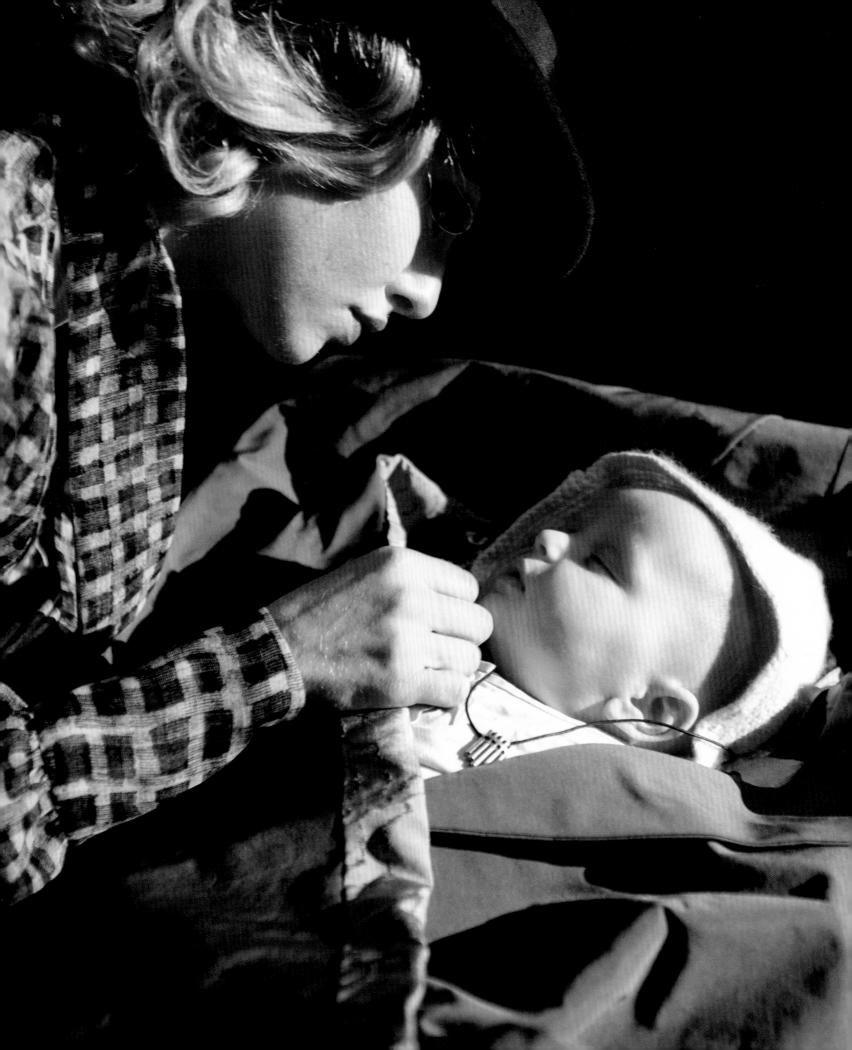

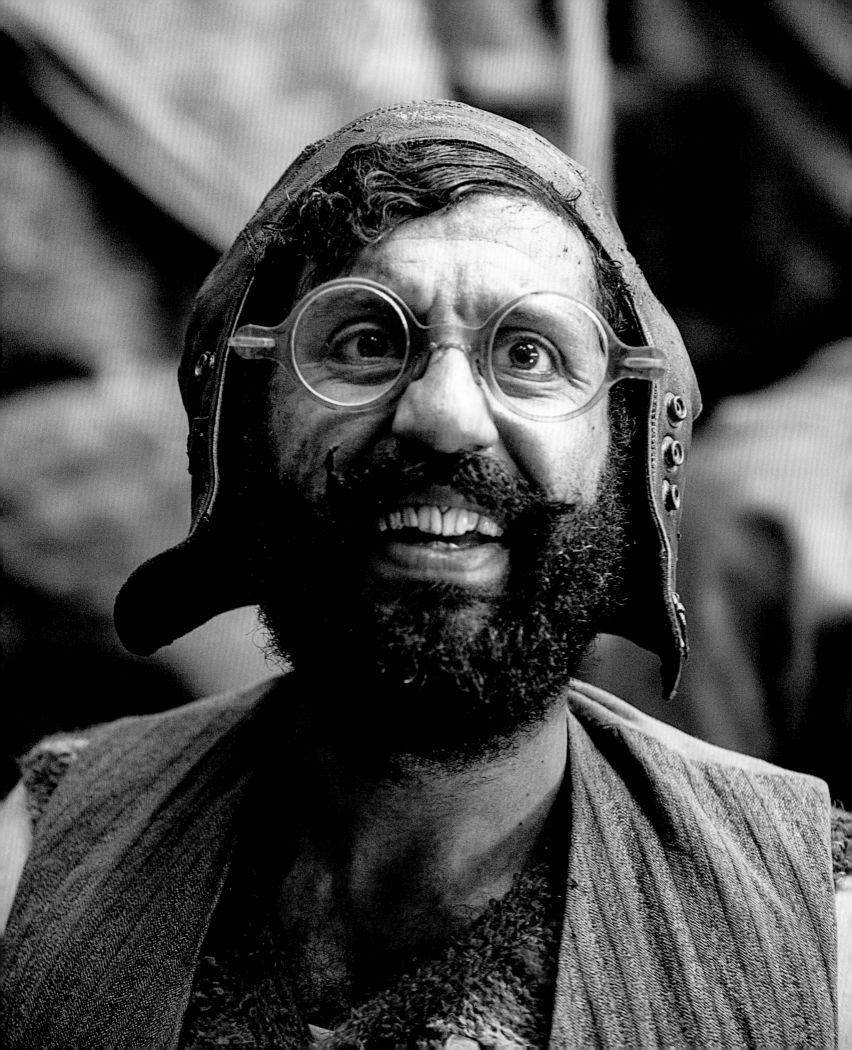

Mr. Smee

In J. M. Barrie's novel *Peter and Wendy*, Mr. Smee is portrayed as one of the most genial and entertaining members of Hook's crew. As played by Adeel Akhtar (*The Dictator, Four Lions*) in *Pan*, Smee is more of a man-child who doesn't always make the right decisions. "The pirates have a tendency to steal kids from orphanages," explains the British-Asian actor. "So Smee's backstory is that he was in one of these orphanages too and was brought over when he was Peter's age. He is in this state of arrested development."

A self-appointed manager, Smee (full name Sam Smeegal), wears a handmade badge and walks around with a little clipboard and takes notes all the time. "He looks up to Hook, but we can tell that Hook is a bit embarrassed by his awkward friend," says Akhtar. "But they look out for each other in a way."

Smee is outfitted with baggy shorts, described as a cross between a skirt and a knee-breeched culotte, and a colorful knitted sweater that sits atop his belly button. "The thought behind it is these pirates go pillaging, and they pretty much grab whatever they want to wear, so this is his outfit," explains Akhtar.

The actor fondly recalls the pre-filming boot camp set up for the actors playing pirates in the film. "It was a lot of fun for me, but not so much for Smee," he says. "He was struggling to find his way as a pirate. We did loads of team-building exercises, figuring out where each pirate came from, played games, and sang a lot of songs."

Looking back, Akhtar says the whole experience has been quite remarkable and eye-opening. "We've had these mad ups and downs. There's this massive ship that is going one way, and the fans are blowing in your face. But through it all, our director Joe Wright has the ability to take all this chaos and bring it along this narrow path that makes you feel safe and looked after. The message of the movie is also quite powerful. It's to embrace the power of imagination but to carry on doing the day-to-day stuff while holding on to a bit of magic."

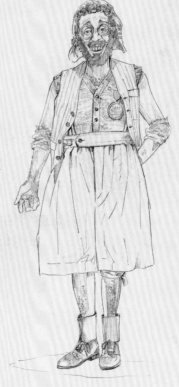

RIGHT *The movie's Mr. Smee is depicted as a self-appointed manager who wears baggy shorts and a colorful knitted sweater.* **OPPOSITE** *Actor Adeel Akhtar portrays Mr. Smee as an obsessive man-child who doesn't always make the right decisions.*

Bishop

With Tom Hagen's brains and Luca Brasi's muscle, the role of Blackbeard's first mate Bishop had to be played by an actor of intimidating stature. And who better to turn to but British born actor Nonso Anozie (*Atonement, Brighton Rock, The Grey*).

"Bishop is someone you don't want to mess with," says Anozie. "He's been through wars. Got some battle scars. And he's the man Blackbeard uses when he needs someone to get the job

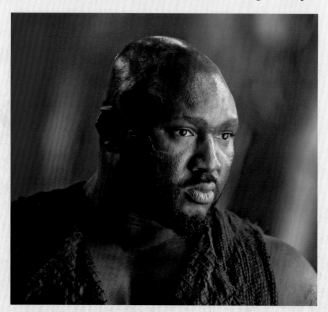

ABOVE *Nonso Anozie brings brawn and brains to the role of Bishop, the commander of Blackbeard's fleet.* **OPPOSITE** *Bishop aids Blackbeard in his fight against the island's native tribe.*

done." In addition to being first mate, Bishop is also commander of *The Ranger*, the smallest ship in Blackbeard's fleet and the one used to kidnap Peter from the orphanage.

To be accurate, the character of Bishop wasn't in the early versions of the script. Rather he emerged from a series of improvisations director Joe Wright put his actor-pirates through before shooting began in early 2014.

In one improvisation game called "Hot Seating," each cast member took turns sitting in the middle of a circle of the other actors. "Then they ask you questions in character about who you are and where you're from," says Anozie. "In that way we were able to come up with specific ideas about our characters and what we were doing in the story."

Bishop, it turns out, is part Nigerian, part Senegalese. He has killed a lot of people over the years. While he's not religious, he is spiritual. Anozie chose the name Bishop for his character in honor of his habit of praying for the souls of the men he has just killed.

"The great thing about working on this film is that we had an opportunity to suggest things that we might do in the moment," Anozie says. "Joe's very open to that. He likes improvisation. So it's been fun."

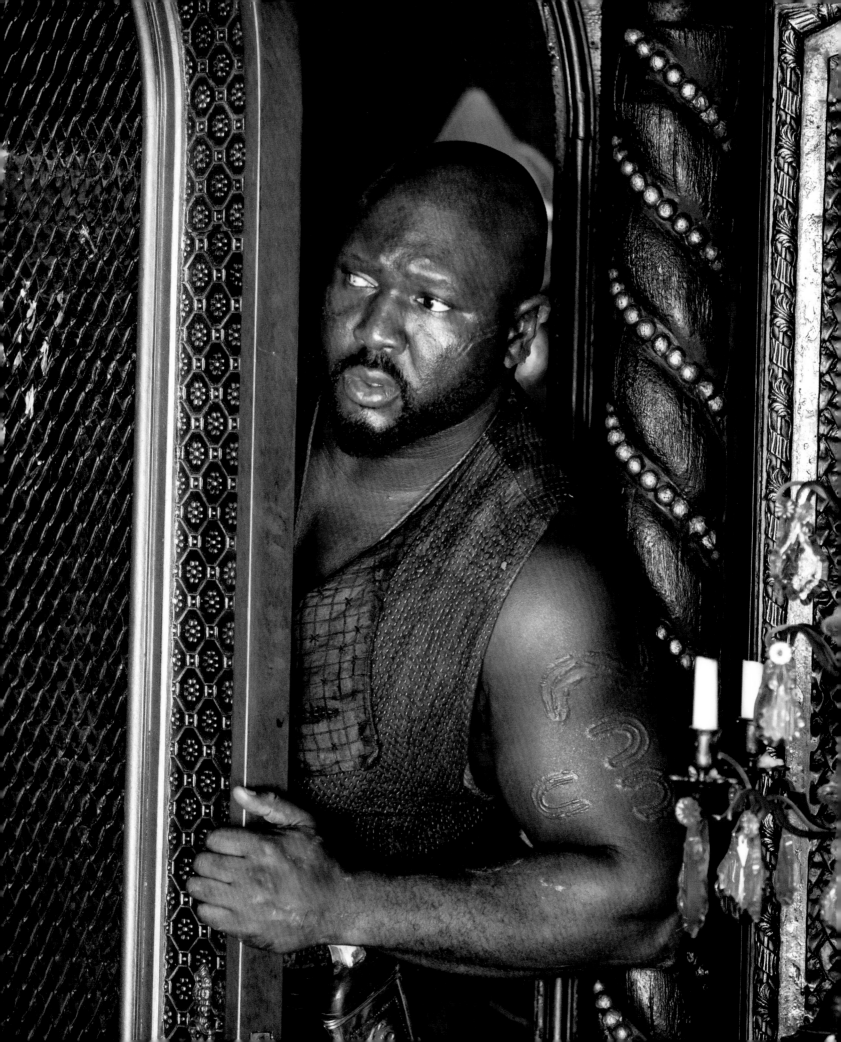

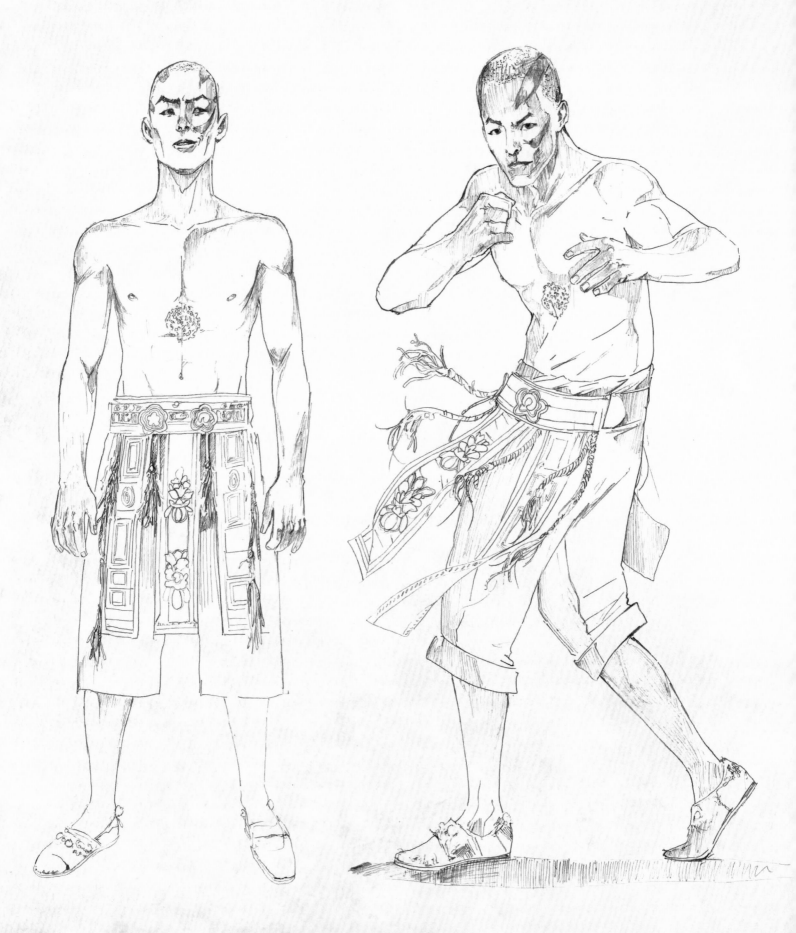

Kwahu

The role of Kwahu, one of the bravest warriors of the Neverland tribe, is played by young South Korean actor, singer, and martial arts expert, Tae-joo Na. The fact that Na is a trained tae kwon do champ could explain his agility and grace in the scene in which he and his betrothed, Tiger Lily, fight the pirates on a trampoline.

"I have practiced tae kwon do for sixteen years, but I had never done a trampoline fight before this movie," he says through a translator. "But thankfully, my body is very flexible, and I could do these backward and forward flips. The director had faith in me and allowed me to do my own thing in the action scenes. Our stunt director Eunice

> *"Tiger Lily's fighting is rooted in ballet, while mine is based on martial arts, speed, and strength. That's why we complement each other so well."*
>
> **—TAE-JOO NA, ACTOR**

Huthart also helped me a lot with the fight scenes. Tiger Lily's fighting is rooted in ballet, while mine is based on martial arts, speed, and strength. That's why we complement each other very well."

Na says he listened very closely to every word of instruction Joe Wright gave him. "He is very well-respected in Korea, so it was a huge honor for me to work with him," Na says. "It was also great to work with Garrett [Hedlund] and Rooney [Mara]. We understood each other even though I don't speak English. We are of the same mind, and we're working together to create something so amazing."

The actor says he really enjoyed the festive atmosphere of the set and the breathtaking backdrop of the village. "I loved the trampoline scene," he shares. "There were hundreds of people cheering, singing, and dancing. It was a big celebration that went on even during the breaks."

Na confesses that he has only one regret about his *Pan* experience: "I didn't get to share an action scene with Blackbeard," he admits. "But I found out that Hugh Jackman had also wanted to have a fighting scene with me. So that made me happy!"

OPPOSITE *Costume sketches for Kwahu depict him as an agile warrior who is not afraid of battling pirates to protect his tribe.*

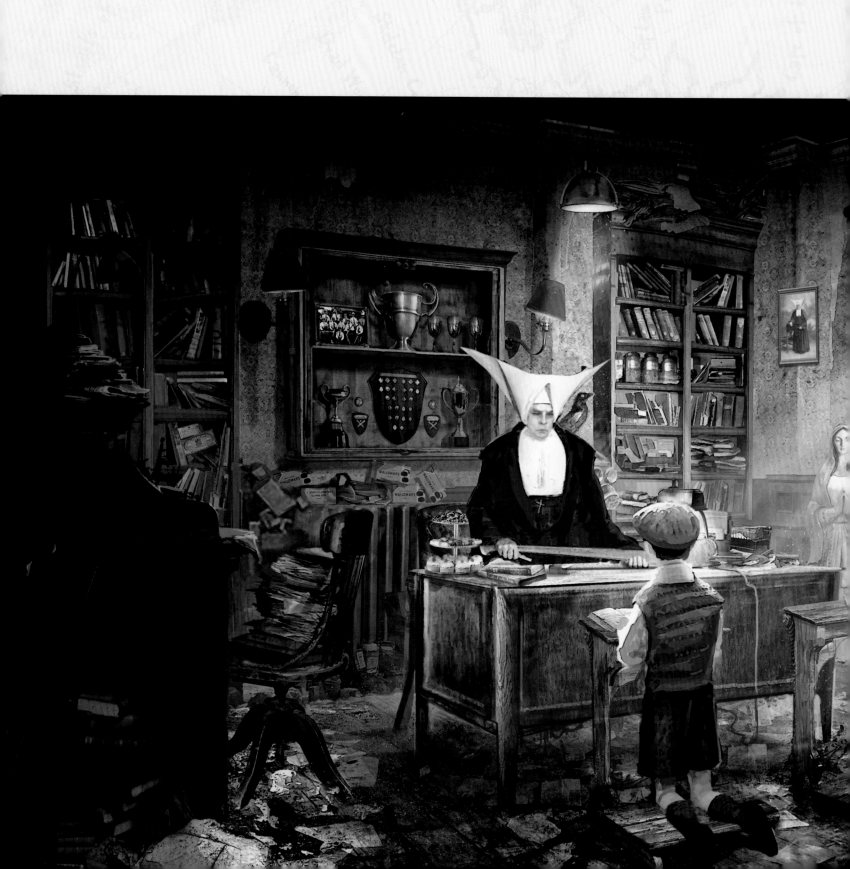

All the Right Colors, Costumes, and Textures

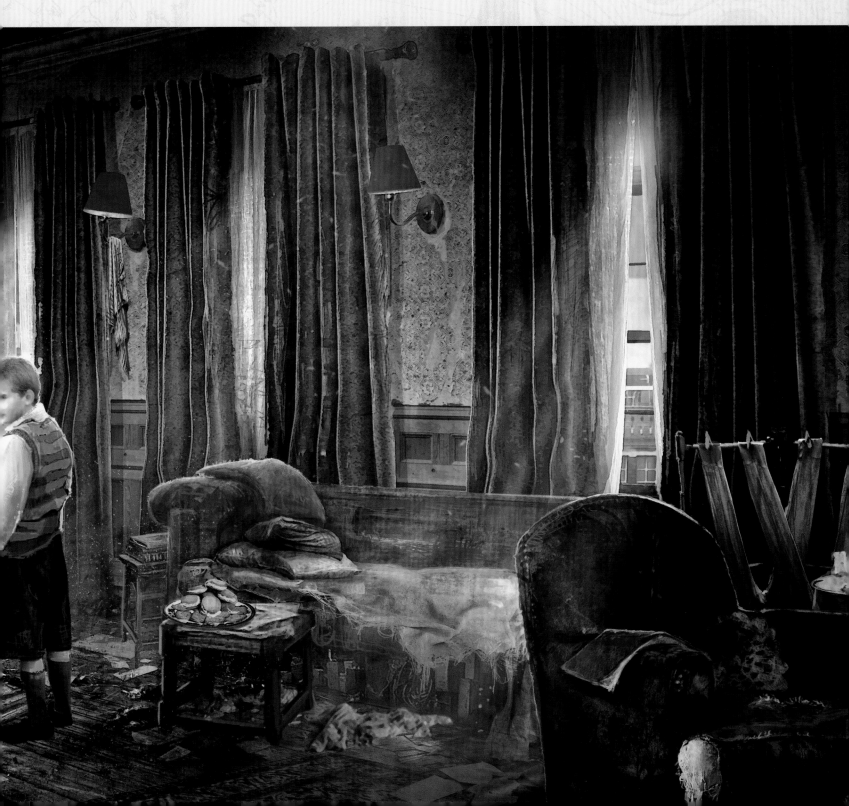

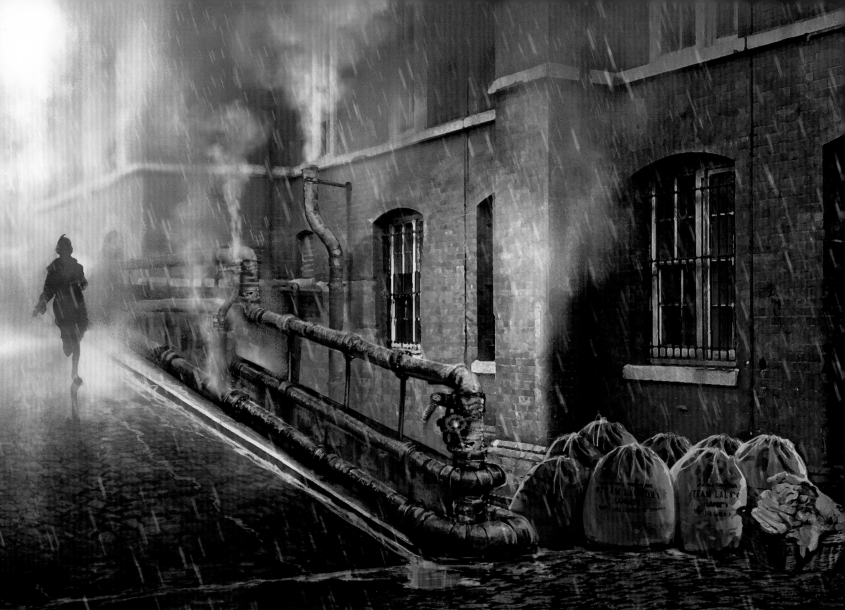

PREVIOUS PAGES
*Mother Barnabas
punishes Peter and
Nibs for disobeying the
rules of the orphanage.*
ABOVE AND RIGHT
*Blitz-era London is
the setting for the film's
first scene, in which
we meet Peter and the
other residents of The
Lambeth Home for
Boys, an orphanage run
by nuns.* **OPPOSITE
BOTTOM RIGHT**
*Mary prepares to say
good-bye to her young
son, Peter.*

One orphanage? Check. One forest? Check. One village? Check. Three galleons? One mine? Check. Check. Eight sets. Five months to shoot.

"It wasn't the number of sets that was daunting," says award-winning production designer Aline Bonetto. But the scope and detail needed to create a world that the audience would willingly suspend their disbelief in was quite another matter. "I think for many of us, this was the biggest and most complex project we have ever worked on."

Given that director Joe Wright wanted his actors to play as much as possible on real sets, the challenge for the whole design team was on. "It's like a series of Chinese boxes, revealing an evermore fantastical world as we go through the story," says producer Paul Webster.

First up was perhaps the most conventional task—designing the setting where we first meet Peter (in the world *before* he becomes Peter Pan). The setting is wartime London ravaged by the Nazi blitz.

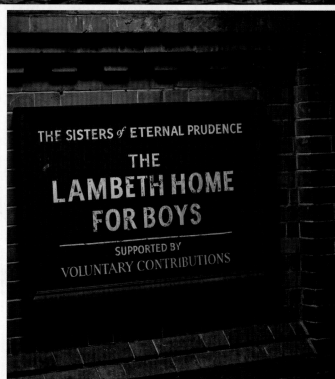

THE SISTERS *of* ETERNAL PRUDENCE

THE
**LAMBETH HOME
FOR BOYS**

SUPPORTED BY
VOLUNTARY CONTRIBUTIONS

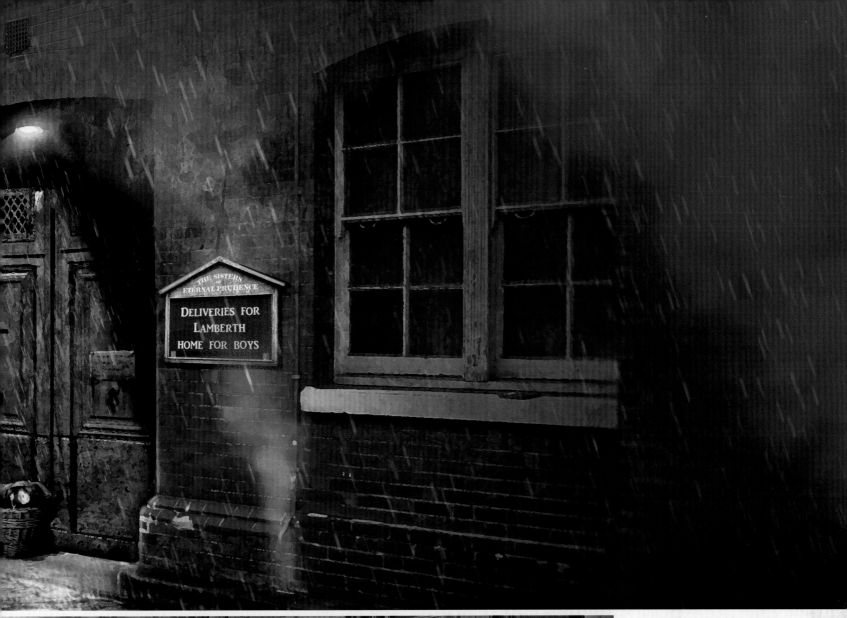

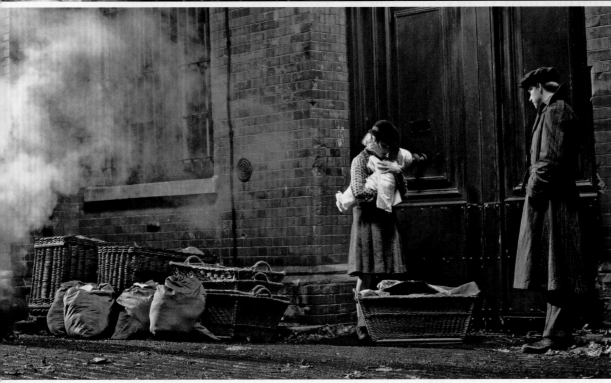

"It wasn't the number of sets that was daunting; I think, for many of us, this was the biggest and most complex project we had ever worked on."

—ALINE BONETTO, PRODUCTION DESIGNER

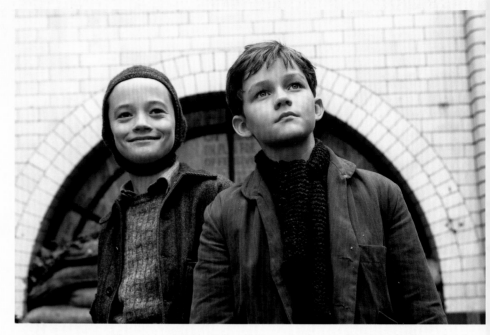

ABOVE AND BELOW *The costumes for Nibs (left) and Peter reflect the typical English schoolboy styles of the 1930s.* **OPPOSITE** *The exteriors and interiors of the orphanage were designed to look especially drab and claustrophobic as a sharp contrast to the rest of the movie, which takes place in Neverland.* **PAGES 82–83** *The boys are put to work under the supervision of the cruel Mother Barnabas, portrayed by actress Kathy Burke.*

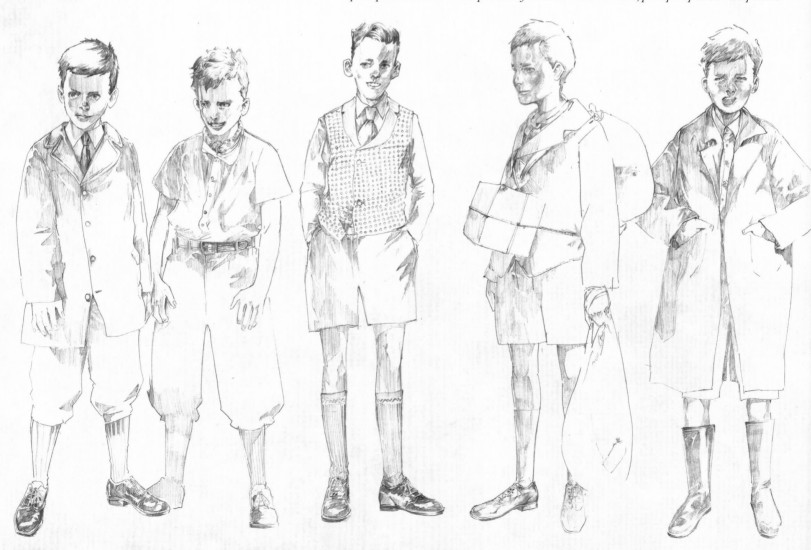

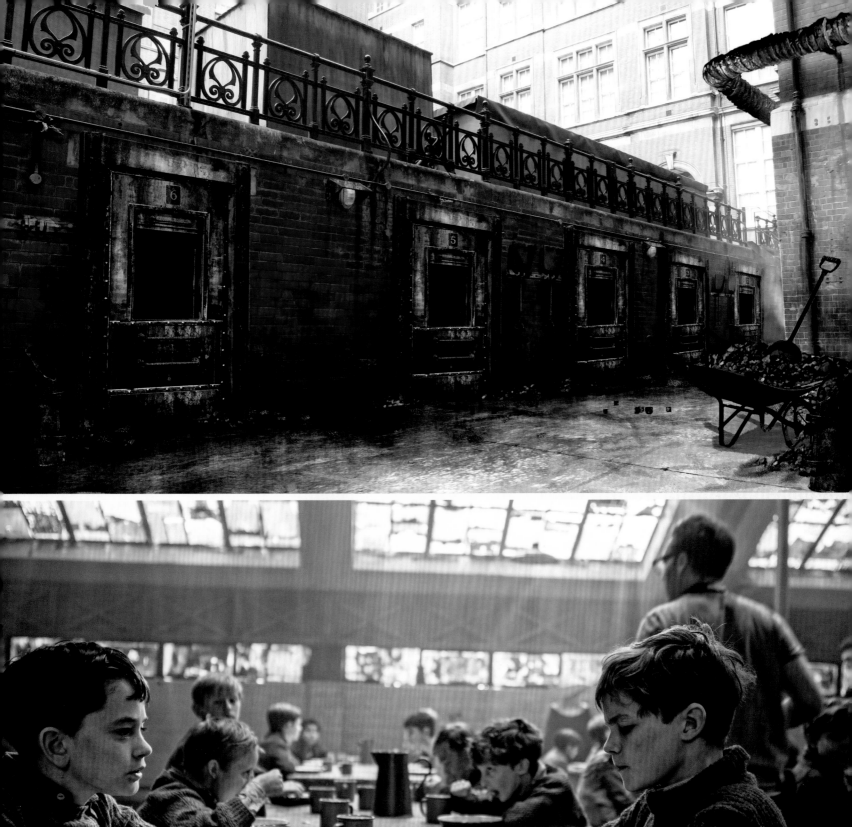

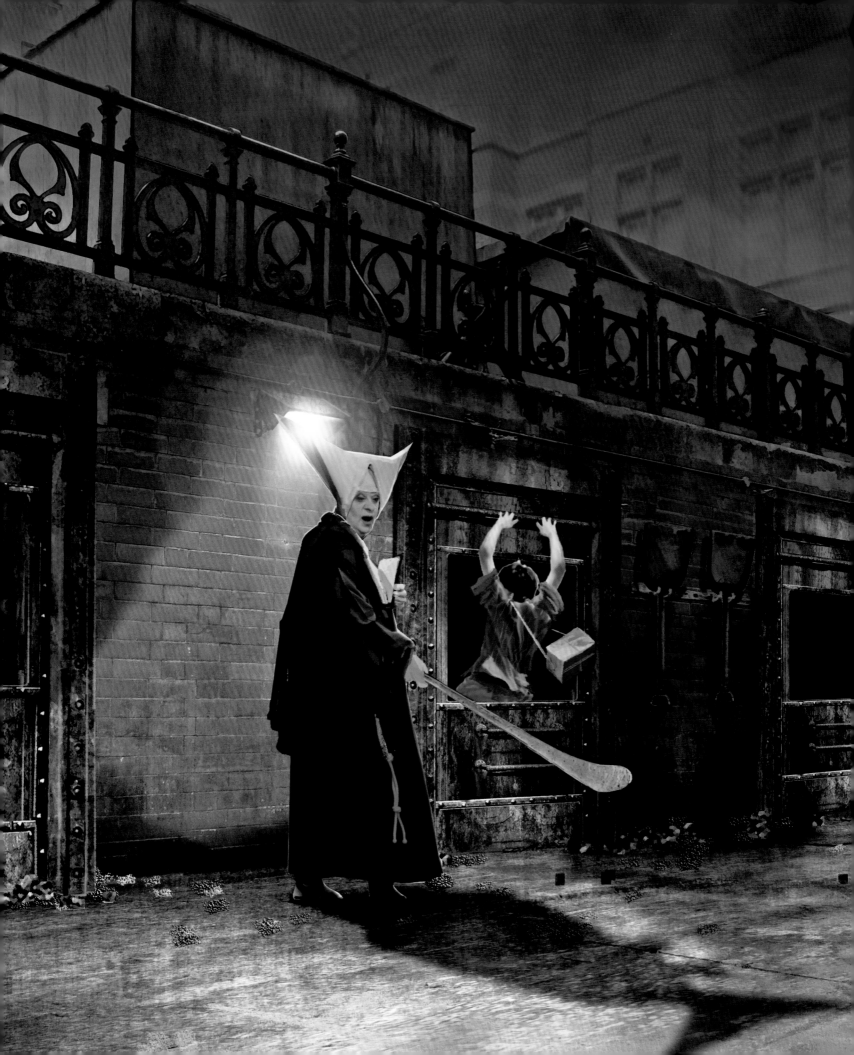

The children are living in a factory repurposed as an orphanage and presided over by a cruel nun, Mother Barnabas (Kathy Burke). "Joe wanted to create a place that was very monochromatic, a place of a drab cold existence," says set decorator Dominic Capon. Instead of the established norm of the browns of 1930s furniture and blandness of British wallpaper, the orphanage was colored with green, grey, and blue. "It was kept grim, deliberately so," Capon says.

In many ways the damped-down grimness of London and the muddy brown of the hellish mines the orphans are taken to are but a dramatic prelude to the vibrant, seemingly limitless world of Neverland that follows.

LEFT *Peter and Nibs get into some mischief at the orphanage before being kidnapped by Blackbeard's men.* BELOW *A sketch of Mother Barnabas's habit.* FOLLOWING PAGES *An illustration of Mother Barnabas's live-in office reflects years of neglect as well as destruction from wartime raids.*

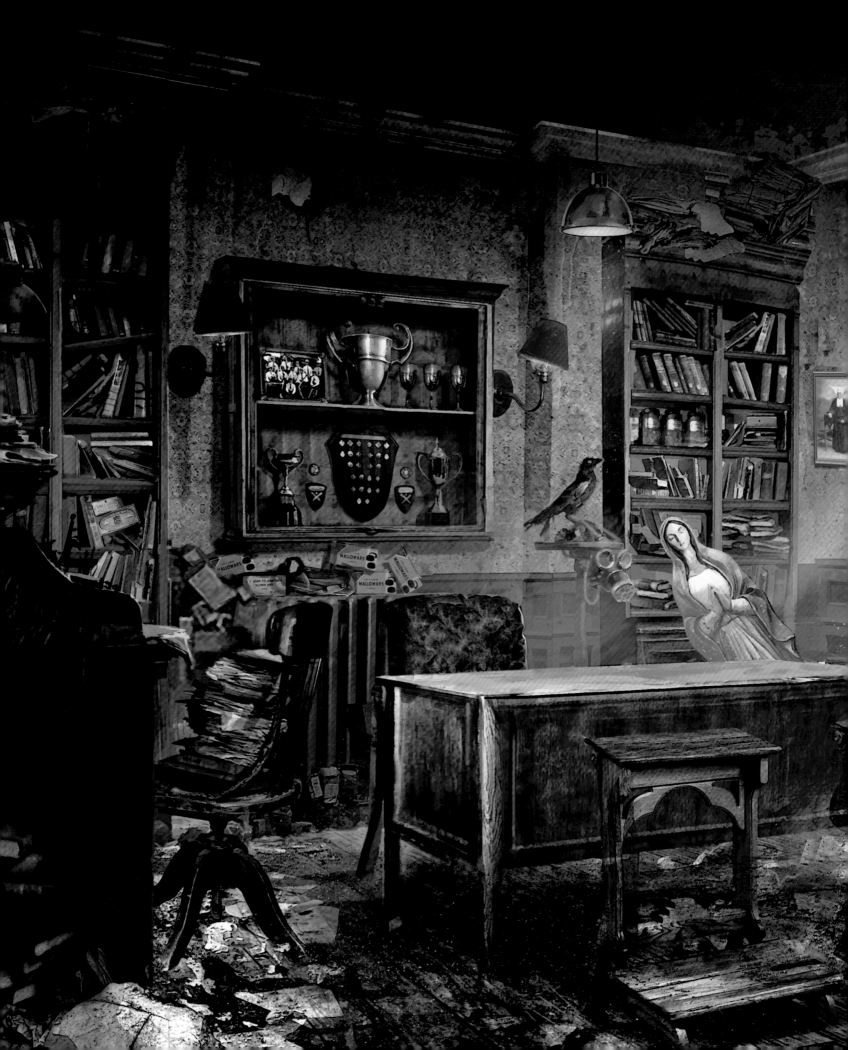

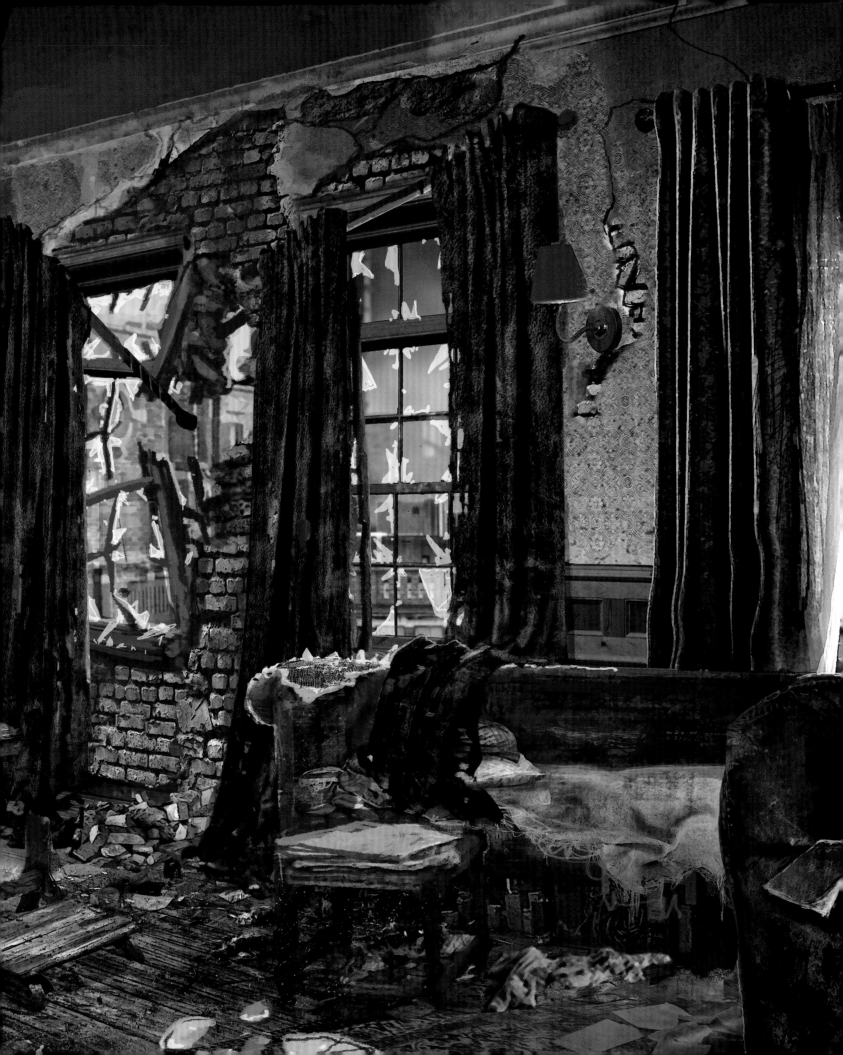

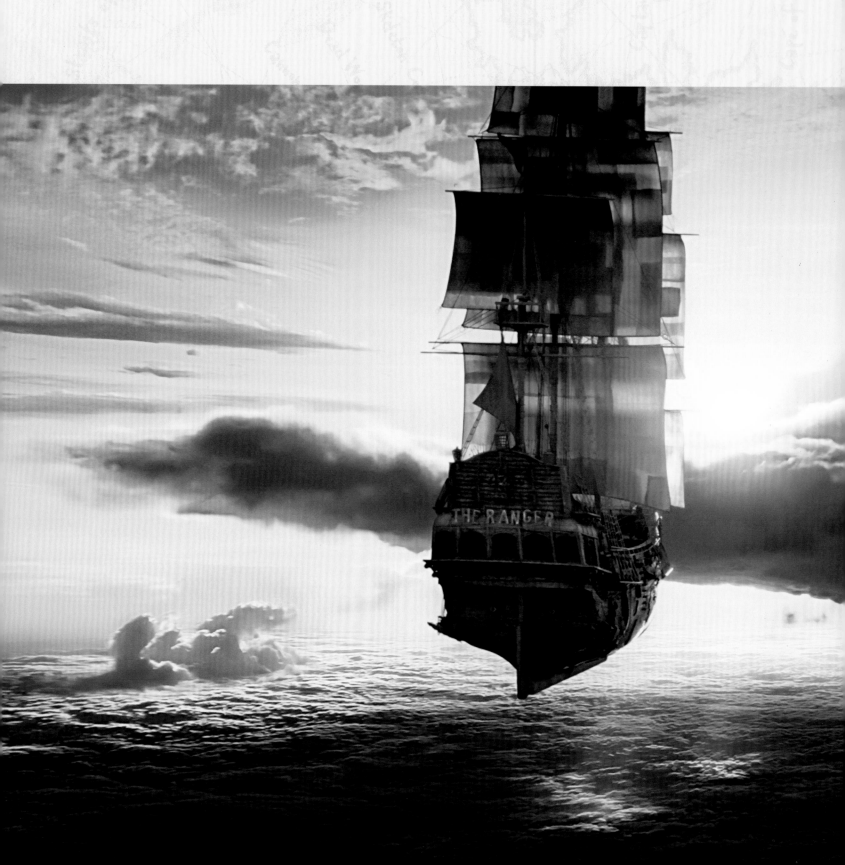

The Great Escape

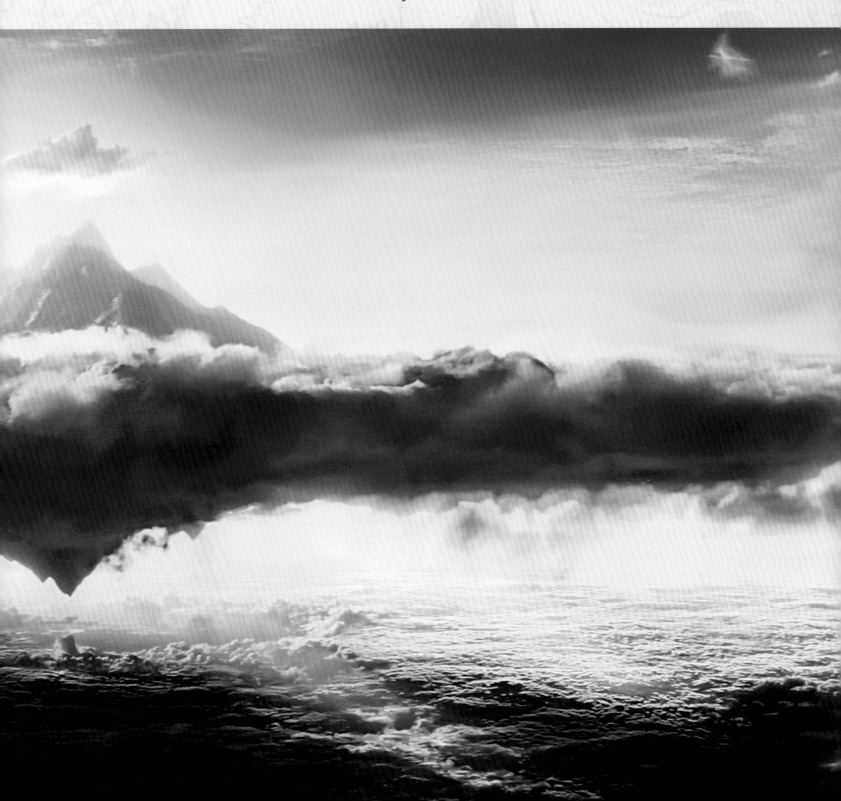

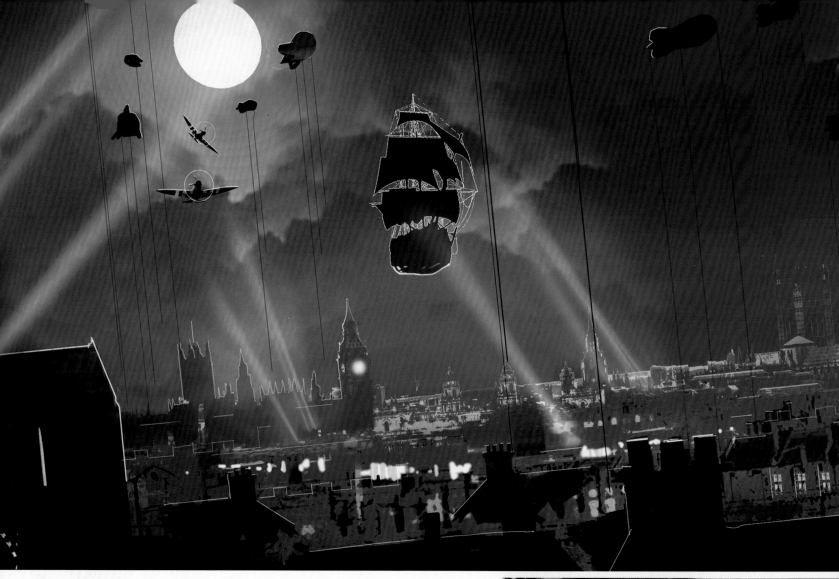

PREVIOUS PAGES *The pirates' galleon floats toward Neverland.* **ABOVE** *An illustration of the "Pirate Snatch" sequence shows the pirates' ship floating away from Blitz-era London, chased by a trio of RAF fighters.* **RIGHT AND OPPOSITE BOTTOM** *Using green screen technology, the visual effects team later adds details of the pirates and their flying ship to the sequence in which Peter is taken from the orphanage.*

One of the most important sequences in the film details how Peter and the rest of the kids are snatched away by the pirates and kidnapped from the orphanage to Neverland in huge flying ships in the sky. This visually stunning transition is a key turning point in *Pan*. As producer Sarah Schechter explains, "The 'Pirate Snatch' sequence was one of the first things that Joe designed, and the pitch that got us the green light was based on it. Joe had seen a play where the actors used bungee cords, so he decided to recreate that for the movie."

Schechter says that in this scene the kids go through an experience that can be very terrifying, and she compares it to seeing the Wicked Witch of the West and her flying monkeys in *The Wizard of Oz*. Screenwriter Jason Fuchs also introduced the idea of mixing pirate ships with World War II fighter planes. "It was part of what Jason originally pitched to me, and it's very close to our hearts," says Schechter.

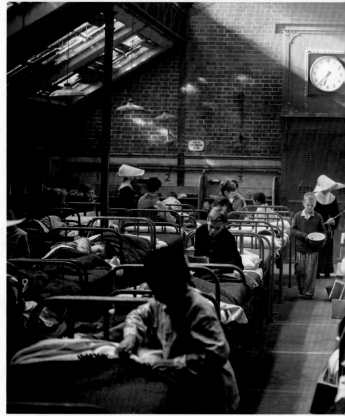

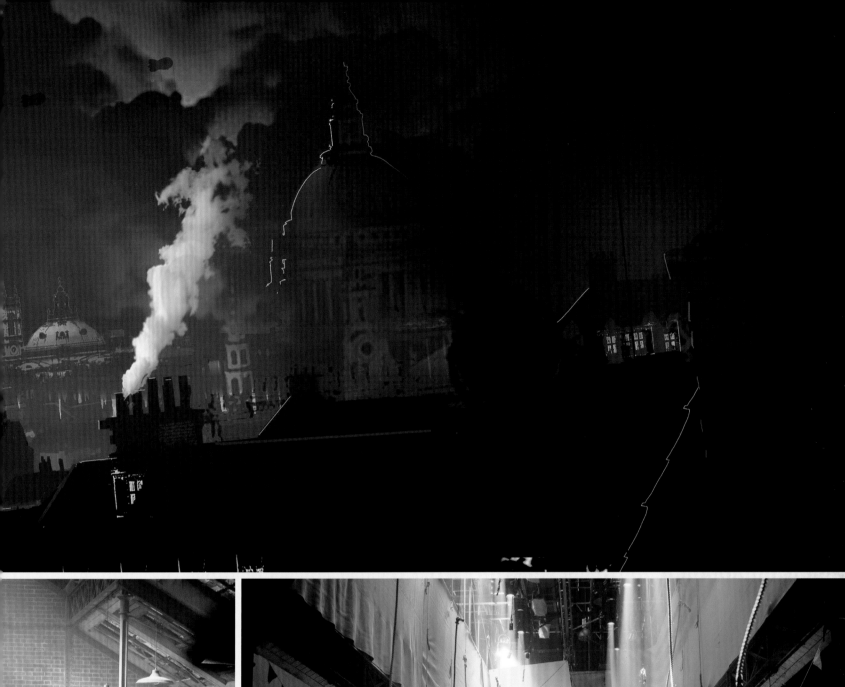

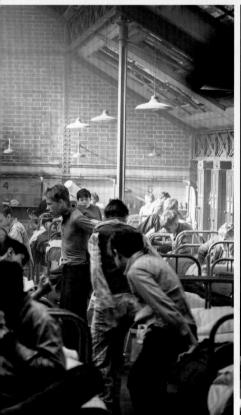

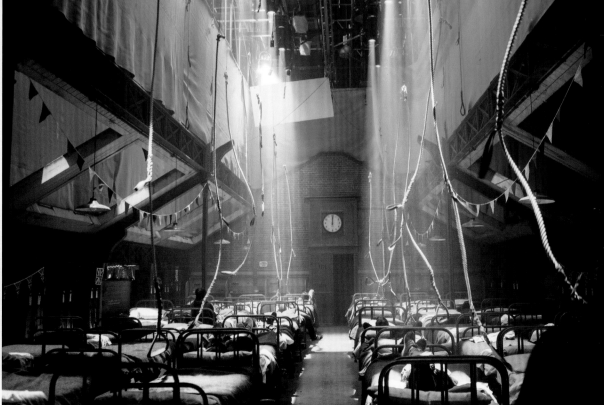

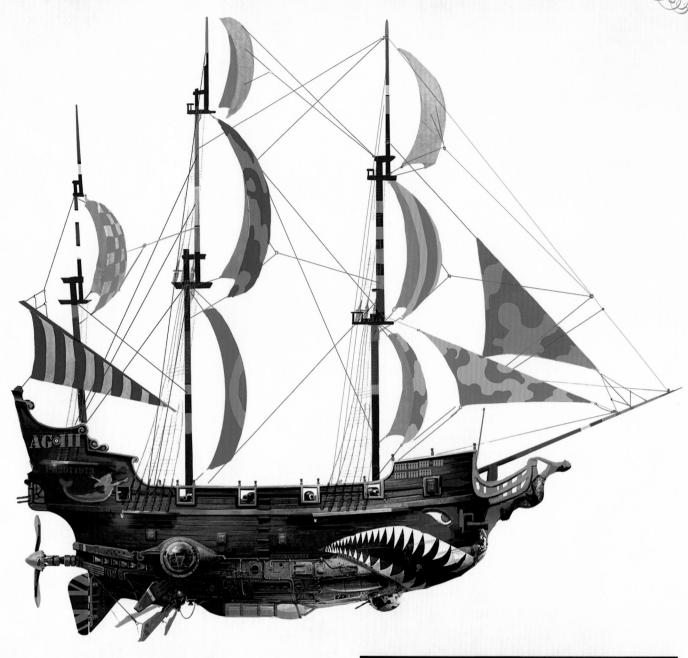

ABOVE, OPPOSITE, AND PAGES 94–95
Drawings illustrate the intricate designs of the pirate's flying ship, described in the script as "a 160-foot, 32-gun, honest-to-goodness 18th century, galleon-class pirate ship—somehow suspended in midair and docked in the rear courtyard along the top floor of the Home."

Cleverly blending the world of the pirates with Blitz-era London, the filmmakers followed the ships as they fight off WWII bombers and dive under one of the city's bridges. "The idea is that the pirates would come to London when there was fear of potential bombings, so they would kidnap the kids to work in their mines under the cover of darkness," notes Schechter. "They fly through the cityscape and then float in space, through this water membrane, and come out through the sky on the other side. We see fish swimming through bubbles in space. It's an extraordinary visual feast that takes us from the darkness of London to the bright, colorful world of Neverland."

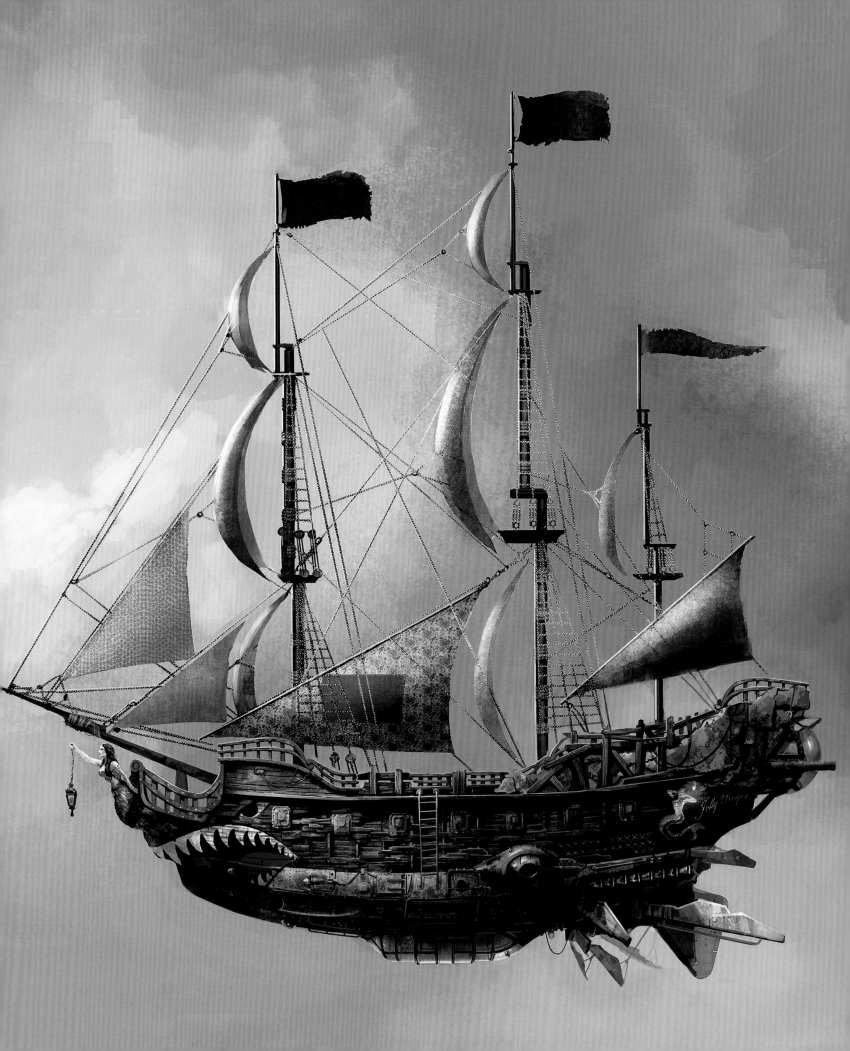

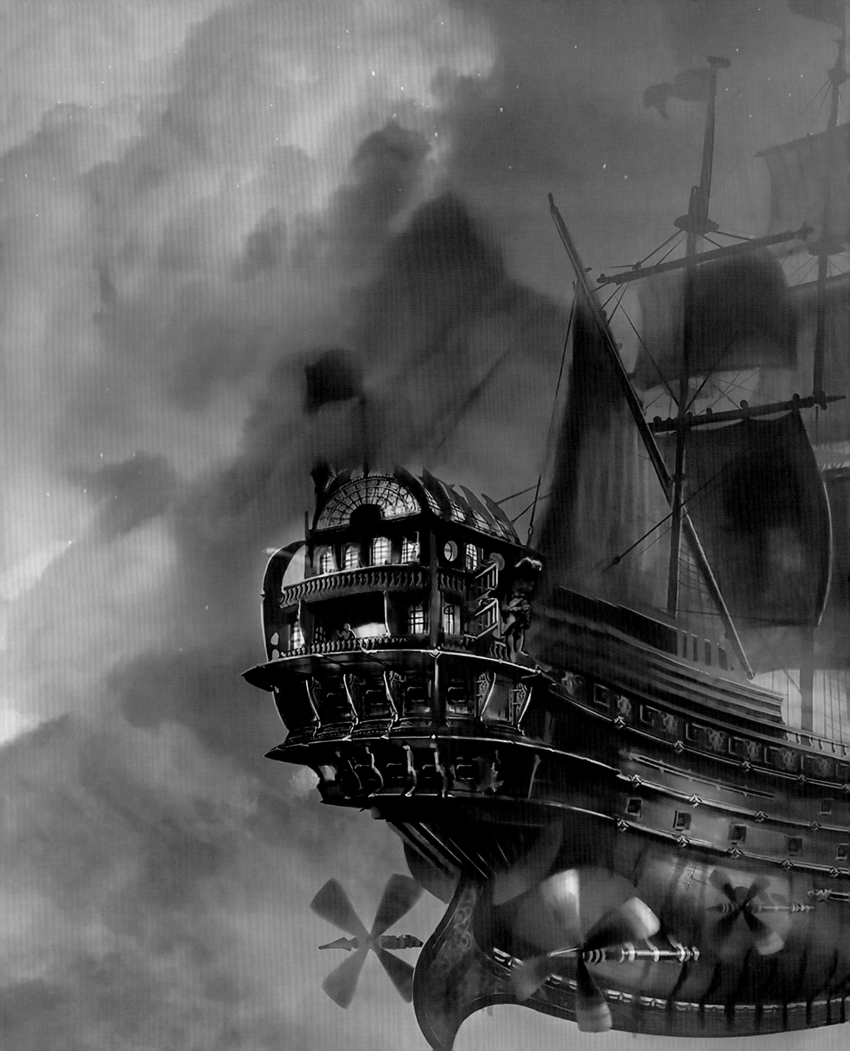

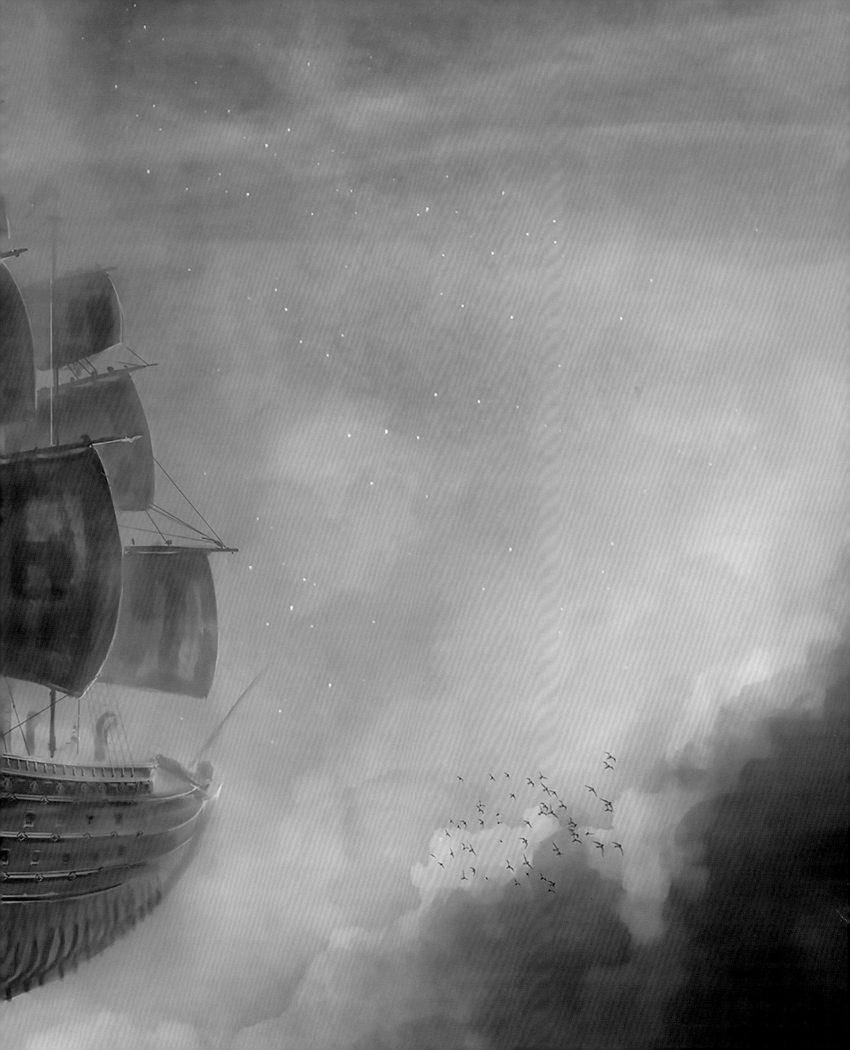

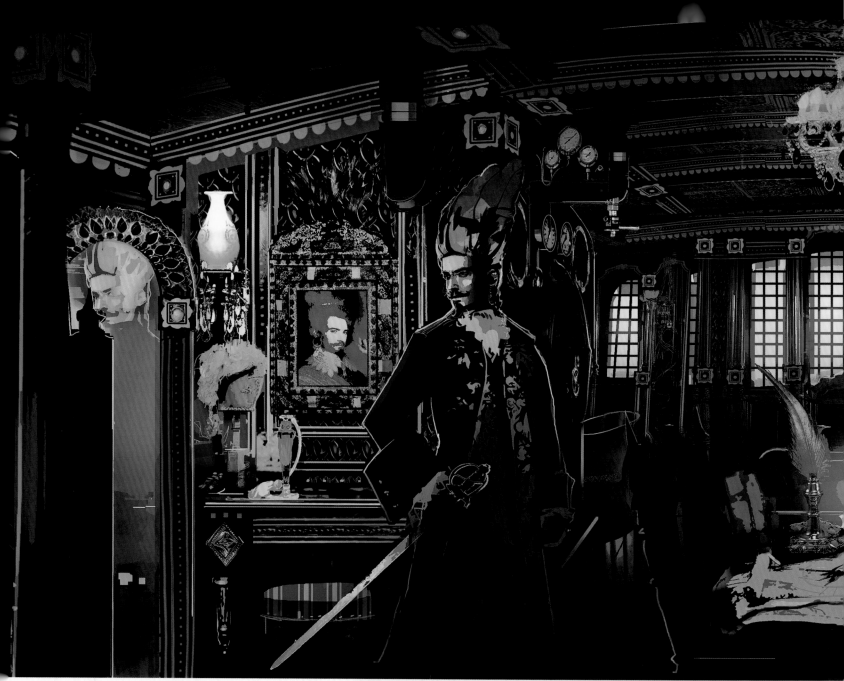

"The first private scene between Blackbeard and Peter in Blackbeard's drawing room below decks leaves a very strong impression. Their performances, the look of the scene, the feel of the scene—it's a great moment of drama. It's a scene that's going to stick with the audience."

—GREG BERLANTI, PRODUCER

THESE PAGES
More illustrations of the pirates' ship, The Ranger, *and Blackbeard's drawing room, in which the terrifying pirate has an intense exchange with* Peter. **FOLLOWING PAGES** *RAF fighters in their Spitfire aircraft pursue the pirates' air galleon in the skies above London.*

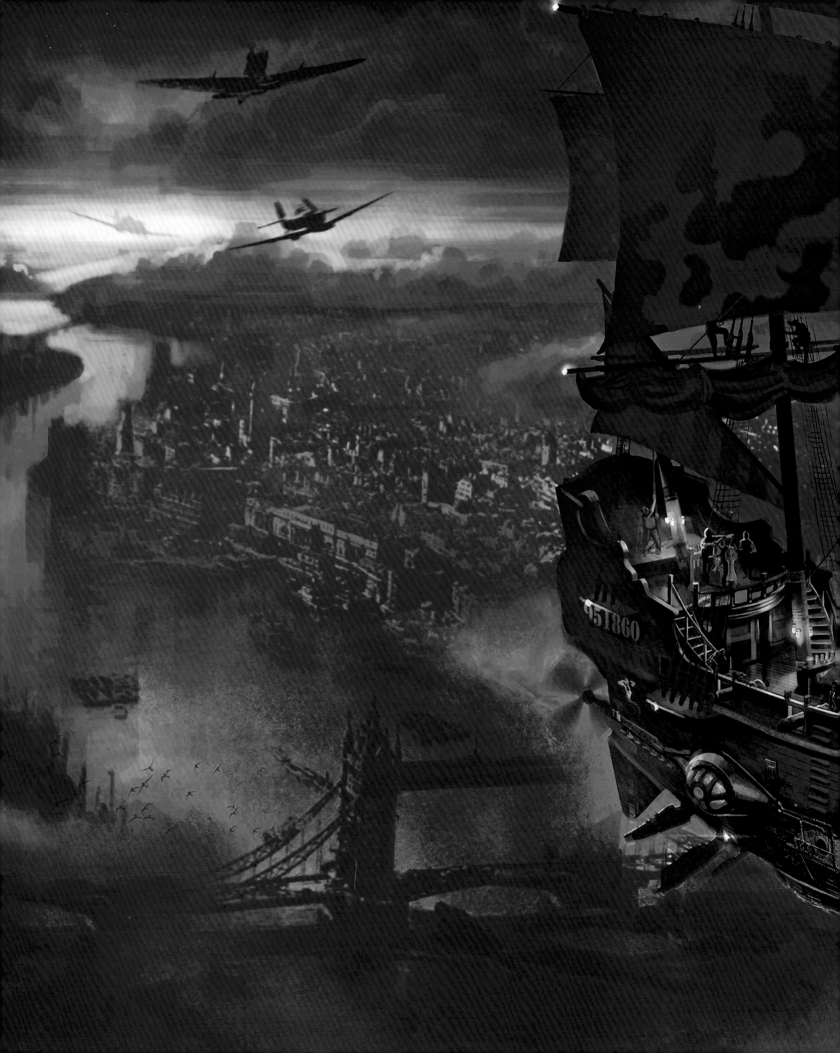

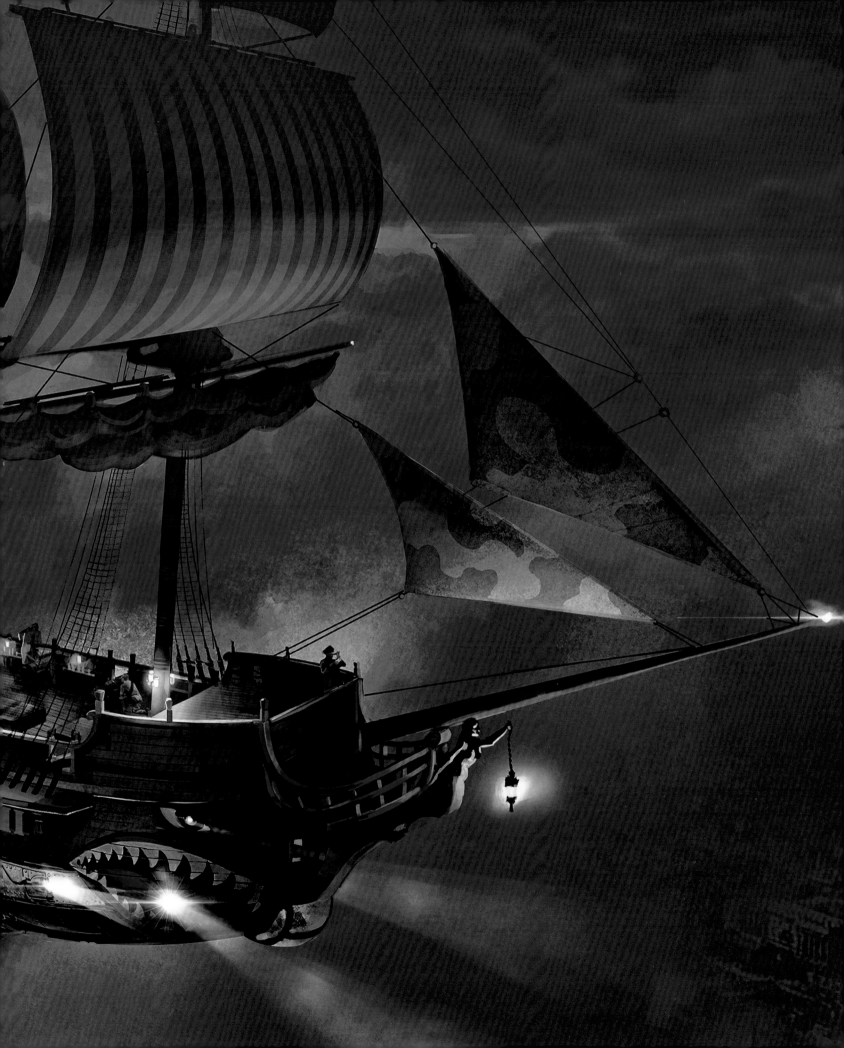

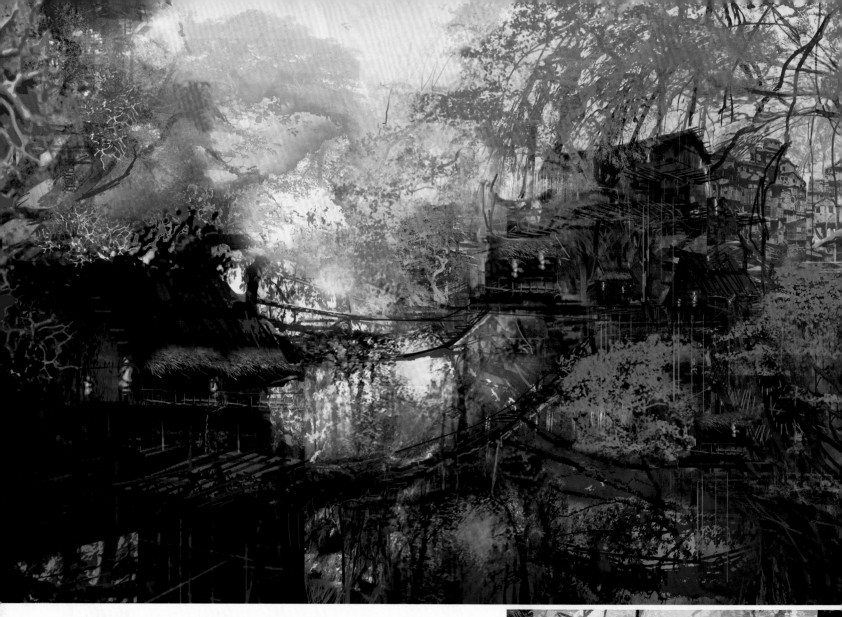

ABOVE AND RIGHT *After escaping Blackbeard's mines, Hook, Peter, and Smee land in the Neverforest, which is home to exotic plants and animals as well as creatures of fantastic proportions.*

When Peter, Hook, and Smee escape from the mines and land in the Neverforest, the world opens up into a place that's full of color, exotic vegetation, creatures of fantastic proportions, and a tribal village filled with extraordinarily dressed natives. "I love it when I have to invent a world. Each time there is something to create," says Bonetto.

The set with the forest and the village within was the biggest Bonetto has ever had to design and construct. "It was easy to get lost," jokes Hugh Jackman. On one occasion, he recalls, it took four production assistants to find the director for a meeting.

So how did it all start?

"Everything begins with color," says Bonetto. Because the set would be home to hundreds of villagers and dozens of invading pirates, there was close consultation between all department heads—production design, set decoration, costumes, hair and makeup, and more.

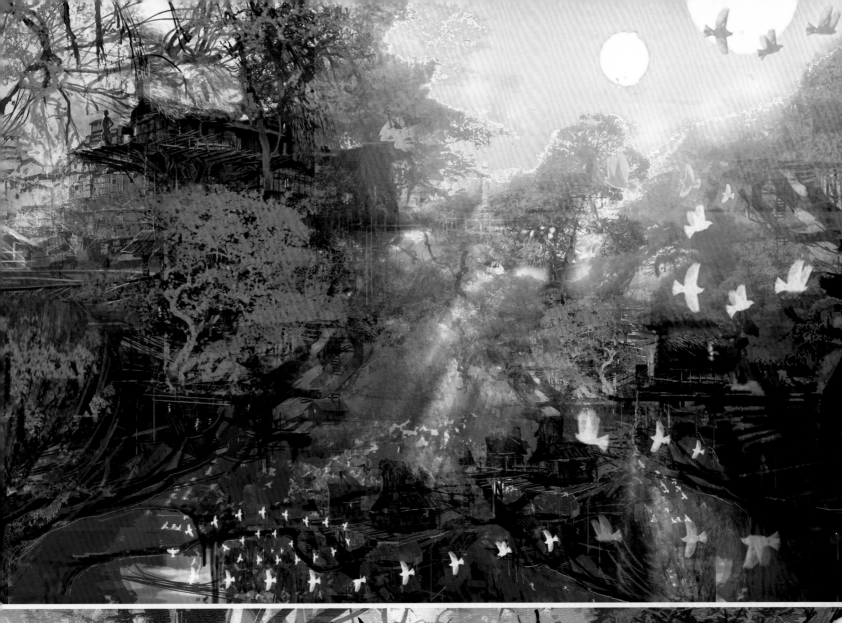

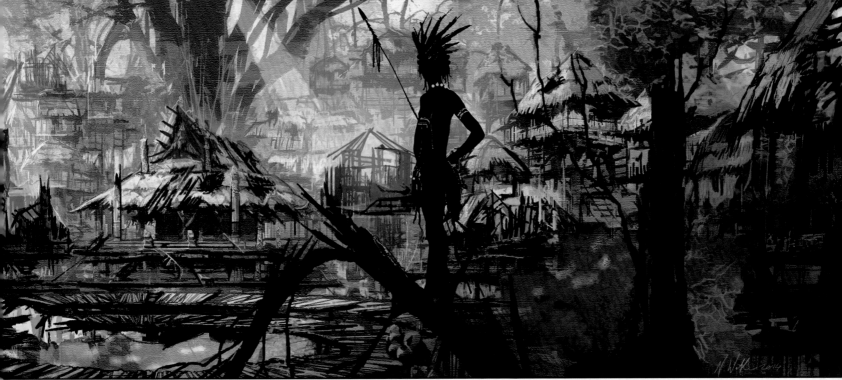

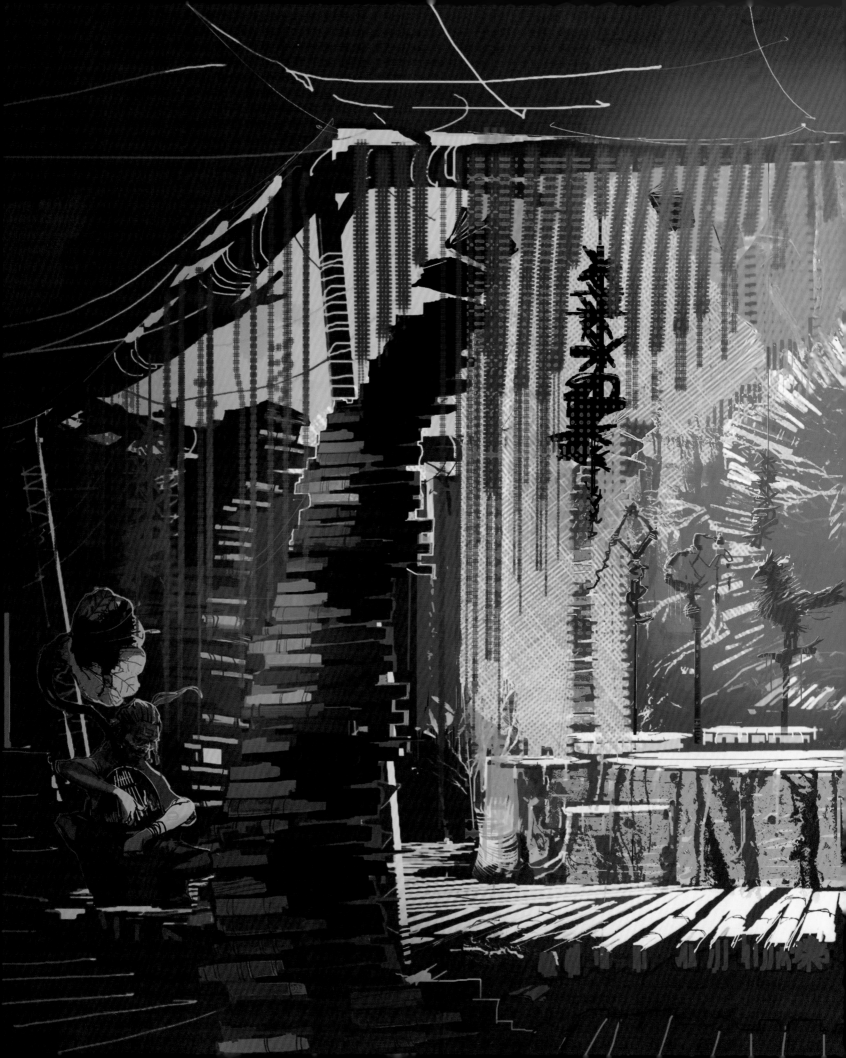

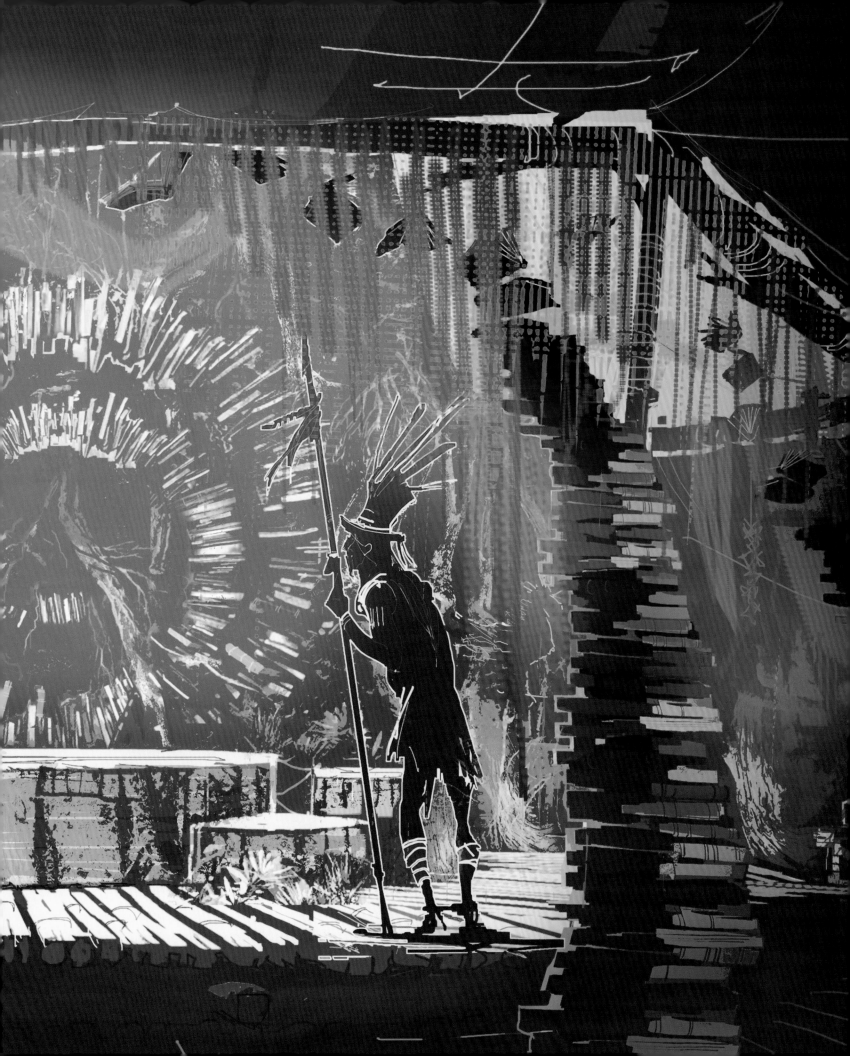

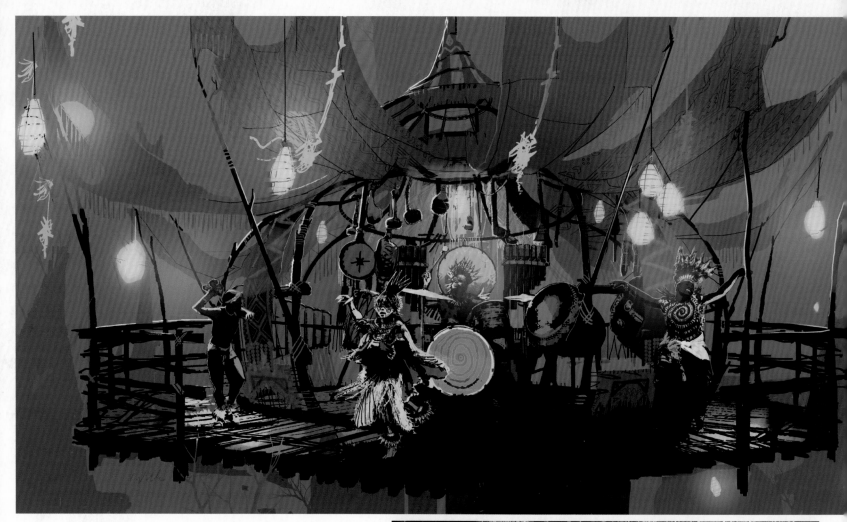

"It all had to make sense," says Bonetto. "It all had to be of a piece." And that is where the palette of colors chosen linked the disparate source.

Capon found the fabrics used for the tribe's tents and banners, for example, in the Nagaland region of India, adjacent to the Himalayas. The inspiration for the tribe's makeup and hair was a cross between Chinese opera and that of the Kathakali dance dramas of the southern Indian state of Kerala. The tribe featured in the movie is multiethnic, with costume cues gathered worldwide. "It was critical to have a language of makeup and hair that signaled that they were a tribe," says hair and makeup designer Ivana Primorac.

Originally the villagers were going to live in the 40-foot trees of the set, but budget and time restraints brought the village to the ground and into tents. Bonetto says establishing the villagers as nomads immediately worked to the story's advantage. "At first we were going in a very surrealistic direction with the design," says Bonetto. "But under Joe's leadership we moved toward something more poetic.

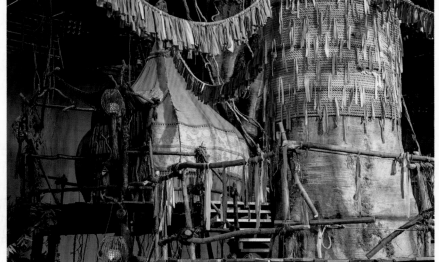

PREVIOUS PAGES AND TOP *Illustrations depict the tribal people of the Neverforest, which were originally supposed to live in the 40-foot-tall trees within the set.* **ABOVE AND OPPOSITE** *Set decorator Dominic Capon found the village's colorful tent and banner fabrics in the Nagaland region of India.*

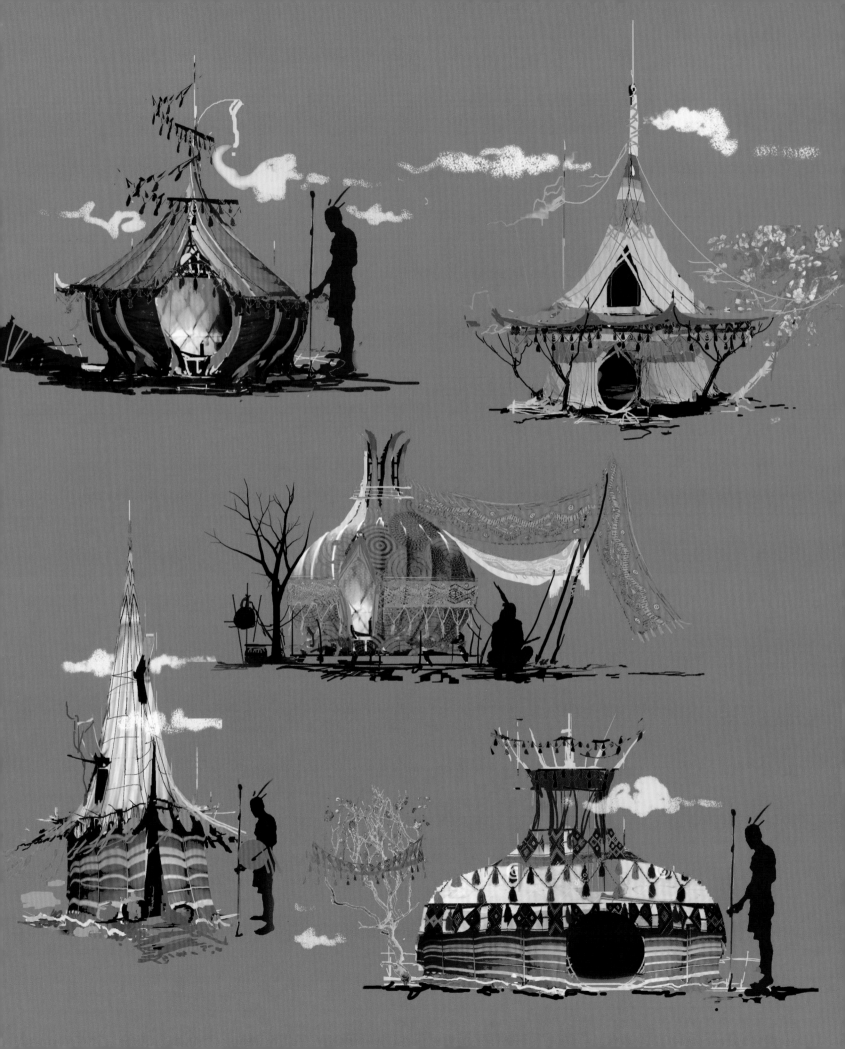

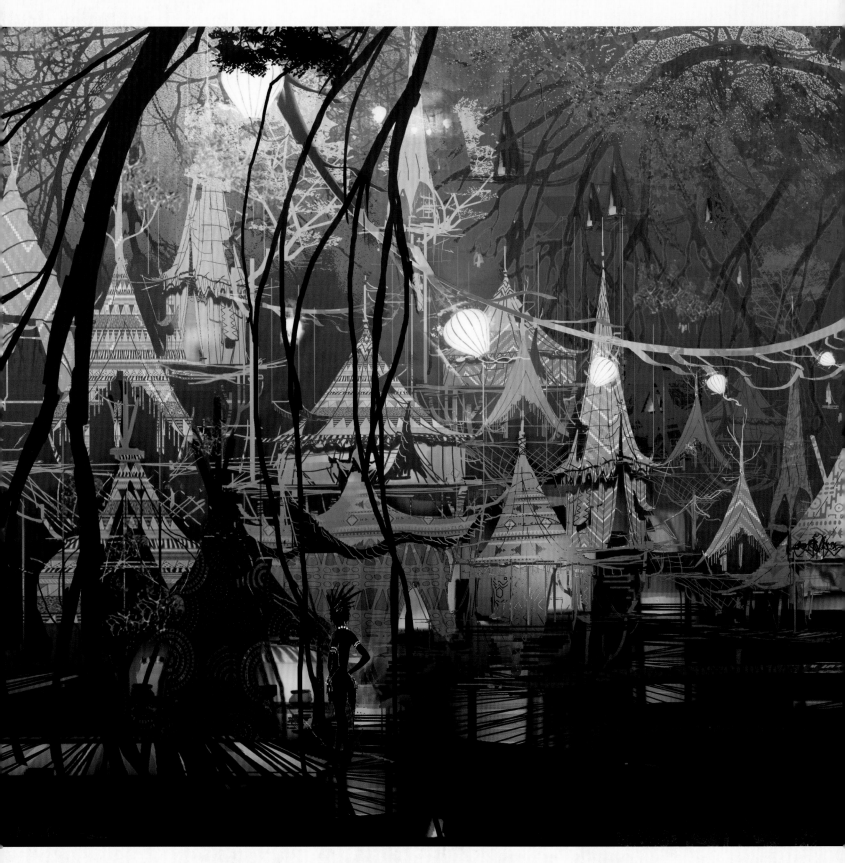

An artist's rendition of the Native village, which is described by the screenwriter
Jason Fuchs as "an entire civilization built into and around the trees, interconnected
by suspended bridges and massive, impossibly curved branches."

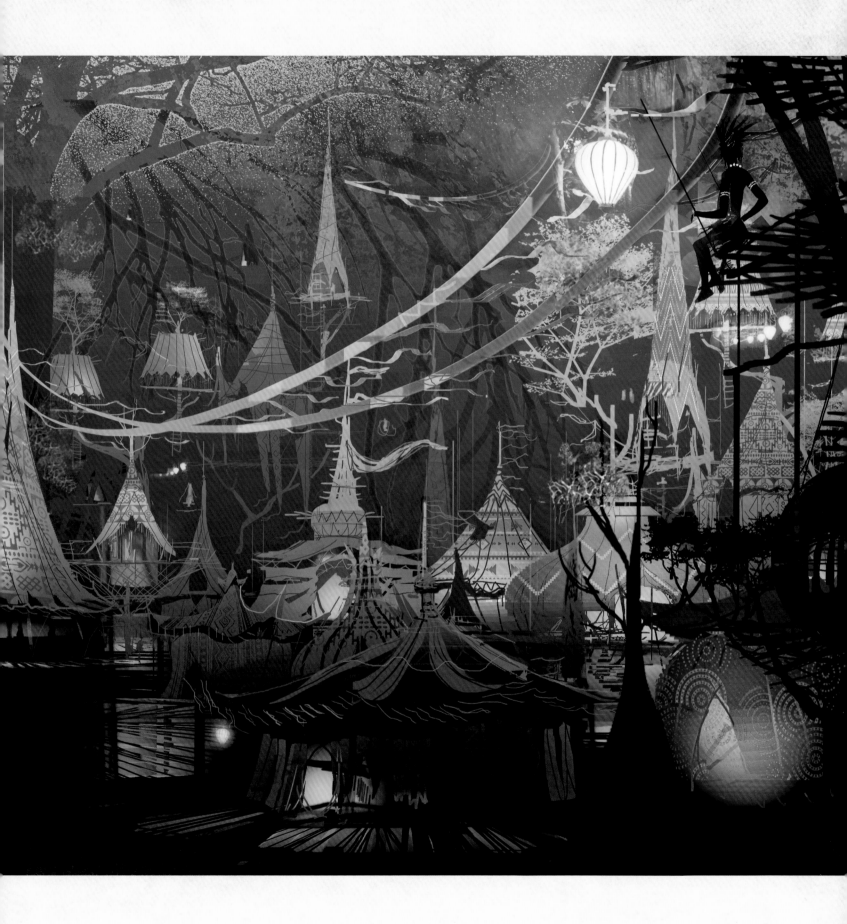

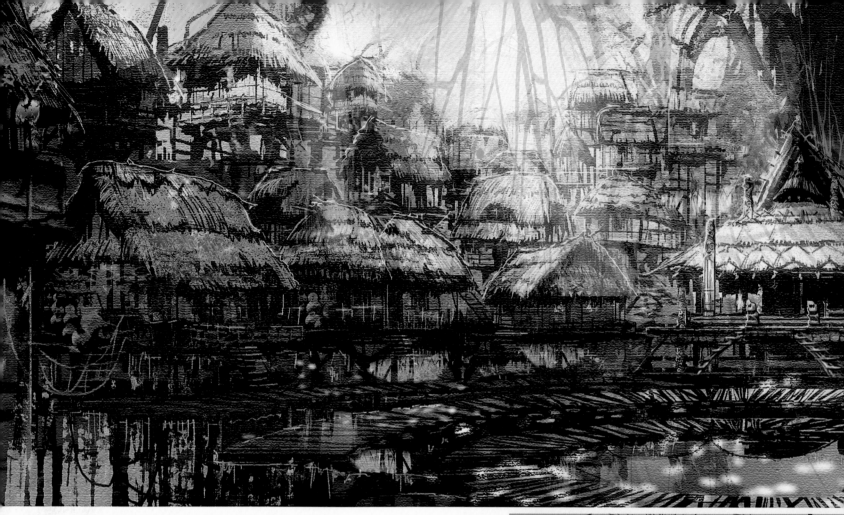

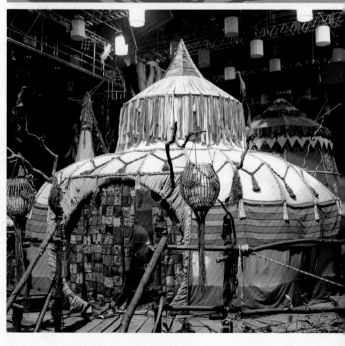

ABOVE *An illustration of the Neverforest village is inspired by thatched-roof huts found in villages in Rwanda, Fiji, and the Himalayas.* RIGHT *The film's creative visual team hung strips of cloth and dangling crystals from tent walls and roofs to absorb, reflect, and refract the light.* OPPOSITE BOTTOM *The colorful costumes of the villagers were also inspired by a multitude of cultures around the world.*

We wanted a film that is readable and accessible for people of every age, but especially children."

This approach rendered some impressive visual results. In a fight scene between Peter and Blackbeard set in a villager's tent, for example, Wright's creative team—including cinematographer Seamus McGarvey—hung strips of cloth and dangling crystals from the tent walls and roof to absorb, reflect, and refract the light. "They created a type of wonderful shadow play, which was a beautiful way of presenting a kind of chase," says producer Paul Webster. "It was somewhat abstract, but it tells the story and gets the point across in a dramatic way."

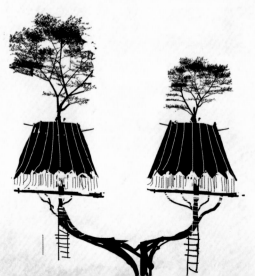

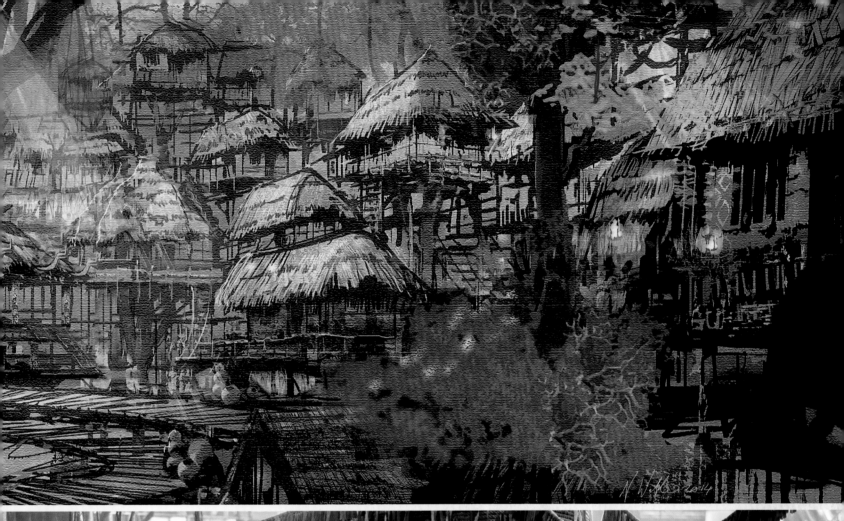

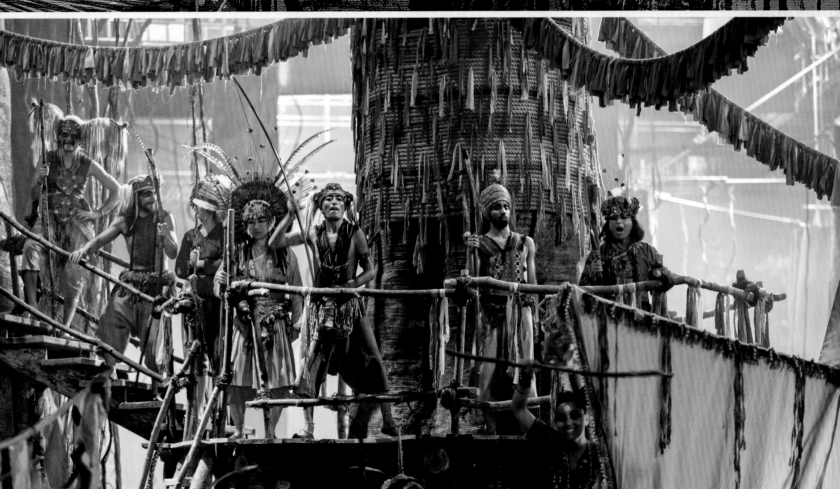

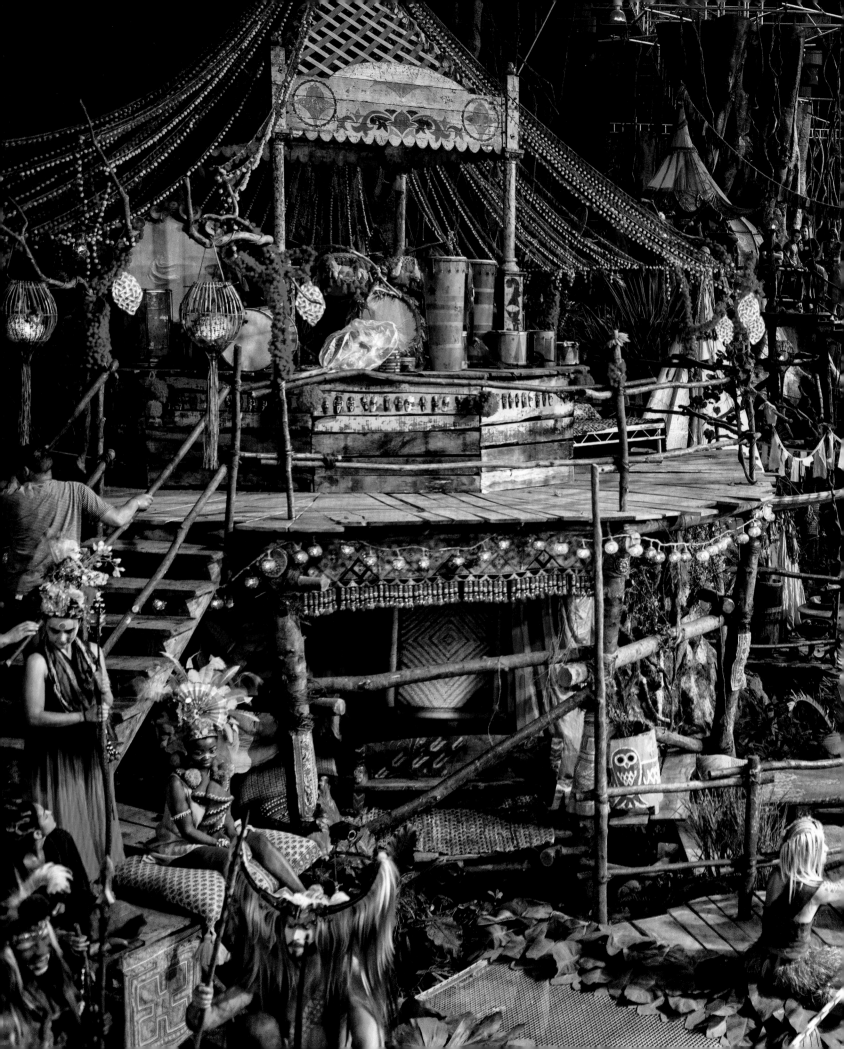

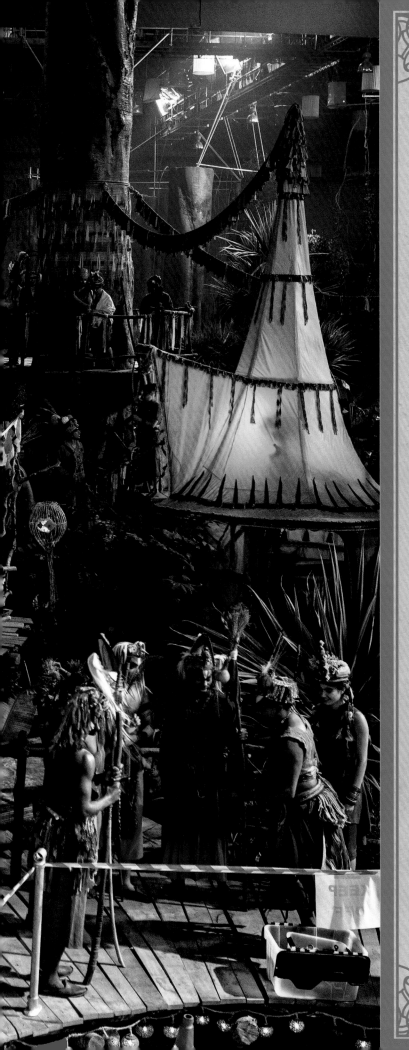

A Few Facts About
Pan's Fantastic Sets

The logistics of shooting *Pan* as envisioned by director Joe Wright was a feat in itself. There were, among other things, eight complicated sets to build—three galleons, one mine, one orphanage, one forest, and one village (within the forest). The forest, replete with some 40-foot-tall manmade trees, was to cover an area nearly the size of a US football field. So how do you get that done in twelve weeks? Here are a few essential ingredients:

- A soundstage big enough to enclose it all. In this case two old airship sheds in Cardington, Bedfordshire, 60 miles north of London. The sheds have a five-acre footprint, making them five times larger than the biggest Hollywood soundstage.

- A construction crew of about 250 carpenters, plasterers, sculptors, and painters.

- An art department/set decoration/prop team of about 65 people.

- One forest, with a 14,400 square-foot footprint (almost exactly an acre). As the treetops are 50 feet tall at their highest point, the set would fill a cube with a volume of 720,000 square feet. (Most of the greenery in the forest is real.)

- One village: 10,000 square feet. Twelve weeks of construction time. Four weeks for set decoration.

- One mine: 7,000 square feet. Ten weeks to build. Two weeks for set dressing.

- The deck of Blackbeard's galleon, *Queen Anne's Revenge*: 3,500 square feet with 25-foot-high masts and rigging. When finished, it's loaded onto a gimbal that can move the deck to simulate sailing on the high seas (and in the sky). Twelve weeks of construction. Four weeks for set decoration.

- The decks of *The Ranger* and *The Jolly Roger*: 1,200 square feet with 21-foot-high masts and rigging. Twelve weeks of construction. Four weeks for set decoration.

- A partial shopping list for construction materials: 200,000 feet of scaffolding; 1,000 8-by-4-by-2-foot blocks of polystyrene; 200 tons of plaster; 500 rolls of plasterer's canvas; 2,000 gallons of emulsion; 1,000 gallons of shellac; 10,000 sheets of plywood; 1.2 million feet of prepared timber; 1,200 sheets of medium-density fiberboard.

- It's important to point out that the 1,000 tons of waste that the shoot produced were all recycled.

LEFT AND FOLLOWING PAGES *It took twelve weeks to construct and four weeks to decorate the lavish 10,000-square-foot village set.*

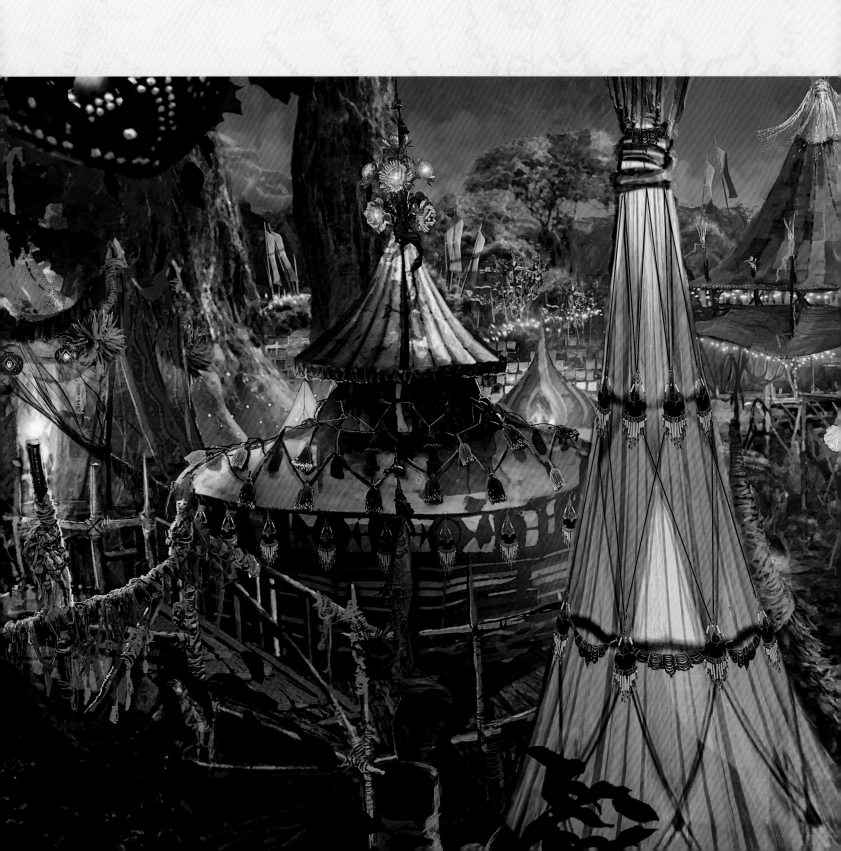

It Takes a Multicultural Village

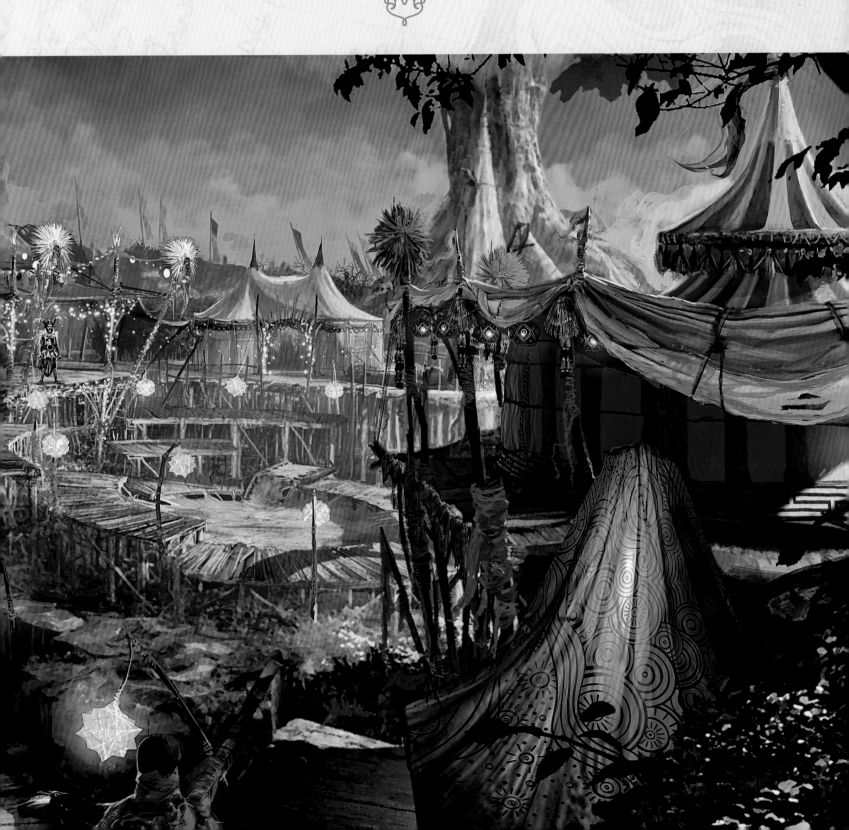

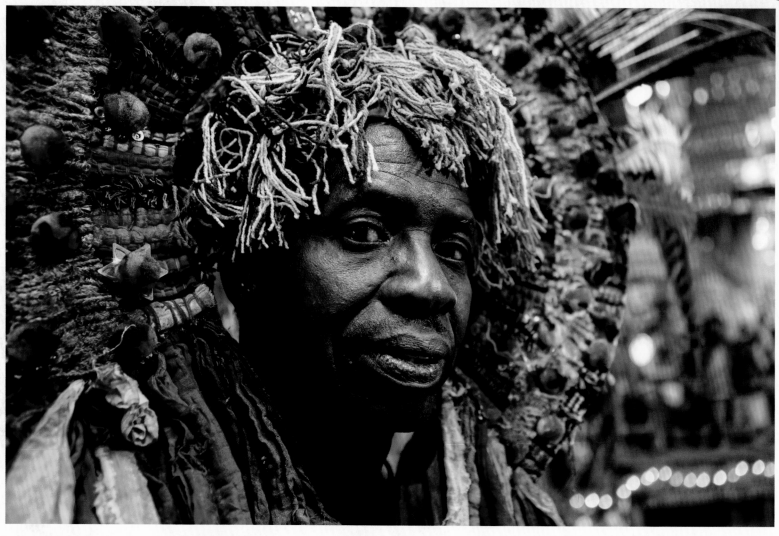

TOP AND OPPOSITE
It was important for the filmmakers that the inhabitants of the Neverland village didn't come from one single culture or ethnicity. Hundreds of actors from all the world's continents worked together to make up this multicultural tribe.

f all the moments in Peter's journey into the heart of *Pan*, probably the most important is when he sees the inhabitants of Neverland village for the first time. "The villagers couldn't look like anything that exists," says costume designer Jacqueline Durran. "It wasn't just about replicating our research. We had to invent."

J. M. Barrie's version of Neverland is filled with simplistic dialect–speaking Indians and other racist tropes—something that had to be replaced in a 21st century prequel.

Great scripts can't get bogged down in a lot of description, so *Pan*'s production team had to take scriptwriter Jason Fuchs' brief introduction to the native village: "No tepees here; more like the native dwellings of Papua, New Guinea," and create something completely different.

"It was Joe's idea that they come not from one culture or ethnicity," says producer Paul Webster. "They're people of the world."

In the group of hundreds of villagers are actors from Asia, South America, Scandinavia, New Zealand, Australia, Great Britain, and more. And there are cross-cultural families. The father of Tiger Lily (Rooney Mara) is played, for example, by Jack Charles, an Australian Aborigine. Another key tribe member, the village's fiercest warrior Kwahu, is played by Korean actor/tae kwon do master Tae-joo Na.

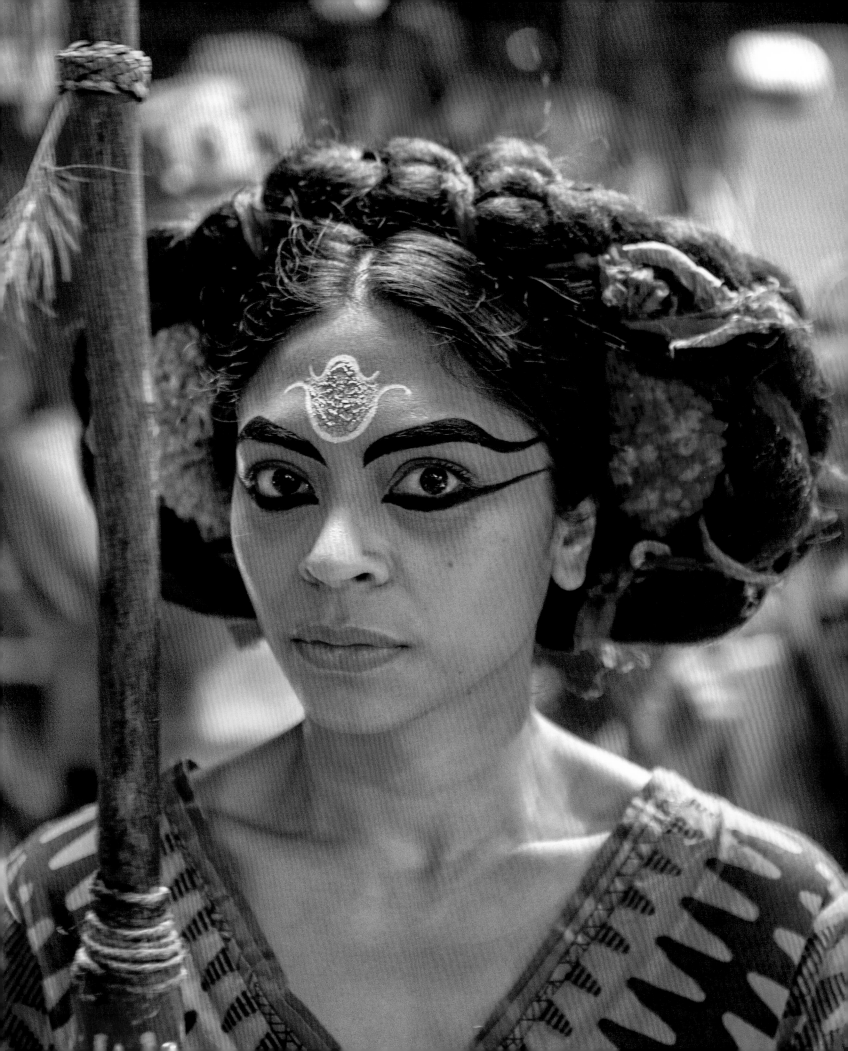

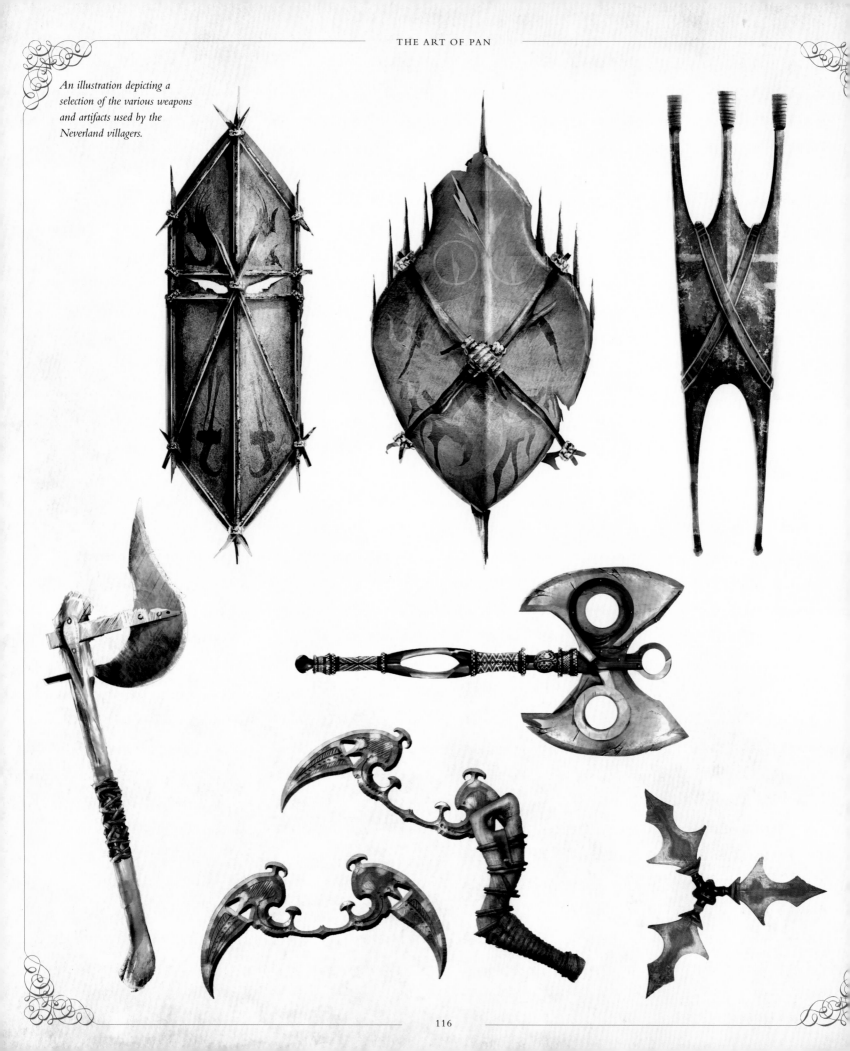

An illustration depicting a selection of the various weapons and artifacts used by the Neverland villagers.

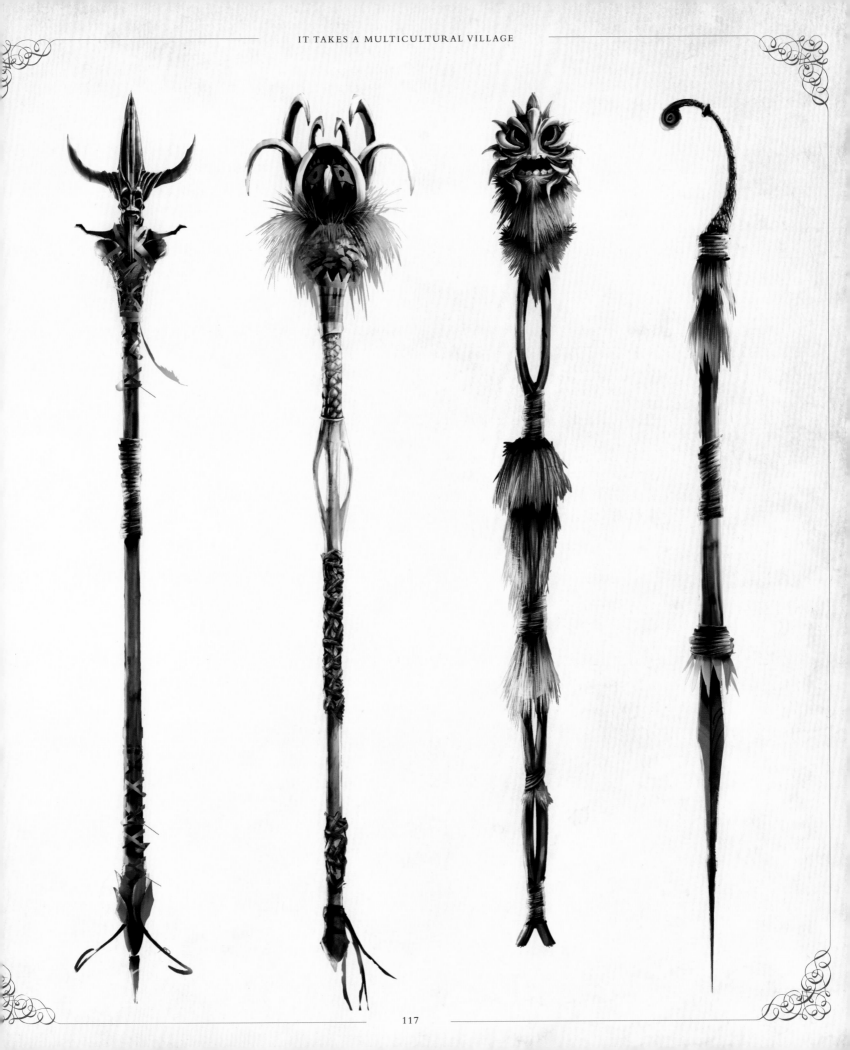

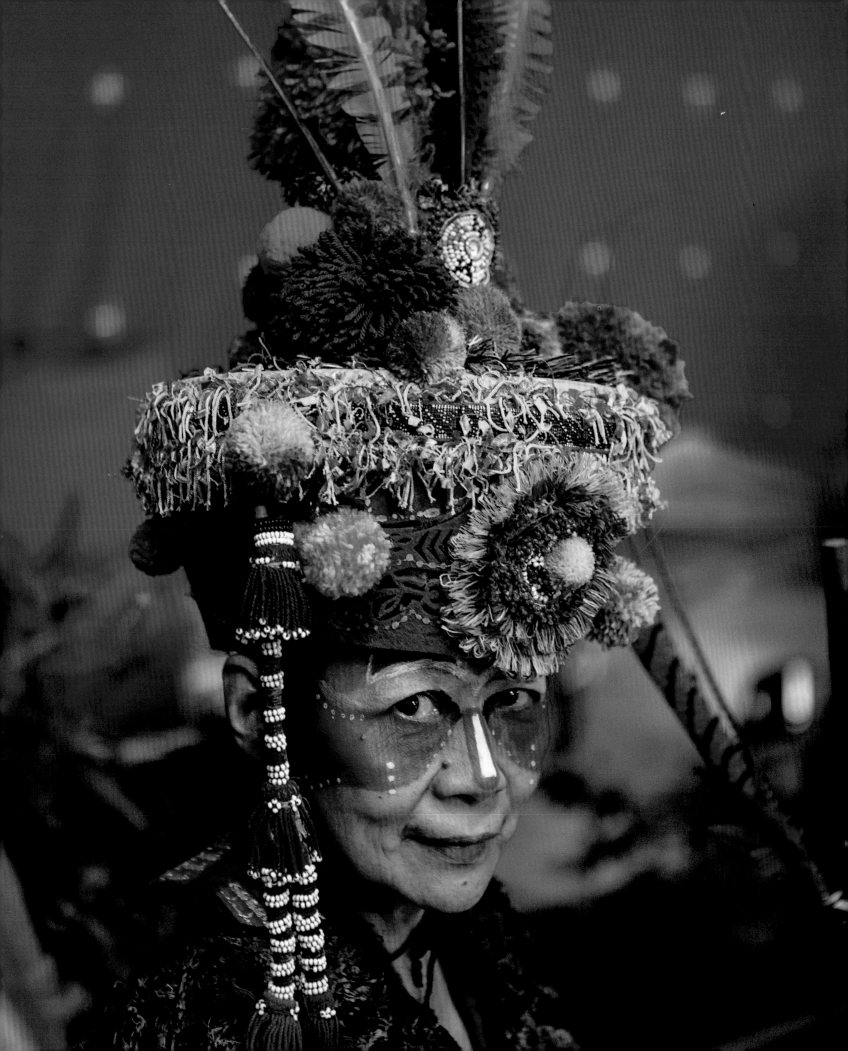

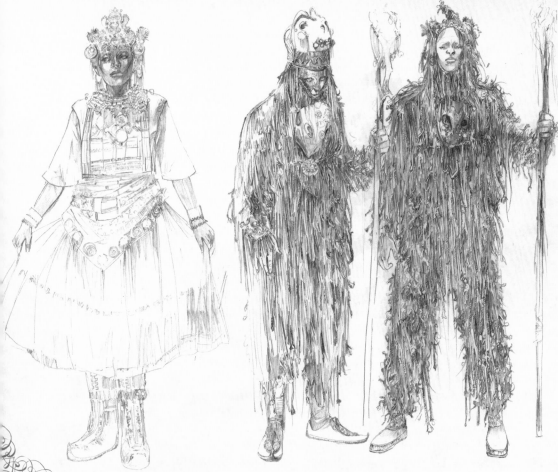

Once it had been decided to make Neverland multicultural, filmmakers moved on to the next piece of the puzzle: "The villagers needed to look like a tribe in all their multiethnic glory," says makeup designer Ivana Primorac. From a starting point of a mix of visual cues from China and the Indian subcontinent, Primorac built out from there.

"There's a complexity to the universe of the village," says producer Paul Webster, "so there are cultural references from everywhere." These references popped up in all aspects of the production, from colors and textures to costumes and accessories.

OPPOSITE AND ABOVE *The stunning variety and colors of the tribal headgear designed by Jacqueline Durran reflect sources of inspiration in India, China, and various African countries.*
FOLLOWING PAGES *Peter has to believe in his ability to fly to prove to the Neverwood tribe that he is the chosen one.*

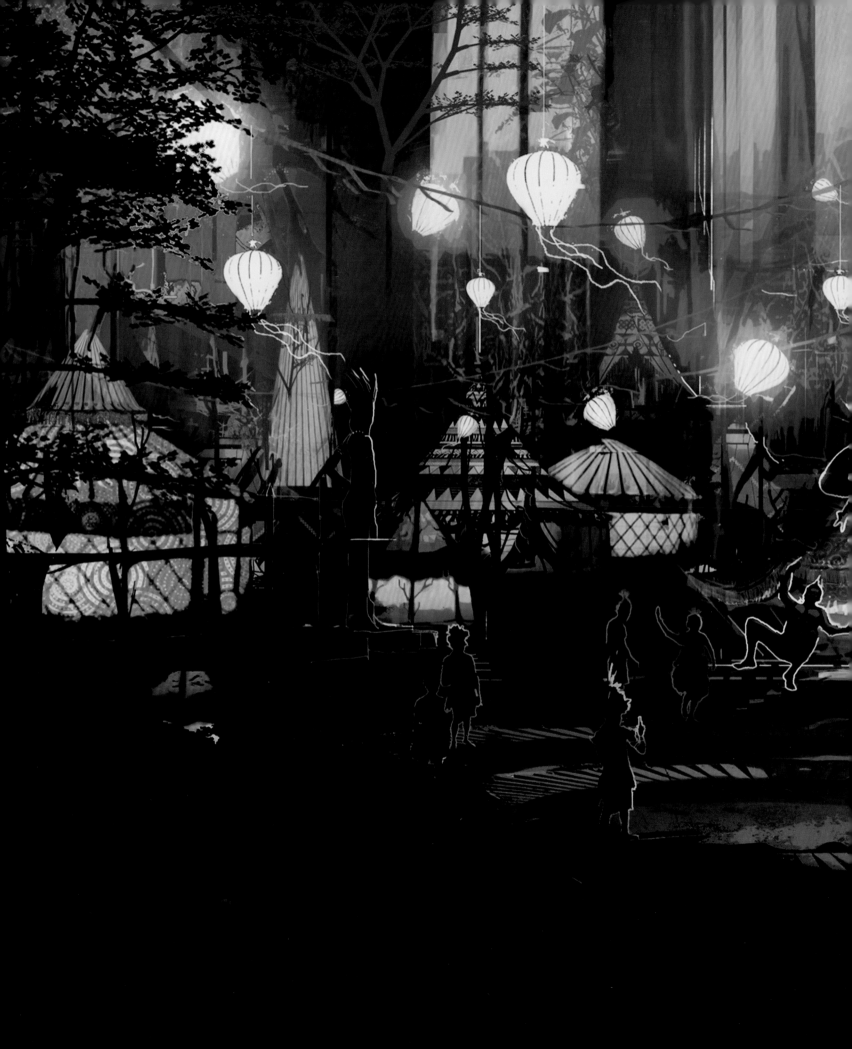

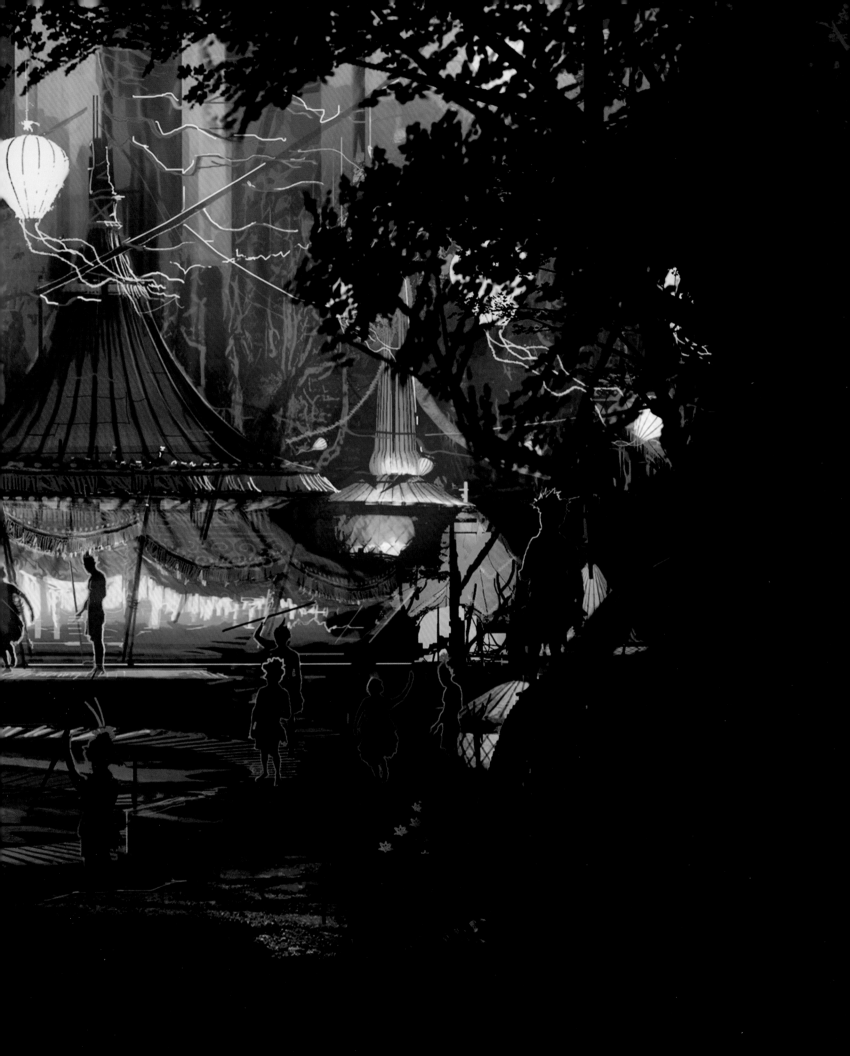

"The villagers couldn't look like anything that exists. It wasn't just about replicating our research. We had to invent."
—JACQUELINE DURRAN, COSTUME DESIGNER

With hundreds of extras to dress, Durran says initial costume parades—when the director and producers view, critique, and make costuming decisions—were a sight to see. "In the opening scene in the native village there are 250 different headdresses, including 50 for the stuntmen," she says.

Because of the unifying themes of costumes, hair and makeup, and the tents they lived in, the actors comprising the village—both principle actors and extras—forged a group identity. "On one of the last shooting days Joe [Wright] gave a speech to the whole village about the legacy of the natives of the world," recalls producer Sarah Schechter. "There were a lot of tears because people didn't want it to end."

RIGHT *Members of the Ugandan Children's Choir perform as the village kids in a festive celebration.* **BELOW** *Costume design sketches for the tribal leaders.* **PAGES 124–125** *An artist's depiction of the pirates' air galleon in flight.*

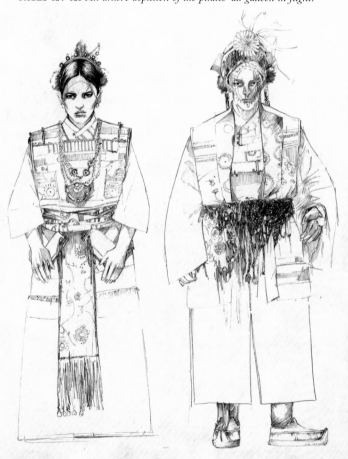

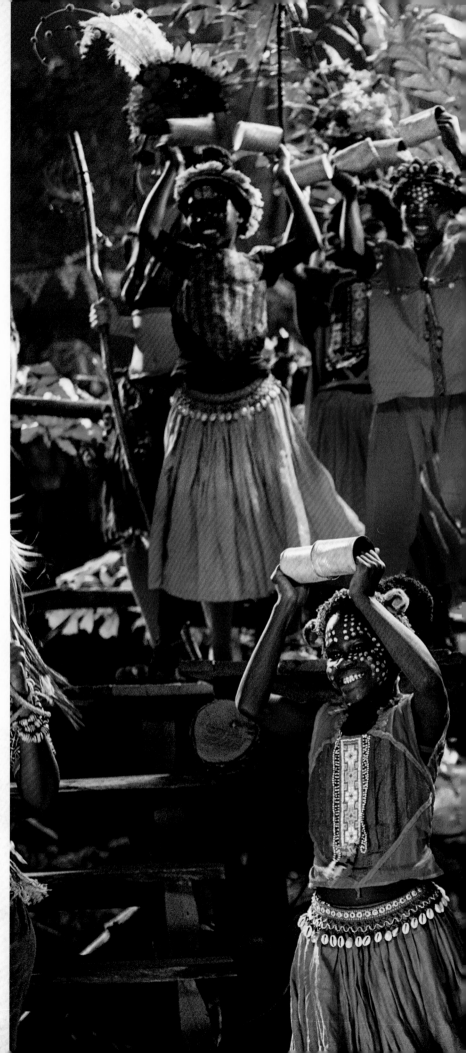

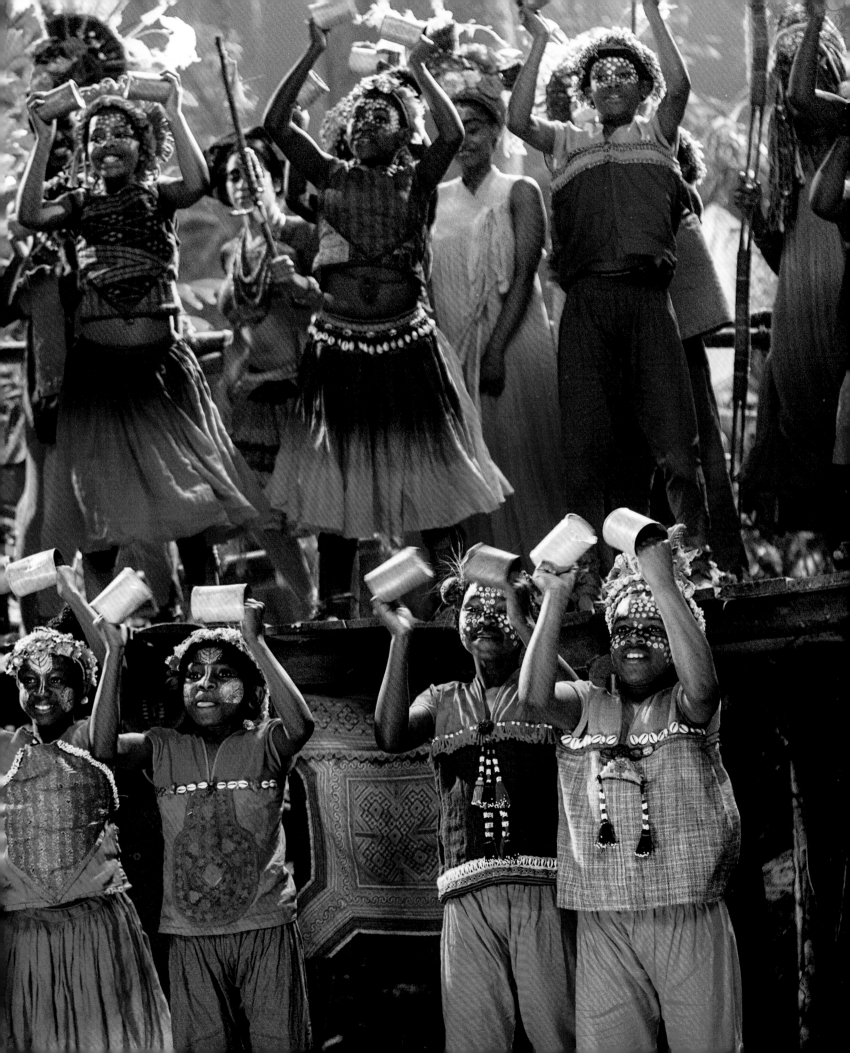

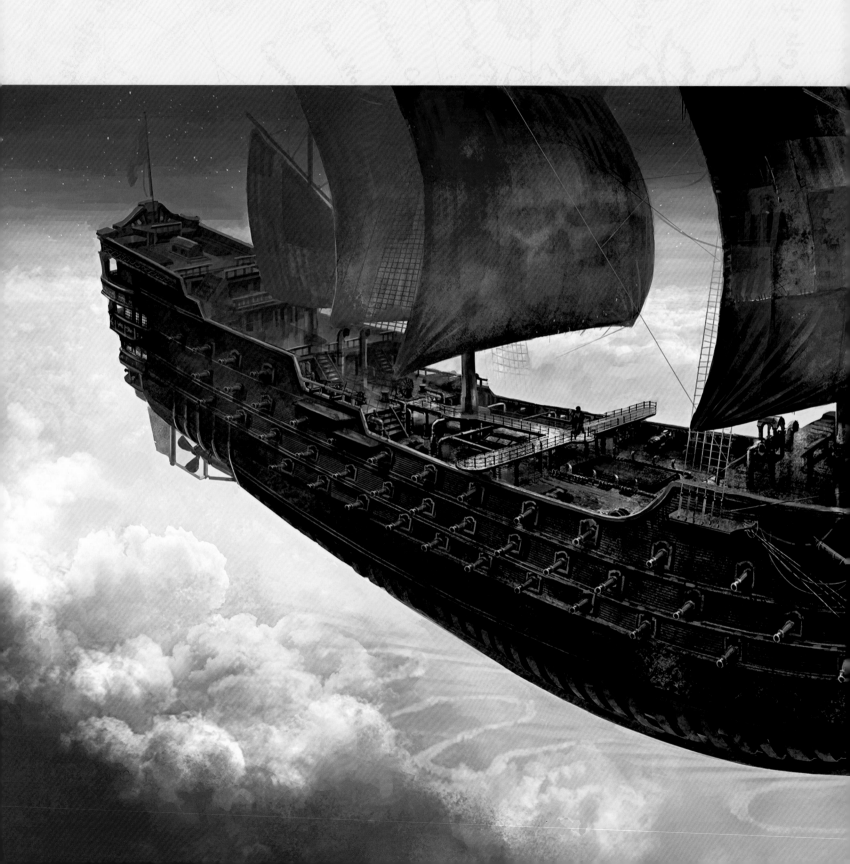

Dreaming Up Thoroughly Modern Pirates

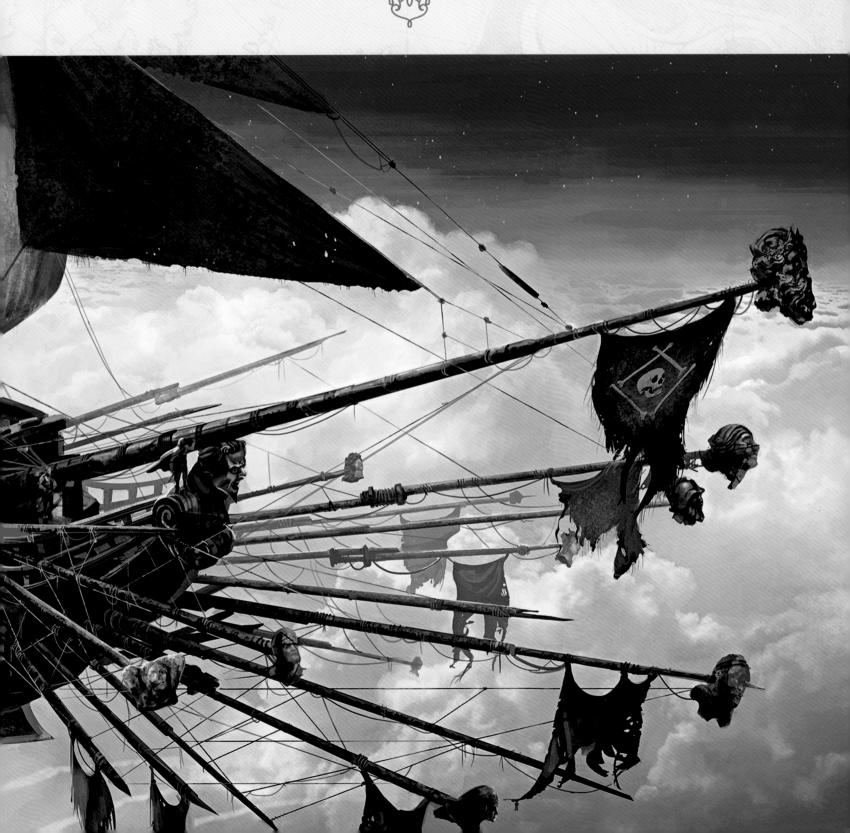

In the past decade the popular image of what a pirate looks like has been firmly emblazoned in our collective mind. That's why the director, producers, and creative team of *Pan* wanted to reboot the whole visual dictionary of a seafaring terror.

"We had to avoid the 18th century," says costume designer Jacqueline Durran. That's the time period of Johnny Depp's Captain Jack Sparrow.

"We needed to create something completely different yet have the results remain recognizably pirate," says producer Paul Webster.

Because Neverland defies traditional timelines, it was decided that individual pirates could come from any time period from the Elizabethan era to the starting point of Peter's journey, which is the 1940s.

TOP *An illustration of Blackbeard's meticulously decorated drawing room aboard his galleon,* Queen Anne's Revenge. **ABOVE** *The detail-oriented production designers created a set of playing cards depicting characters from the movie.* **RIGHT** *A costume design sketch depicting a pirate.* **OPPOSITE BOTTOM** *Blackbeard and some of the other pirates interact against a blue screen backdrop.*

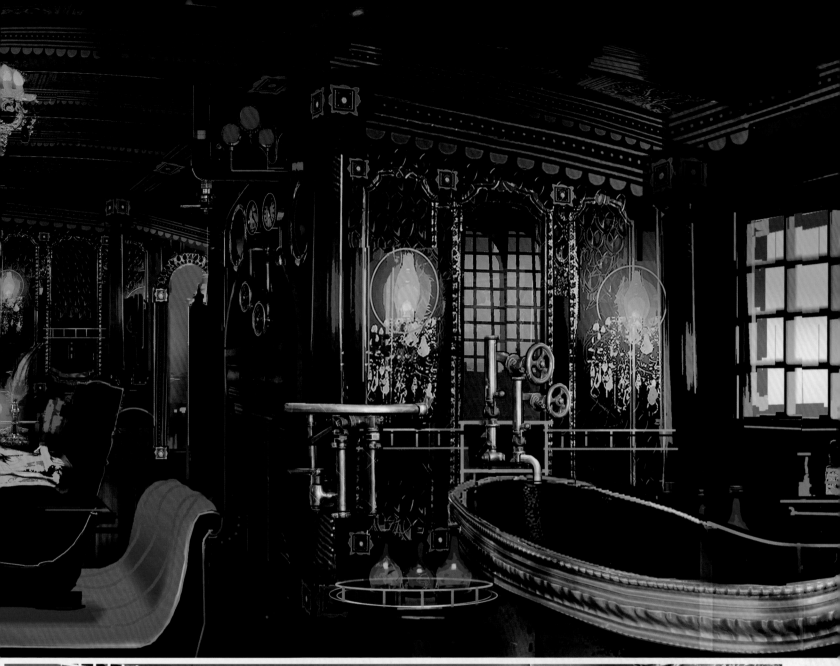

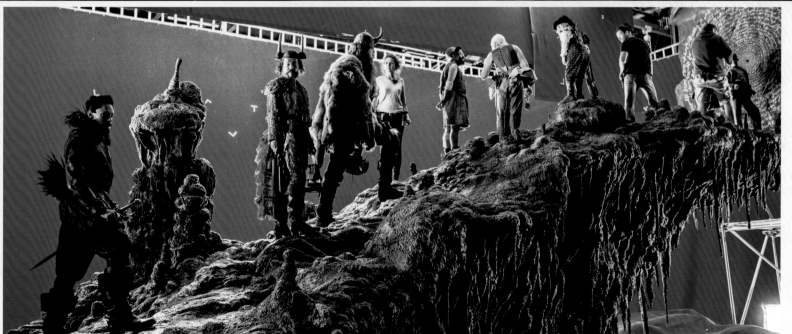

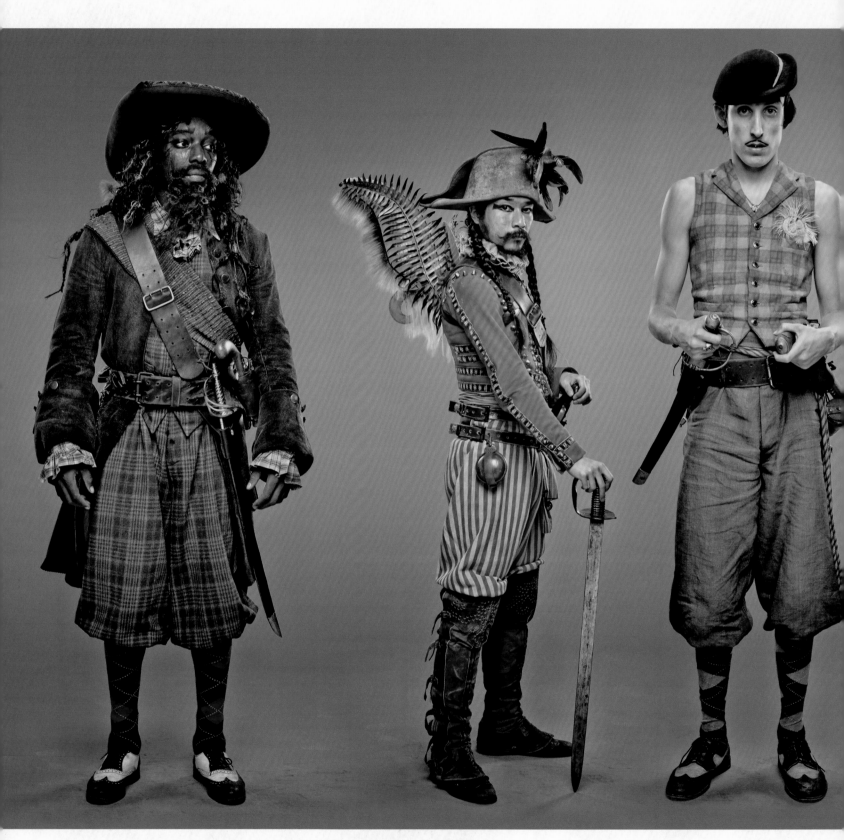

The filmmakers selected a diverse group of actors to portray Pan's colorful band of pirates.

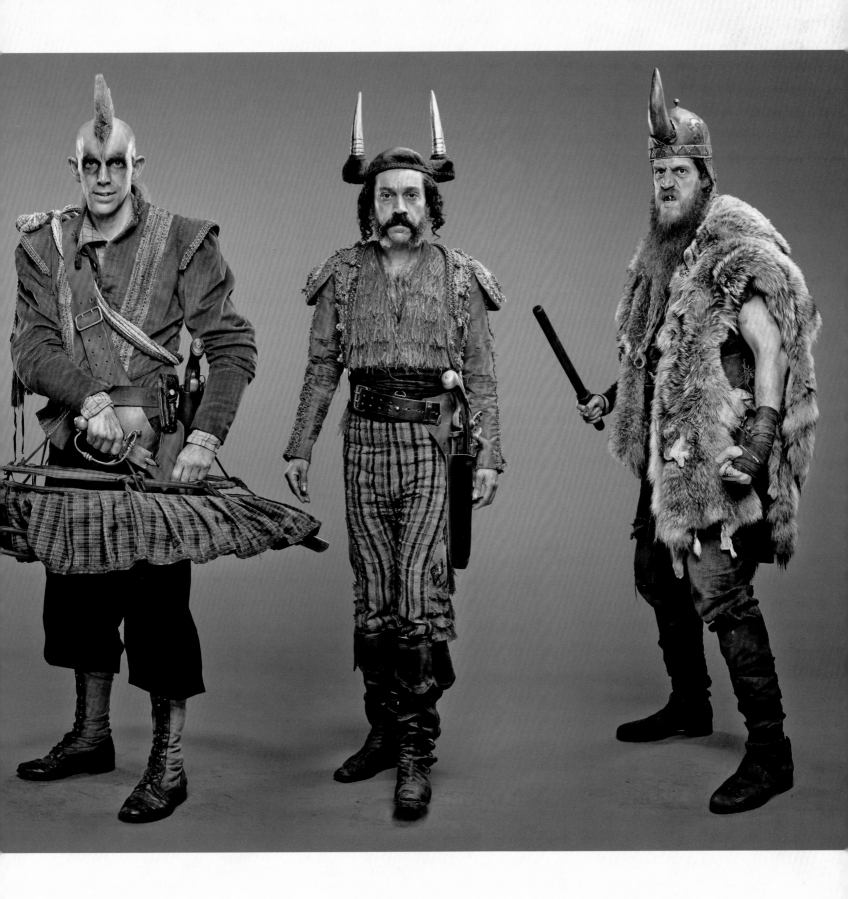

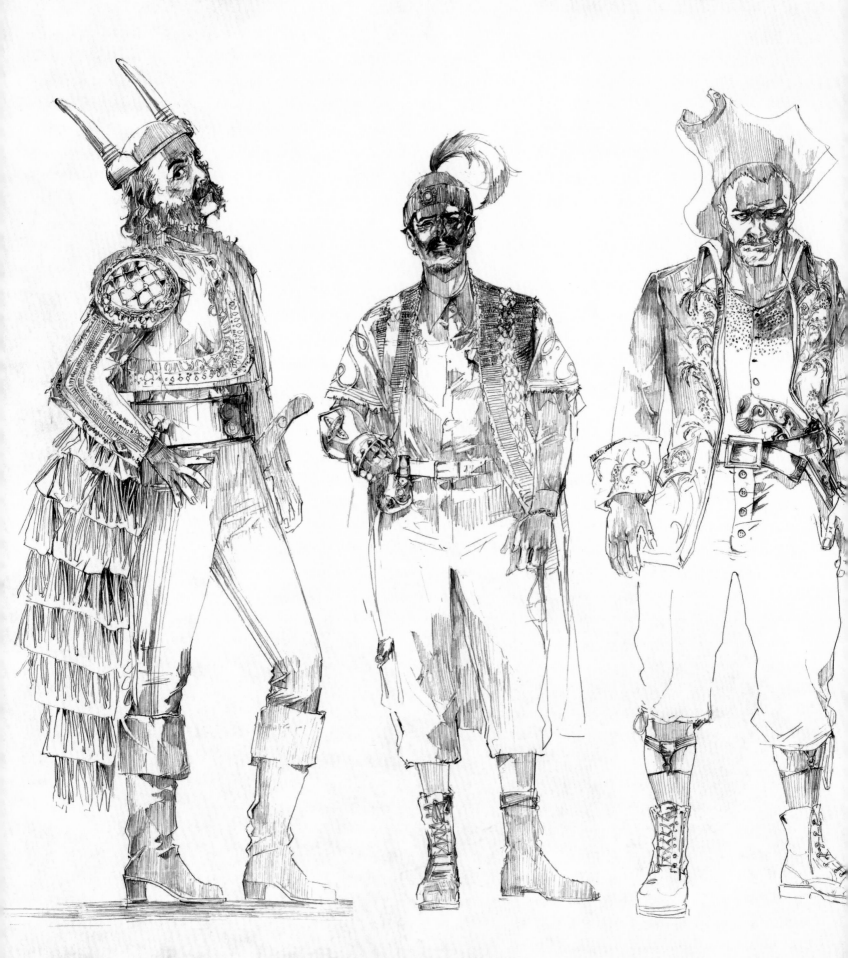

"We had to avoid the 18th century. We needed to create something completely different yet have the results remain recognizably pirate."
—PAUL WEBSTER, PRODUCER

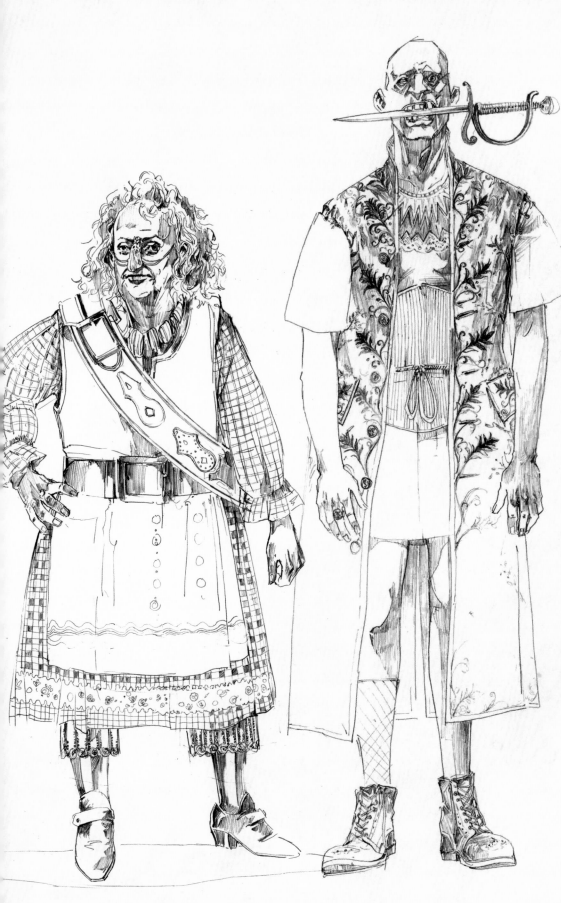

One morning before rehearsal got underway and with chests full of costume pieces, wigs, and weapons in front of them, director Joe Wright had the actors portraying the pirates play an adult dress-up game. "All Joe told them was: Pick something out. Create your own style. Create your own persona," Webster recalls.

When Wright was researching modern-day pirates, he had come across disturbing images of rebels in the recent civil war in Sierra Leone. Some of them wore pieces of women's underwear on top of their military uniforms and wore crazy wigs and makeup while they were also visibly loaded down with AK-47s, machetes, and pistols. *Pan's* pirates were consequently encouraged to cross-dress.

The result of *Pan's* pirate dress-up day, says producer Sarah Schechter, was: "Kind of 1970s punk meets (designer) Vivienne Westwood." And when a Sid Vicious type is coming at you loaded with weapons? "They're brutal." That should banish any image of Keith Richards's mumbling version of Blackbeard from the audience's mind.

LEFT *This costume design sketch depicts the eclectic look for the film's unique lineup of buccaneers.* **FOLLOWING PAGES** *Blackbeard and Bishop lead the other pirates in their battle against the Neverwood village tribe.*

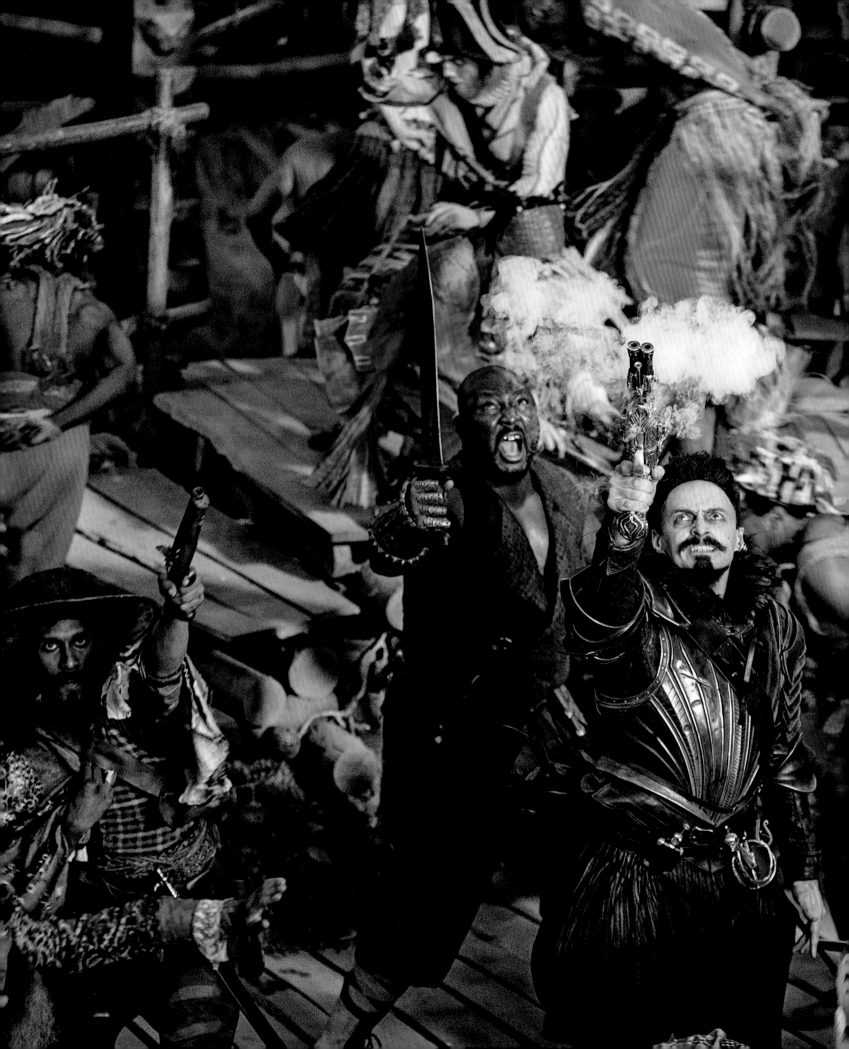

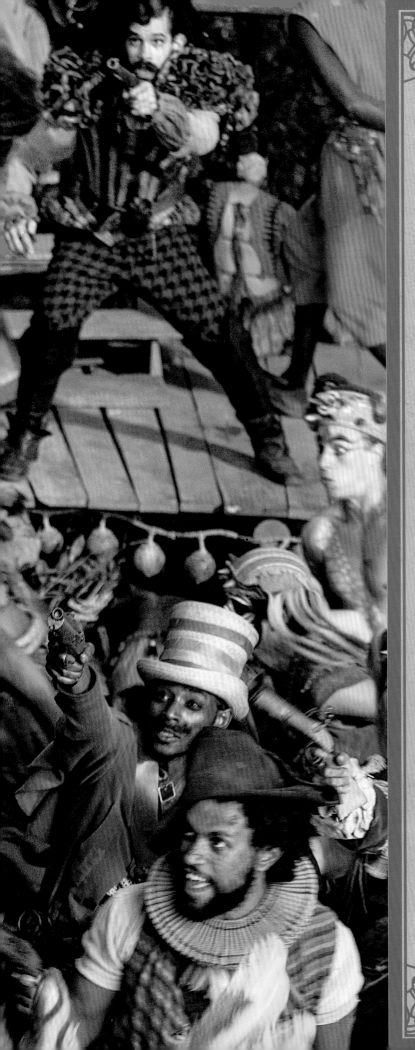

BECOMING
Blackbeard

Once Hugh Jackman was on board to play the film's antagonist, Blackbeard, the producers knew they had struck gold: "He's got movie-star good looks, he has a fantastic theatrical background, and he's a song-and-dance man," says producer Paul Webster. "He brings to Blackbeard a kind of theatrical malice the part demands."

Jackman himself shares the following observations about playing the fearsome pirate and revisiting the world of Peter Pan:

ON READING *PETER AND WENDY* FOR THE FIRST TIME: "I was a bit embarrassed that I hadn't read the book when I was younger. I immediately started reading the book to my kids. It was such a joy for them as well as for me. *Peter and Wendy* is a reminder of how serious and important we think we are as adults and how we're really not!"

· ✳ ·

WORKING WITH DIRECTOR JOE WRIGHT: "There are so many ways Joe distinguishes himself as a director. For one thing, he has the shoot pretty much all worked out. But he also allows for a lot of invention. To work with Joe you feel so supported by him. You feel he'll accept anything. There are no mistakes. You can fall on your ass. You can fall on your face. You can go for it. And he loves that. And then he has a way of molding it all together. He's very playful. He's the perfect director for this film."

· ✳ ·

THE *PAN* EXPERIENCE: "*Pan* is an adventure story first and foremost. You're going to a world that's beyond your imagination. You're going to places and meeting characters steeped in this great literature and history. But ultimately, the film is very moving, and you will both love and hate those characters. I know my kids are really going to love it. I know they're going to fall into that water really easily. And if there's any semblance of the nine-, ten-, or thirteen- or fourteen-year-old kid in us, the audience is going to fall in there as well. It's got great adventure, great action, humor, and whimsy—and it's eccentric. And I think people will find it a little surprising."

· ✳ ·

LIVING THE PIRATE'S LIFE: "One of my favorite things has been the creation of the gang of pirates. The ship and the crew couldn't be more diverse. They couldn't be more eccentric, frightening, and ridiculous. As Joe said, Neverland is really a child's imagination. It's a child's dream, and all adults in children's dreams should be equally frightening and ridiculous. And we pirates fulfill that, I think."

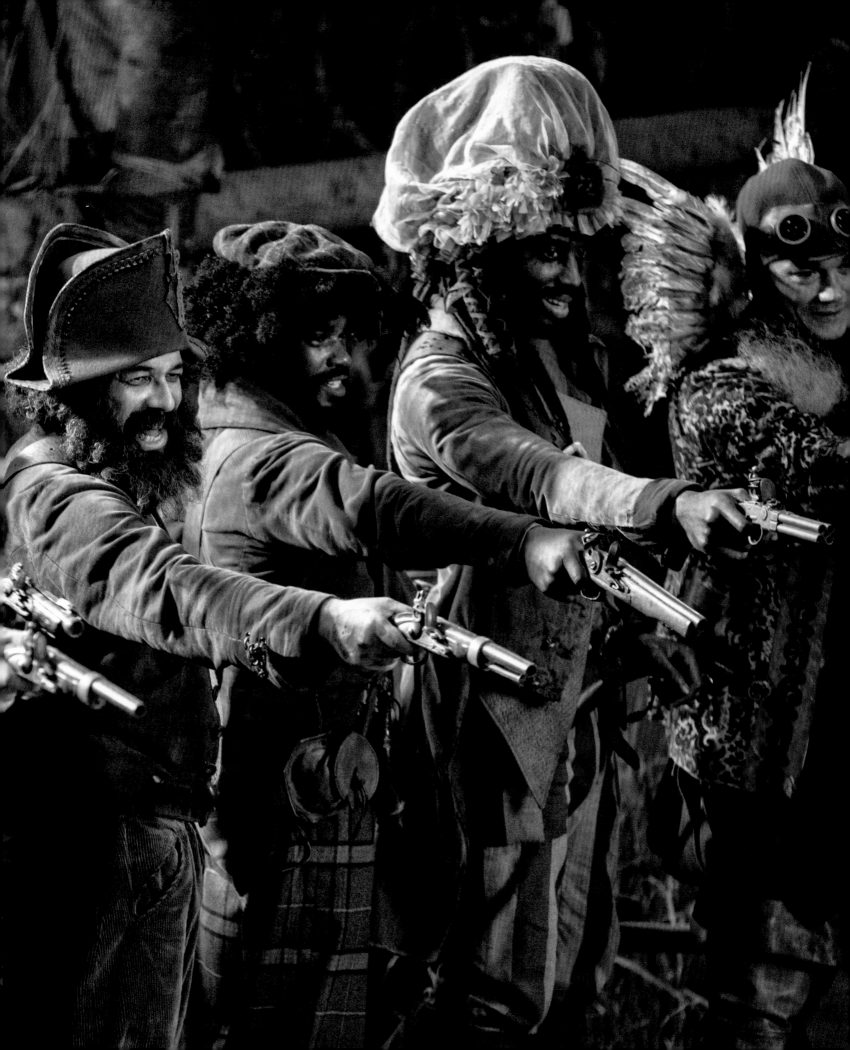

Para mi Madre

"One of my favorite things has been the creation of the gang of pirates. The ship and the crew couldn't be more diverse. They couldn't be more eccentric, frightening, and ridiculous."

—HUGH JACKMAN, ACTOR

THESE PAGES *These four immaculately crafted gun designs were some of the weapons used by the film's band of pirates.*

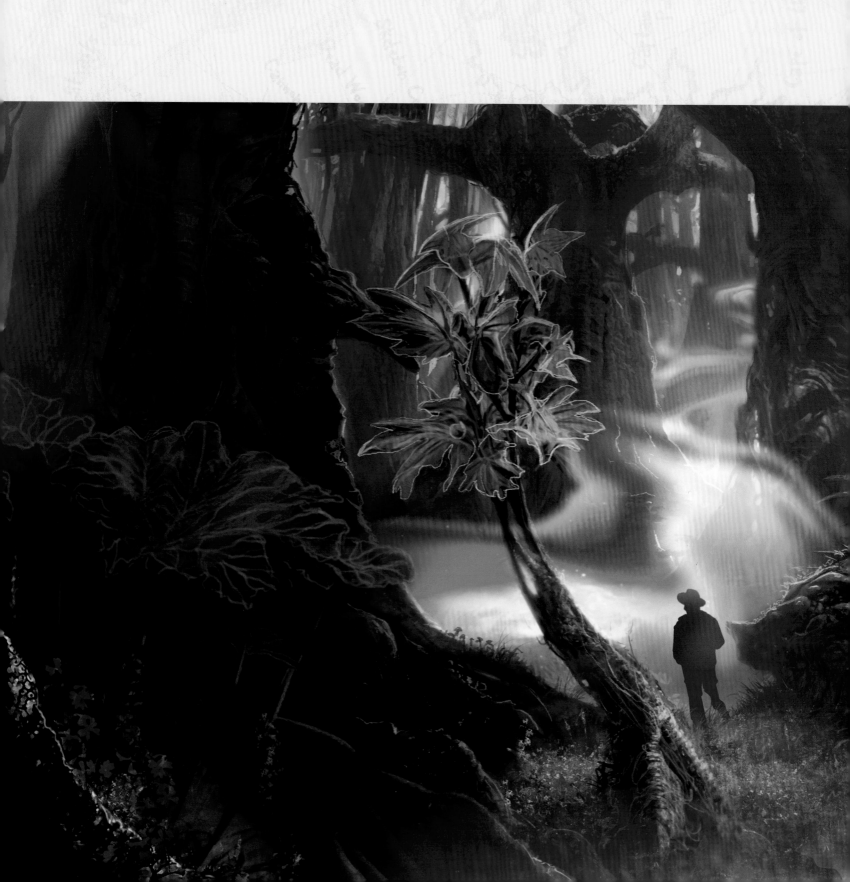

Fearless Feats of Wonder

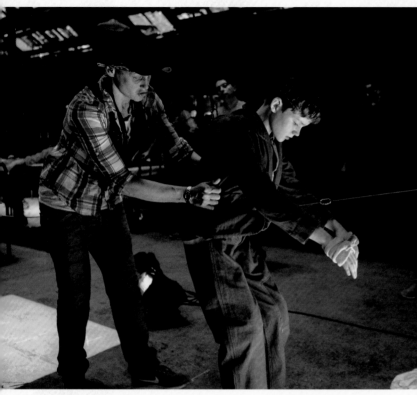

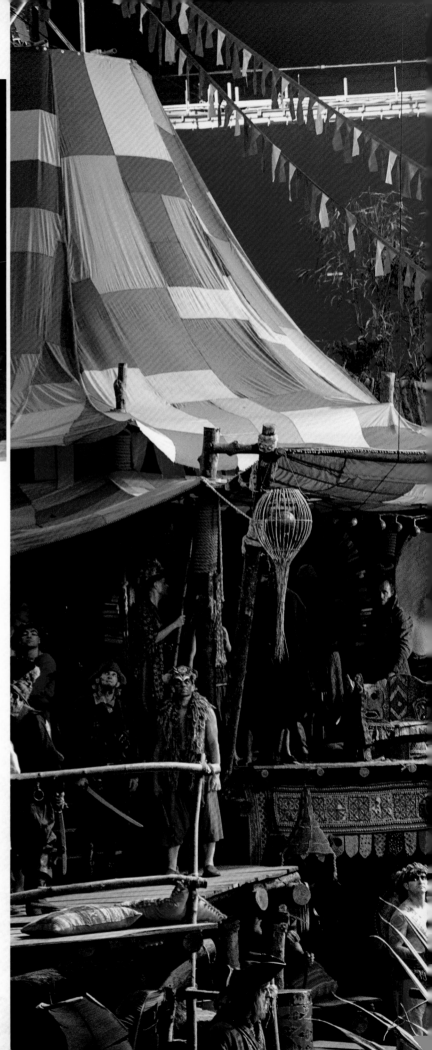

PREVIOUS PAGES *Hook observes the magical waters of the Mermaid Lagoon surrounded by the lush, exotic plants of Neverwood.* ABOVE *Stunt coordinator Eunice Huthart teaches Levi Miller how to fly using a harness.* RIGHT *Special wires and harnesses are used to keep one of the pirates suspended in the air against the blue screen set.*

Eunice Huthart has walked the walk in the world of big-budget film stunts.

She has worked as a stuntwoman (*Charlie and the Chocolate Factory, The Tourist, '71*) as a stunt double (doubling for Angelina Jolie on numerous occasions) and, more recently, as a stunt coordinator on an impressive list of films (*Maleficent, Dark Shadows, Alice in Wonderland*).

So she was pleasantly surprised to see how things worked out on the set of *Pan*, a big-budget, visual-effects-heavy action movie directed by a guy who had never directed one. "Although Joe may not be known for shooting action, when he sees what he wants to shoot, he shoots it and shoots it very well," says Huthart, who was the stunt coordinator for *Pan*.

In a set-piece battle between Blackbeard's pirates and the villagers of Neverland, for example, the logistics were complex: "We had 250 extras, 60 stunt people, people dropping from the roof of the soundstage, cannonballs going off, and our lead actors in a pitched battle in the middle of it all," Huthart continues. She says they should have had two weeks to prepare

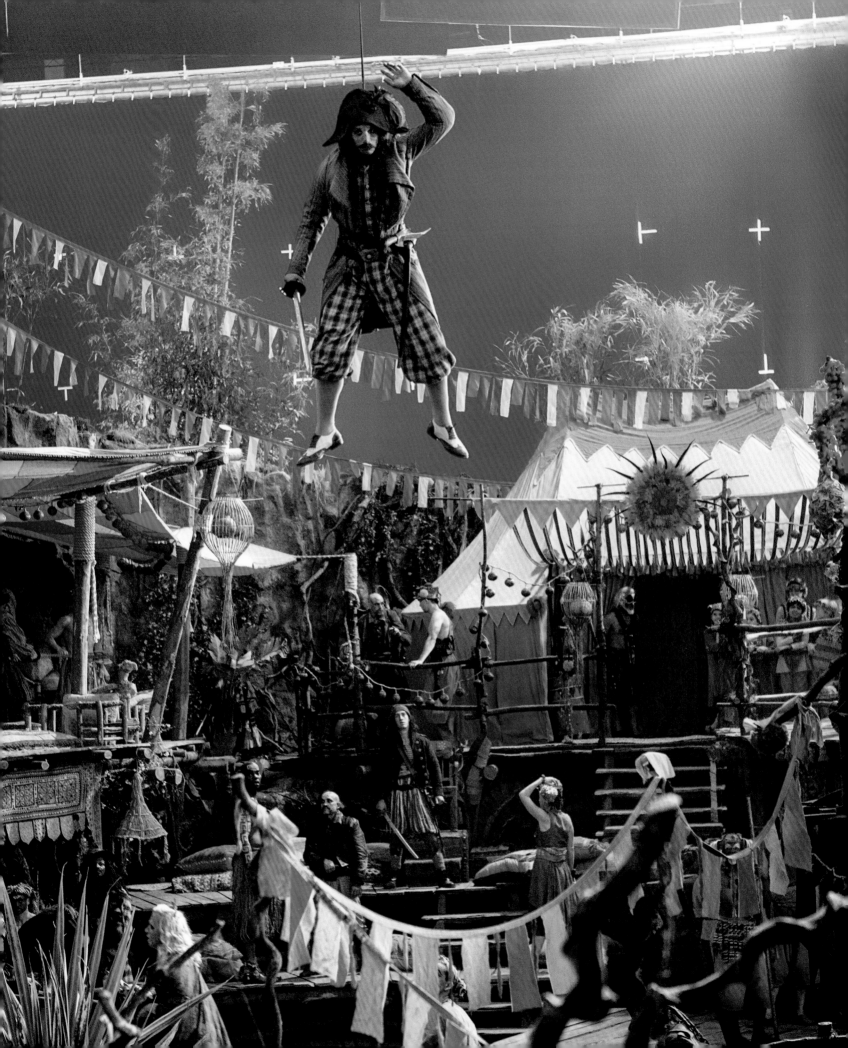

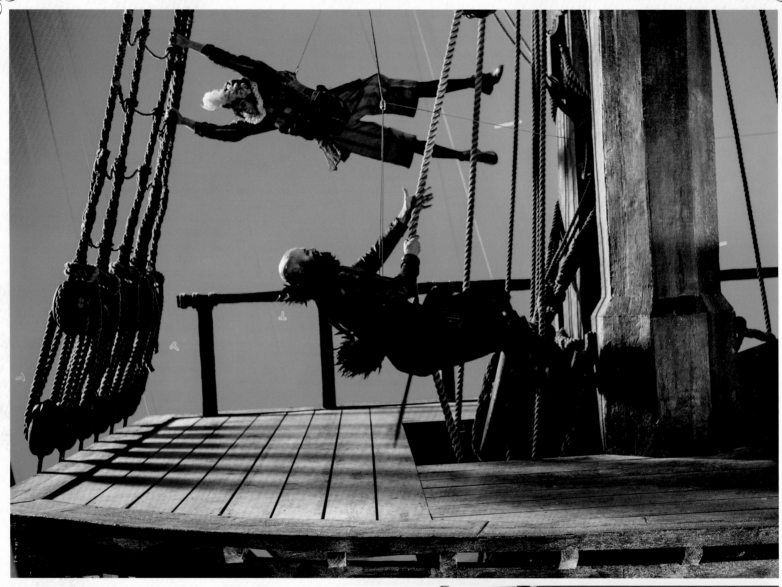

the director for the sequence, but because of budget and time constraints, they only had one day to do it. "Joe pulled it off," she says. "And it looked great."

The key to getting the sequence right, she says, lay in Wright's talent of fine-tuning the specificity of each character's physical actions. "We wanted the villagers to be agile and free-running in the jungle. They know the ins and outs, the quick loops around, where one can jump off things, and where the vines are that can be swung on," she says. The pirates, meanwhile, come in straight ahead in *crash-bang-wallop* mode and destroy everything in their path. "His approach to all the fight scenes was to make them character-related," Huthart says. "We didn't want to have conventional action sequences with action just for action's sake."

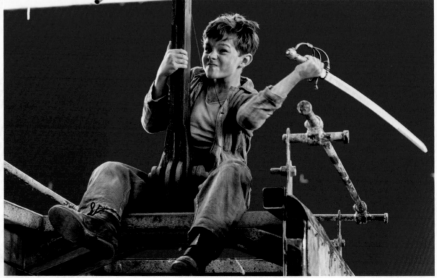

TOP *Blackbeard takes over an action sequence set on his pirate ship.* **ABOVE** *Peter wields a sword in a blue screen fight.* **OPPOSITE** *The actors, including Levi Miller, were encouraged to be agile and swing from the many vines and ropes of the sets.*

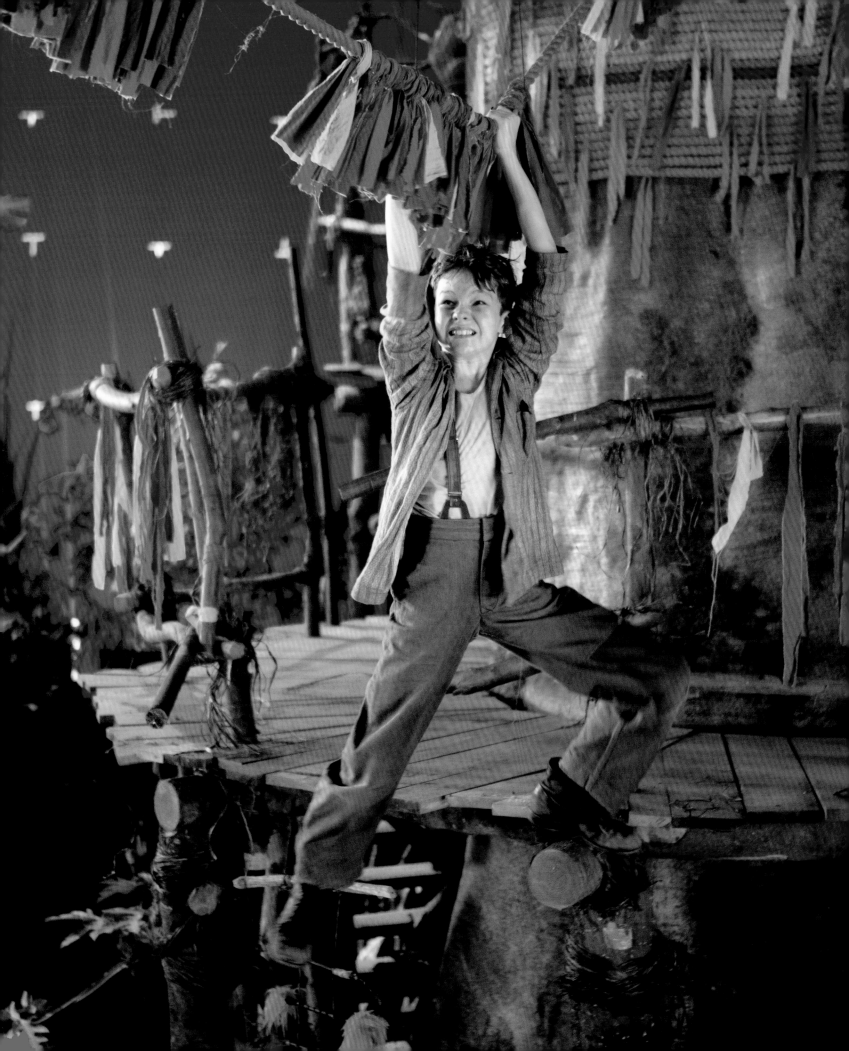

One of the most challenging sequences happens early in the film. Children have been mysteriously disappearing from the orphanage where Peter lives. (He is, at this point, unaware of his half-human, half-fairy heritage and of his ability to fly.) When he and a friend stay up late one night to find out what happened to the missing children, they are horrified to see sleeping orphans being stolen from their beds by pirates in a galleon floating over London.

"We had to make it scary. Because, for children, being stolen out of their bed is a common nightmare," says Huthart. With twenty pirates and sixty children in the scene, everything had to be meticulously planned. "There are certain restraints for what children are allowed do in an action sequence, so we had to execute the scene with military-like precision," she explains.

As Wright wanted to keep as much of the action as real, on-set effects as possible rather than green screen digital effects, the most common tool on the set of *Pan* was wire assistance and harnesses. "We did everything we could possibly do with the actors in the physical world," says Huthart.

In the scenes where Peter had to fly, Wright waited until the last possible second before he'd let CGI take over. "Only when he was quite small, about the size of a penny on the screen," she says. Everything else you see is the young actor who plays Peter, Levi Miller. "He was fantastic. He did all the stunts himself."

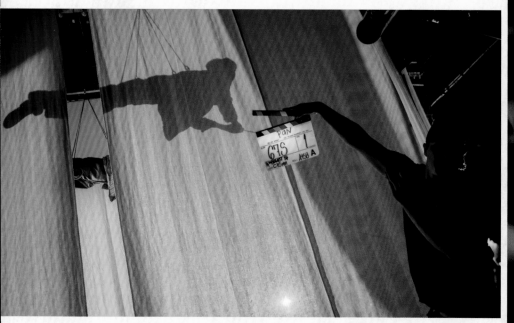

ABOVE *Wire assistance and harnesses help create the illusion of Peter's flight.* **RIGHT** *A pirate steals one of the boys from his bed in the orphanage.* **PAGES 144–145** *The pirates' air galleon travels through a magical passage through space and time to reach Neverland.*

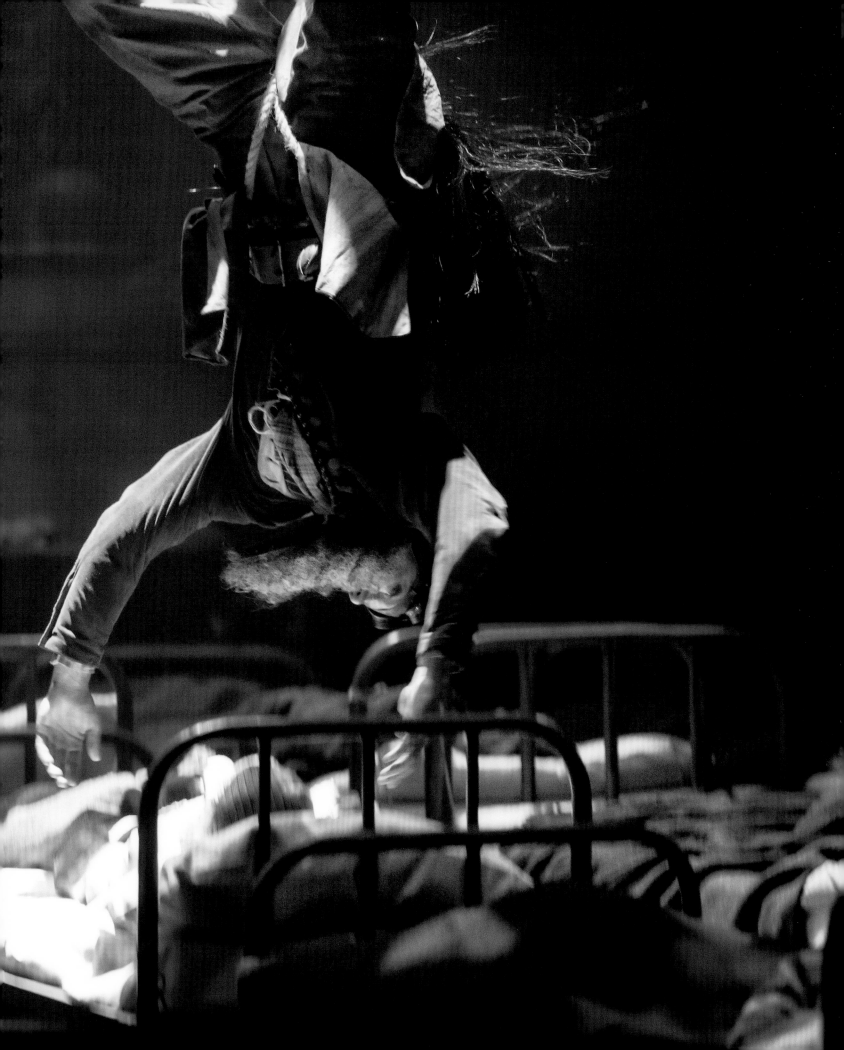

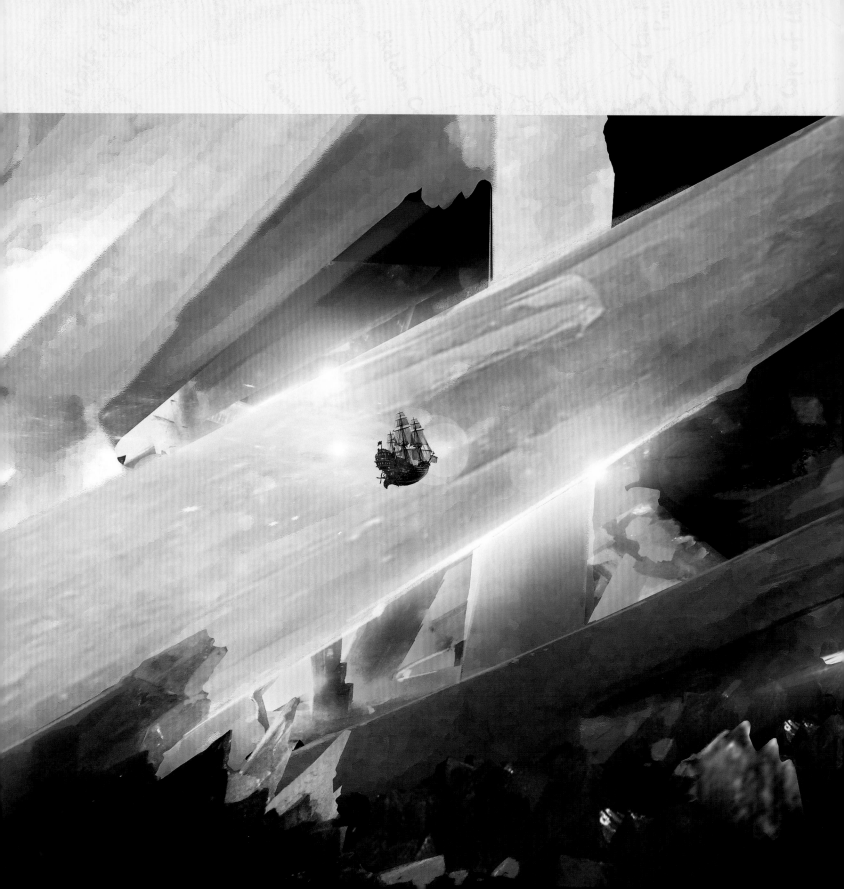

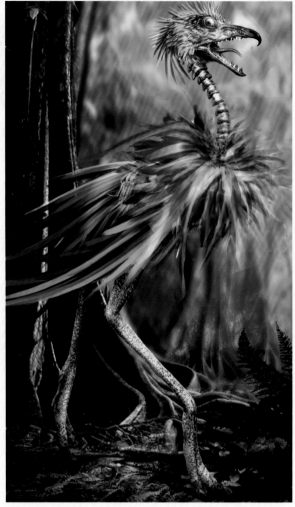

ABOVE AND RIGHT *The island's peculiar Neverbird is one of the imaginary creatures created for the movie using a combination of a feathered maquette and digital technology.*

As much as director Joe Wright likes to keep it real by shooting actors on a real set with real objects, there comes a time, especially in a fantastical film like *Pan*, where there are no options *but* computer-generated imagery.

"There are a lot of digital effects in *Pan*," says Wright. "That's in its DNA."

But instead of being forced to abandon his non-digital predilections, Wright and his team found new ways to work, developing a kind of hybrid of digital and analog filmmaking techniques.

"We stopped thinking about computers on this film," says visual effects supervisor Chas Jarrett, a veteran of some recent big-budget CGI films (*Sherlock Holmes*, *Sweeney Todd*, *Harry Potter and the Sorcerer's Stone*, *Harry Potter and the Chamber of Secrets*). "In general I find it best to glean as much information as possible from the real elements created by the art and construction departments before giving them to the CGI teams to photograph, cyberscan, and re-create digitally."

Case in point: the creation of one of Neverland's digital creatures, the Neverbird.

Typically, exotic creatures such as the Neverbird are designed and drawn on a computer and then put though their paces with pre-visualization software to test how the character will move through the set and interact with the other characters and camera. "It lets you solve problems before you get to the set," Jarrett says.

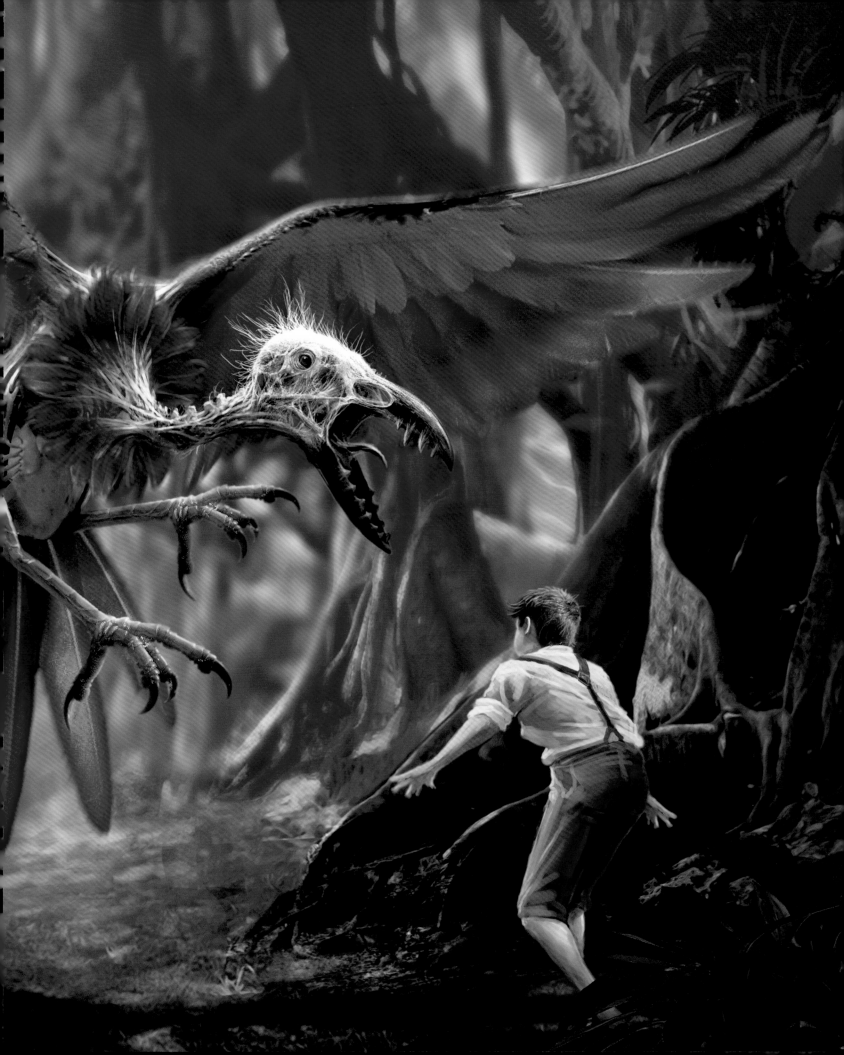

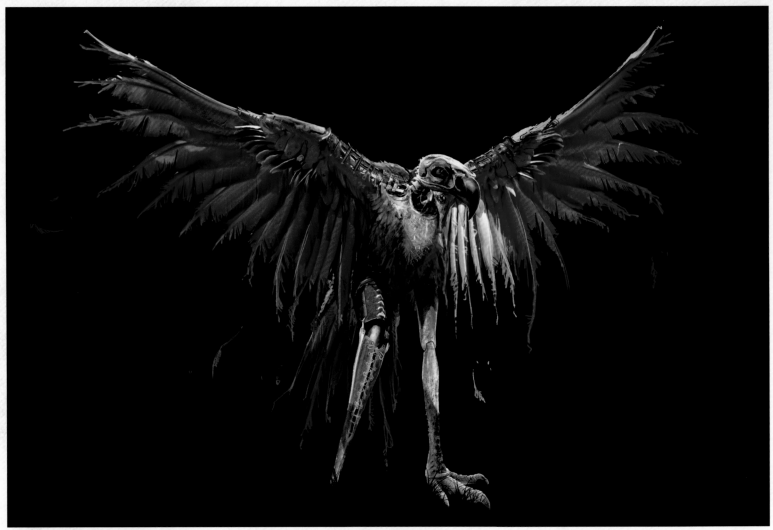

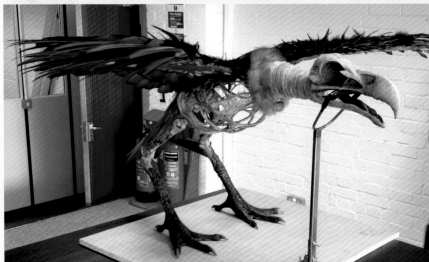

TOP AND OPPOSITE PAGE *Artists' depictions of the exotic Neverbird, which helped inspire the puppet and the CG creation.* ABOVE *A puppet built from chicken bones, chicken feet, and the skull of another bird helped inspire a Neverbird maquette, which was then scanned into the computer as a 3-D object.* FOLLOWING PAGES *The giant Neverland crocodile attacks Peter, Hook, and Smee as they make their escape from the mines.*

For his part, Wright is a fan of puppetry, growing up as he did in a household of puppeteers. "There are many very skilled designers who could have done this on a computer," says Wright, "but I wanted to come at the development of the Neverbird from a different angle."

So a puppet was built from a mishmash of chicken bones, chicken feet, the skull of another bird, and rubber bands. "But it was beautifully strung just like any puppet," says Jarrett. A set of miniatures had been built, and using Jarrett's Canon 5D SLR, footage was shot. On that basis a number of adjustments were made to the puppet, eventually yielding a very complex and feathered Neverbird maquette that was scanned into the computer as a 3-D object, and the digital bird was born. "At Joe's urging we reversed the standard pre-visualization process of moving a stand-in character through a 3-D space first and then designing and refining the creature last," Jarrett says. "The result," adds Wright, "is something exotic and more original than if we'd created it solely in a computer."

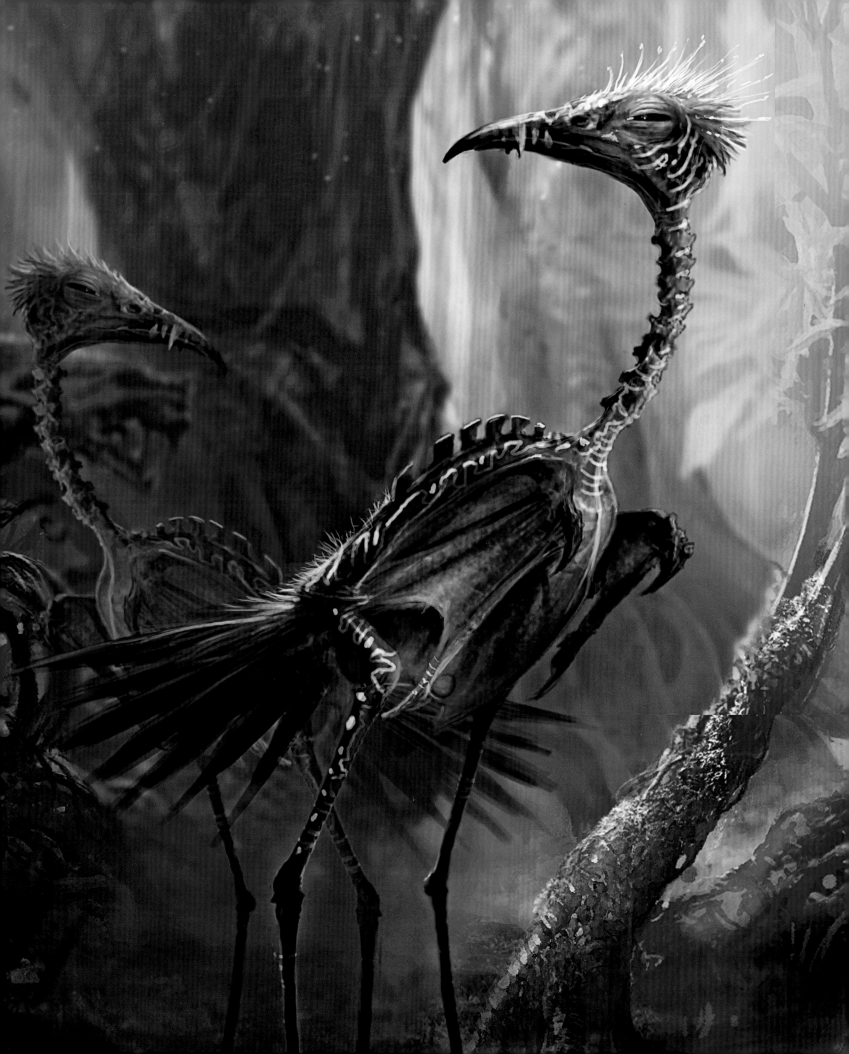

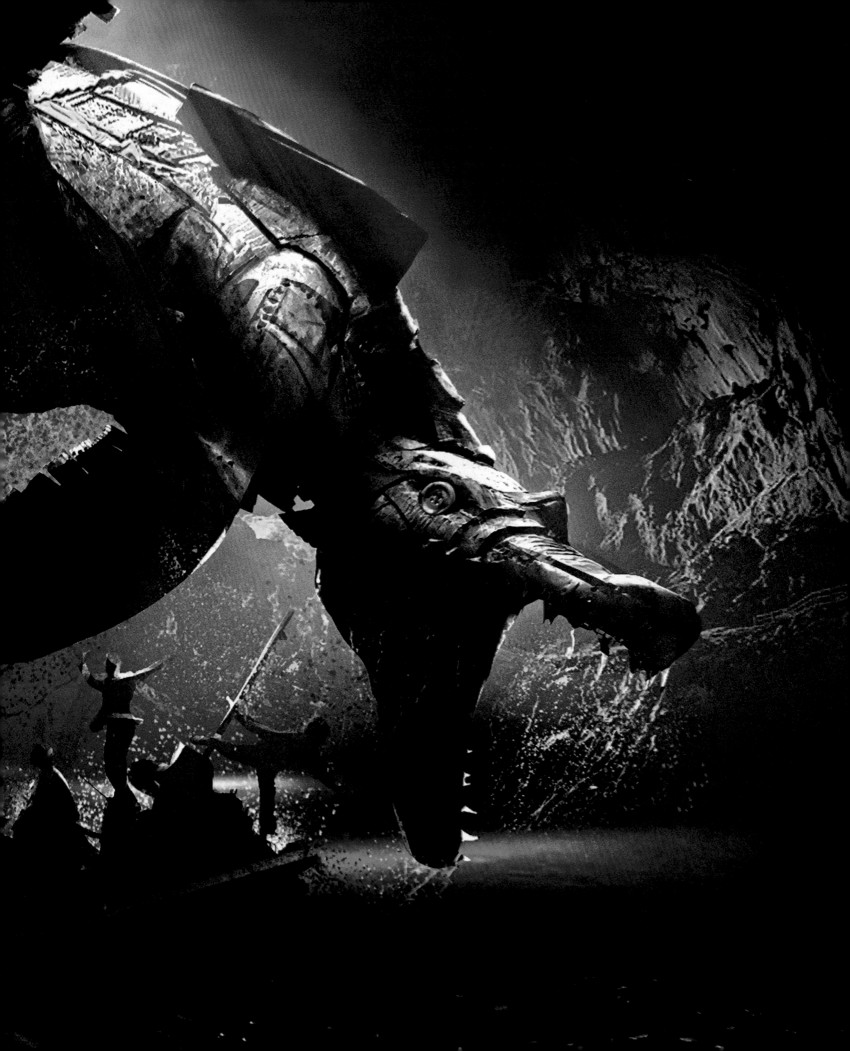

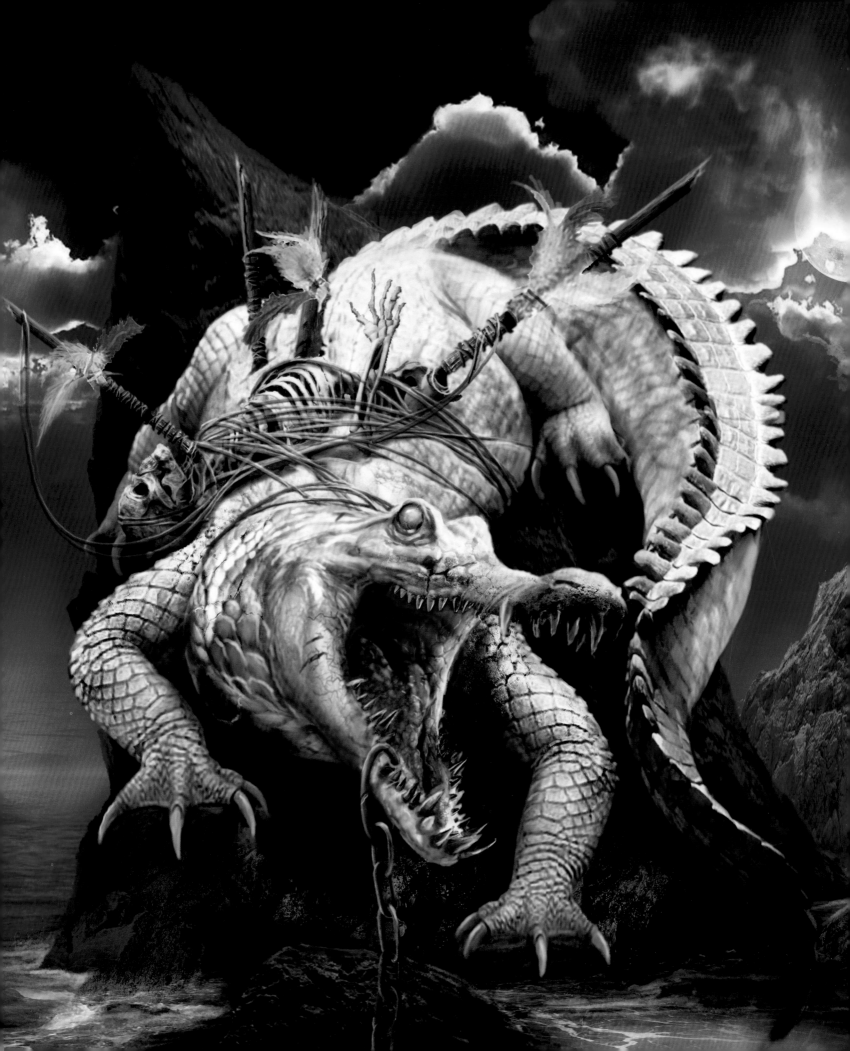

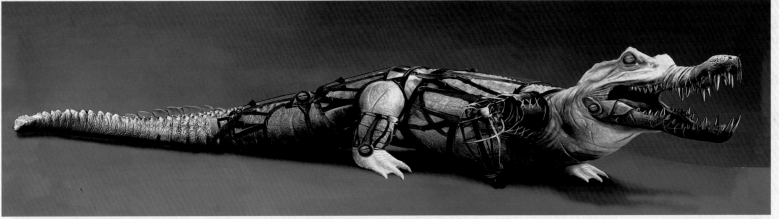

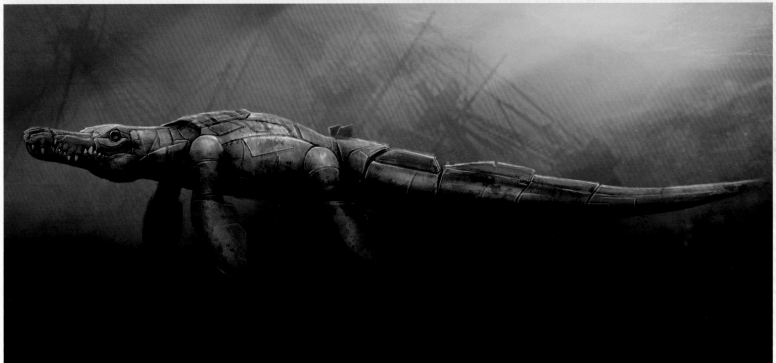

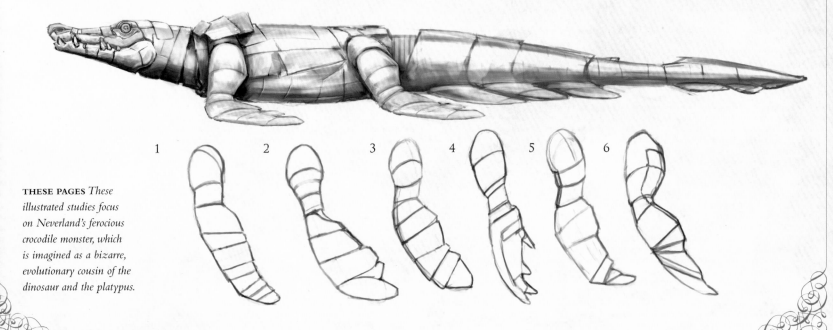

1 2 3 4 5 6

THESE PAGES *These illustrated studies focus on Neverland's ferocious crocodile monster, which is imagined as a bizarre, evolutionary cousin of the dinosaur and the platypus.*

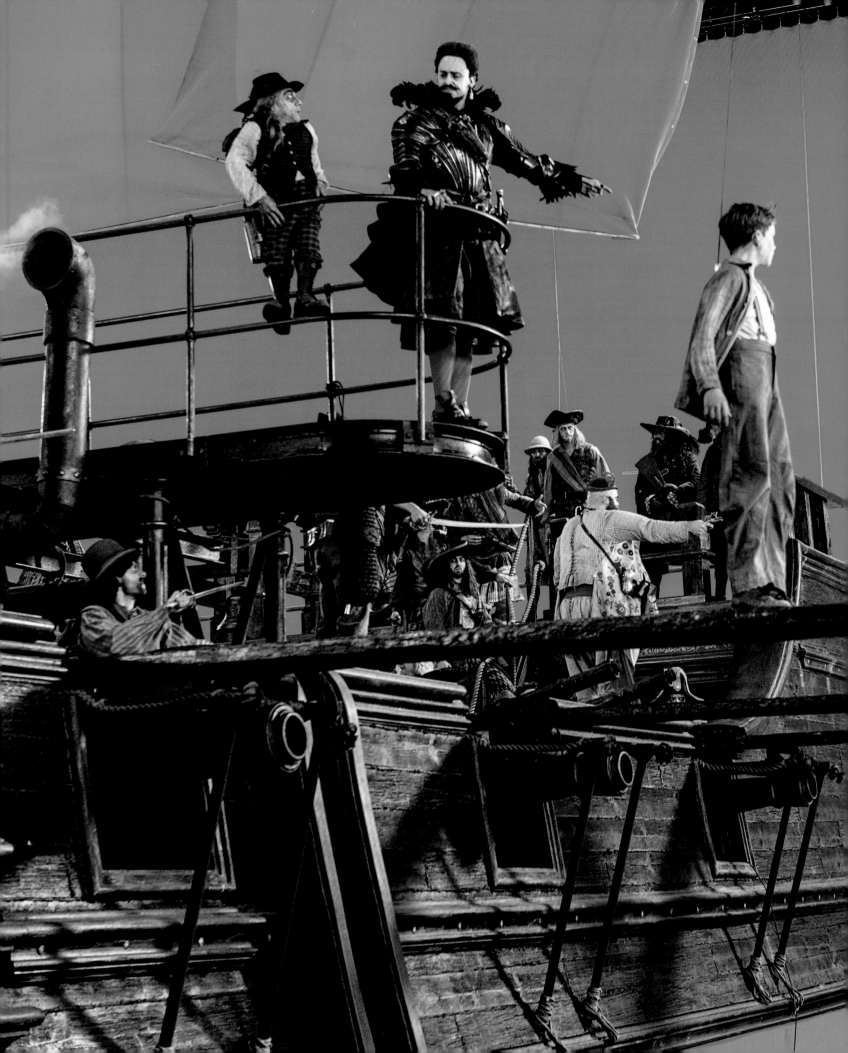

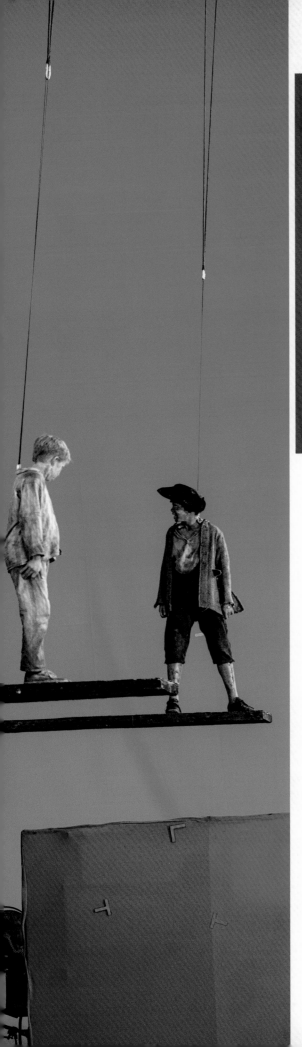

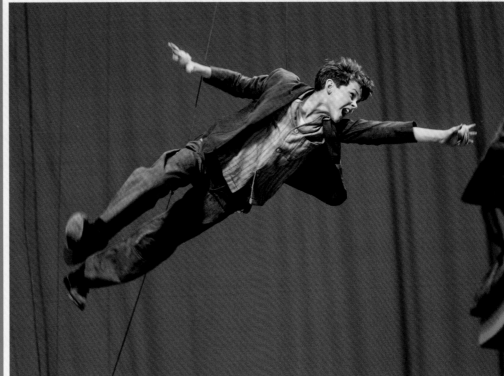

Wright and the digital effects team extended this emphasis to important scenes of Peter flying and, earlier in the film, floating in space. Of paramount importance to Wright was to have the real face of actor Levi Miller reacting to his digital surroundings. Using technology developed for the film, young Miller was attached to the arm of a repurposed KUKA Robot (similar to those found on automobile production lines) that had been programmed with motion data from a pre-visualization animation sequence.

As the arm moved him through space, motion-controlled cameras programmed with the same motion data followed. Being in a weightless environment (and this is fantasy, so, yes, there is air) they needed to deal with Peter's hair, which would float off his head; and his clothes, which would move differently than with gravity. The simple solution was using a skull cap and minimal clothing for the actor held in his carbon-fiber harness, with wavy digital hair to be added later, along with clothing. "It's a brilliant looking sequence," says Jarrett.

"Joe's approach is all about real emotion and performance," says producer Sarah Schechter. "While CGI is an amazing tool, sometimes it can overwhelm the story and the emotion. Here, the story and performances come first."

LEFT AND ABOVE
Levi Miller is suspended in the air via wires and harnesses. He is able to react to his digital surroundings using the arm of a KUKA Robot programmed with motion data from a pre-vis animation sequence.

FOLLOWING PAGES
The pirates' air galleon flies through Neverland.

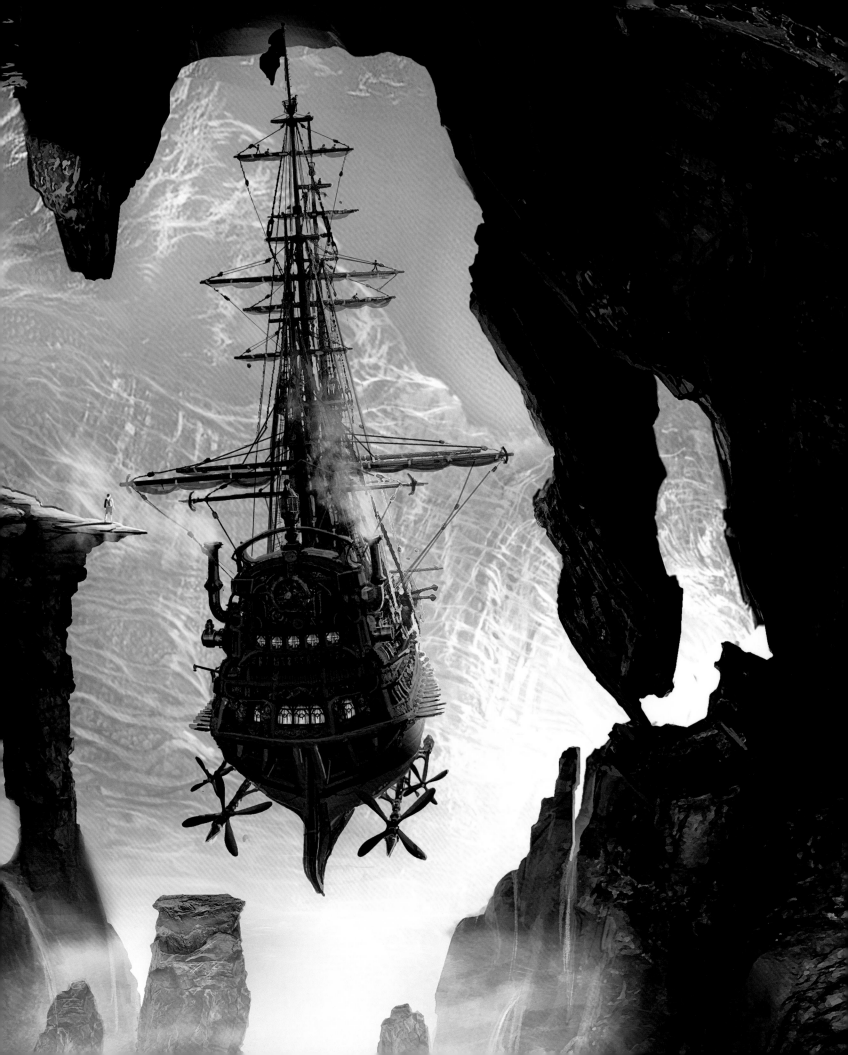

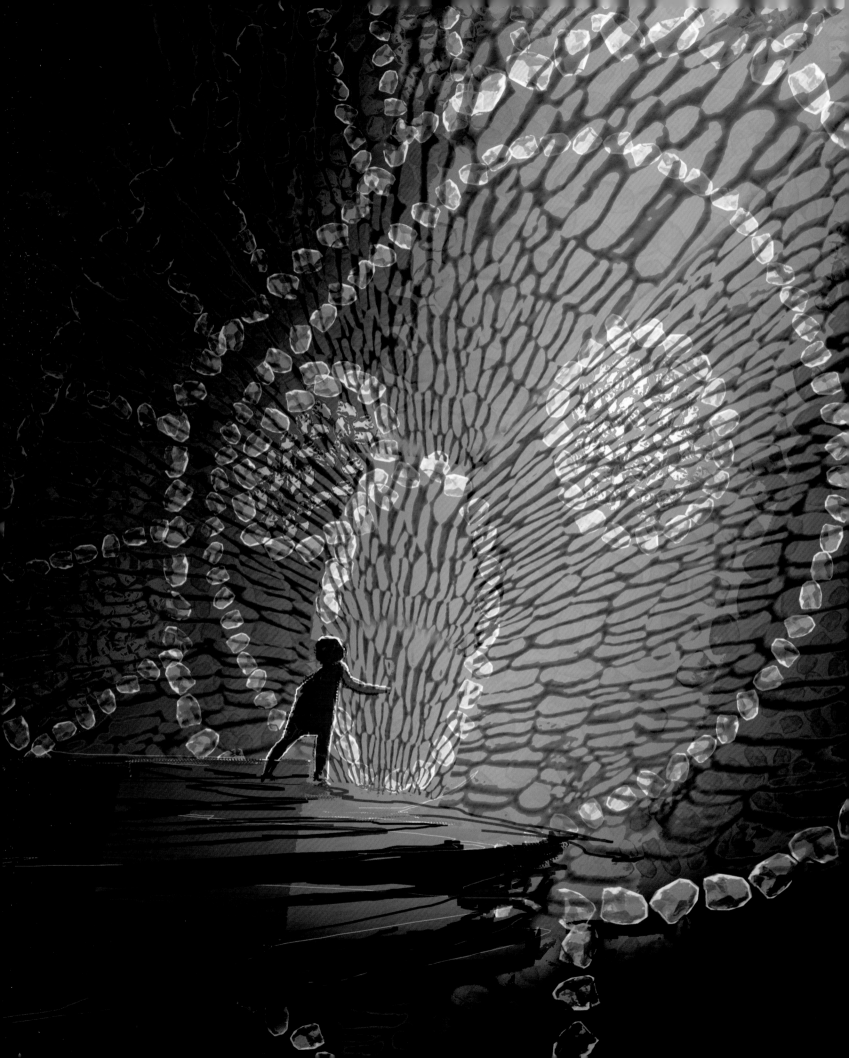

Conclusion

EXPERIENCING AN 'AWFULLY BIG ADVENTURE'

It's been more than a century since Peter Pan first appeared in British playwright and novelist J. M. Barrie's *A Little White Bird* in 1902 and then inspired the stage play *Peter Pan, or The Boy Who Wouldn't Grow Up* in 1904. "All of this has happened before, and all of it will happen again," wrote Barrie in the original book.

In late 2013, the creative team behind *Pan* set out to make a family film about the origins of one of the most enduring characters in children's literature. They realized that it would be a challenging, yet deeply rewarding journey.

"It's kind of a mad world we've been creating," says director Joe Wright shortly after wrapping principle photography in November 2014. "It's a big, baroque, and beautiful story."

Thanks to the distinctive eye and unique vision of Wright and an A-list cast and crew, *Pan* has turned out to be much more than just a cinematic visit to a familiar childhood place.

"Historically, Warner Bros. has been really successful putting together these kinds of stories, collaborating with auteurs with a strong vision," says producer Greg Berlanti, one of the early champions of the film. "Joe has created a world in *Pan* that is unlike anything that's been captured on screen before. He's accomplished it by assembling the same kind of crew for this family action-adventure movie that he'd put together for an Oscar-worthy drama. *Pan* has a wonderfully mature aesthetic. And it also has the heart and wonder of a great family film."

"What's amazing about Peter Pan is that there isn't one right way to tell his story," adds producer Sarah Schechter. "It's a universal tale that has been part of our shared cultural history. While we have been able to use CGI to bring the story's magic to life, Joe's approach is all about real emotions and genuine performances by the actors. Peter Pan's quest to find his mom and discover his place in the world is a timeless one. It speaks to the core of human experience and the value of embracing a child's imagination." It's a testament to the lasting power of J. M. Barrie's vision and *Pan*'s remarkable creative team that Peter Pan is soaring again in 2015. No doubt, the movie will inspire a whole new generation of moviegoers to let their imaginations fly toward that second star to the right and to relive Barrie's "awfully big adventure."

LEFT *Peter learns the truth about his past and legacy from a magical Memory Tree in Neverland.*

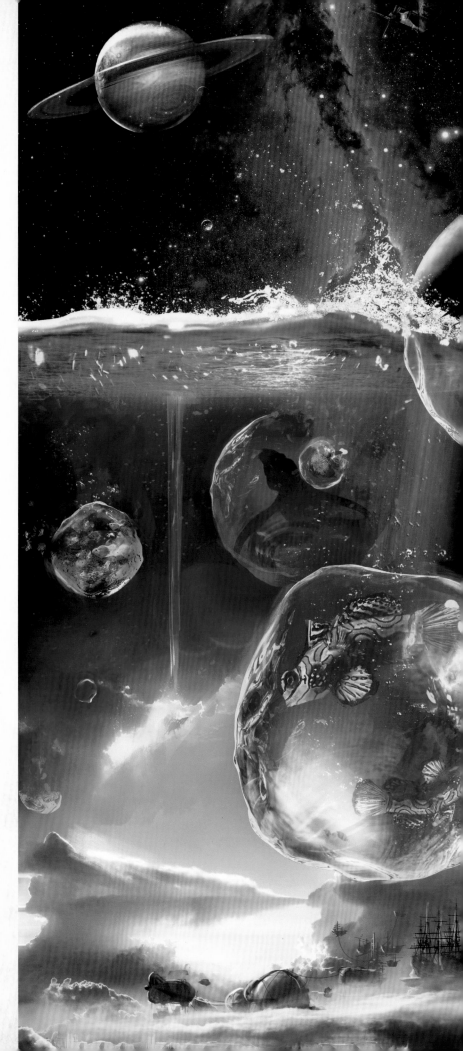

INSIGHT
EDITIONS

PO Box 3088
San Rafael, CA 94912
www.insighteditions.com

Find us on Facebook: www.facebook.com/InsightEditions
Follow us on Twitter: @insighteditions

Library of Congress Cataloging-in-Publication Data available.

ISBN: 978-1-60887-668-6

ROOTS of PEACE REPLANTED PAPER

Insight Editions, in association with Roots of Peace, will plant two trees for each tree used in the manufacturing of this book. Roots of Peace is an internationally renowned humanitarian organization dedicated to eradicating land mines worldwide and converting war-torn lands into productive farms and wildlife habitats. Roots of Peace will plant two million fruit and nut trees in Afghanistan and provide farmers there with the skills and support necessary for sustainable land use.

Manufactured in Hong Kong by Insight Editions

10 9 8 7 6 5 4 3 2 1

INSIGHT EDITIONS
PUBLISHER: Raoul Goff
ACQUISITIONS MANAGER: Robbie Schmidt
ART DIRECTORS: Chrissy Kwasnik & Jon Glick
DESIGNER: Jenelle Wagner
EXECUTIVE EDITOR: Vanessa Lopez
SENIOR EDITOR: Ramin Zahed
PRODUCTION EDITOR: Elaine Ou
EDITORIAL ASSISTANT: Greg Solano
PRODUCTION MANAGER: Jane Chinn

ARTISTS: Michael Kelm, Dominic Lavery, Peter McKinstry, Howard Swindell, Norman Walshe, and Thomas Wingrove
PRODUCTION DESIGNER: Aline Bonetto
PROPS AND WEAPONS: Max Berman
VFX: Scott Mcinnes

RIGHT *After taking Peter from the orphanage, the pirate ship travels through a stunning, intergalactic passageway to reach the shores of Neverland.*

PAGE 1 *Peter learns the truth about his past from the ancient Nevertree.*
PAGE 2 *Levi Miller portrays Peter Pan in the new origin story of the popular character, originally created by Scottish author and dramatist J. M. Barrie in 1904.*
PAGES 4–5 *An artist's depiction of the floating air pirate ships and the colorful Neverland village.*
PAGES 6–7 *Peter and Hook band together to fight Blackbeard's evil schemes.*
PAGES 8–9 *An artist's rendition of Neverland's ethereal Mermaid's Lagoon.*